KU-304-936

WITHDRAWN

BRITISH ART
SINCE 1900

FRANCES SPALDING

BRITISH ART
SINCE 1900

211 illustrations, 50 in colour

THAMES AND HUDSON

For Daniel, eventually

Acknowledgments

I wish to acknowledge a debt to those who in recent years, through the exhibitions they have organized or through the articles and books they have written, have deepened my enjoyment of twentieth-century British art. Reference to their work can be found in the bibliography. My thanks go also to Maureen Daly, for typing assistance, and to Kathleen Moynahan and Sheila Walker for making this book possible.

Designed by Roger Walker

Any copy of this book issued by the publisher as a paperback is sold subject to the condition that it shall not by way of trade or otherwise be lent, re-sold, hired out or otherwise circulated without the publisher's prior consent, in any form of binding or cover other than that in which it is published and without a similar condition including these words being imposed on a subsequent purchaser.

© 1986 Thames and Hudson Ltd, London

All Rights Reserved. No part of this publication may be reproduced or transmitted in any form or by any means, electronic or mechanical, including photocopy, recording or any information storage and retrieval system, without prior permission in writing from the publisher.

Printed and bound in Spain by Artes Graficas Toledo S.A.
D. L. TO: 1892 -1985

CONTENTS

PREFACE

It has taken a long time for twentieth-century British art to receive the attention it deserves, and for the richness and diversity of its achievement to become apparent. One reason for this is that a concern with modernism has blinkered critical evaluation of twentieth-century art, encouraging historians, in its emphasis on innovation, to look for a linear evolutionary development, a tendency which has helped banish into temporary obscurity much that did not uphold the dominant avant-garde ideology. But this forward thrust, in Britain especially, has periodically broken down and ended in a cul-de-sac. Innovation has instead been made through a return to personal convictions or native traditions, to a revival of narrative, for example, or a realist approach. The individualism inherent in British art has liberated artists from unthinking adoption of fashionable styles. It has also fostered those who, though isolated by their individual concerns, together constitute an eccentric mainstream in British art. Links can be found, such as David Hockney's interest as a student in Stanley Spencer. But the centrality of this tradition is best proved by the fact that between 1957 and 1973, when the impact of American art was at its height, the Professor of Painting at London's leading art school, the Royal College of Art, was Carel Weight, whose fascination with the forlorn gentility of South London kept him insulated from intellectual theories and foreign influence.

Soon after the re-evaluation of modernism began in the 1970s, the spectrum of twentieth-century British art began to shift, revealing facets that had previously been undervalued or ignored. Within the restrictions necessarily imposed by this book, I have tried to register this change of focus. The modernist art historian's obsession with the move towards abstraction is here balanced by an equal emphasis on the realist tradition which links Sickert, Bratby and Freud with their predecessors Constable and Hogarth. The 1920s, formerly regarded as dull and reactionary, can now be seen to be imaginatively inventive: the revival of landscape encouraged artists to look for new ways in which to express a sense of place; figurative art also revived, Stanley Spencer producing some of the most original religious paintings of this century. Meanwhile, as is more widely recognized, the sculptors Henry Moore and Barbara Hepworth were extending the European classical tradition through the assimilation of primitive influence.

British art of this century is outstanding for its range of interest and style. A leaning towards the romantic and particular, the fanatical and self-obsessed can be discerned, but sufficient contradictions exist to keep talk of national characteristics at bay. Ben Nicholson's art may uphold the English love of understatement, linear elegance and tonal restraint, but the Pop artists displayed brazen indifference to these qualities. If a love of narrative revived in the 1920s and has remained a recurrent characteristic, the 1960s and 1970s saw the production of an abstract or 'minimal' art in which content evaporates into muteness. If landscape has continued to inspire, offering solace to the neo-romantics, fostering St Ives abstraction and satisfying our nostalgia for wide-open spaces through the work of Richard Long and Hamish Fulton, the urban environment has also been highly influential, on Sickert, Lowry, the Vorticists, the New Generation sculptors, Prunella Clough, Leon Kossoff and Frank Auerbach, to name just a few. Moreover, although it is said that the British distrust theory, this country has produced some of the most doggedly theoretical 'conceptual' art. And though much berated for its philistinism, Britain continues to maintain some of the world's finest museums and art galleries and sends a higher proportion of its population to art school than any other European country.

One noticeable factor is the oscillation between periods of isolation and ready assimilation of foreign influence. In the 1930s, and again in the 1960s and early 1970s, British artists moved towards an international style. But this willingness to accept ideas from abroad is matched, and perhaps overreached, by the recurring desire to marry foreign influence with native interests, as Graham Sutherland and Paul Nash did by absorbing Surrealism into the British landscape tradition. British art has also been enriched by the émigré contribution, and, from a broad point of view, weakened by the overriding supremacy of London which has relegated Scottish and Irish art to a secondary position. Joyce was not alone in his need to work in 'silence, exile and cunning', for to achieve a reputation outside Ireland most Irish artists have found it necessary to exhibit and even live elsewhere. Scotland is perhaps more successful at maintaining its traditions separate from the dominating influence of London and its art institutions.

Analysis of those cultural channels which have helped shape the art of this century is here necessarily limited. Within the space allowed, I have tried to outline the main ideas and interests informing each period, to describe the art produced and to hint at the broader context. Selection inevitably involves judgment, but I hope that personal bias has been modified by awareness of established critical opinion as well as of alternative views. We have recently witnessed the exhilarating realization that in Britain, as in every period and in every country,

there exist concurrent trends and traditions which develop and pursue their own evolution; and the fact that one or other may appear to predominate at any one moment does not necessarily mean that the others are stagnating or worthless. In practice, this realization has fostered an explosion of wide-ranging interests, talent and energy, and the final chapter of this book samples some of the fertile developments within recent art.

Despite the fact that twentieth-century British art has proved difficult to export, certain of its artists are today enjoying leading international reputations. This, however, has not changed the essentially provincial nature of its achievement. Twentieth-century British art represents, like many English gardens, an enclosed world which holds our attention, not so much through its immediate impact, but through the slow revelation of the subtlety and complexity of species contained within it. It is this multiplicity, together with the sustained imaginative effort that gives to the work of Gwen John, Paul Nash or David Jones, for example, a quiet intensity, which links British art of this century with the greatness of its past.

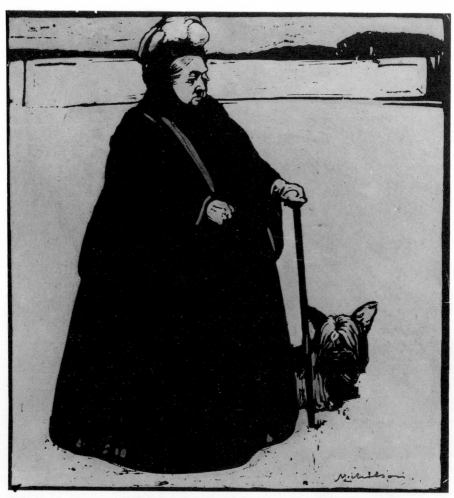

1 William Nicholson, *Queen Victoria*, 1897

CHAPTER ONE
EDWARDIAN REFLECTIONS

To celebrate Queen Victoria's jubilee in 1897, the *New Review*, in a
double-page supplement, carried a woodcut of her by William
Nicholson (1872–1949). It had first been offered to the publisher
William Heinemann, but he had demurred over publishing this
'animated tea-cosy'. The print, however, enjoyed immediate success
and Heinemann did not hesitate to include it as the first in the series,
Twelve Portraits, a collection of Nicholson's woodcuts published in
1899. Its appeal tells us much about English taste at the turn of the
century. The strictures and strait-laced morality governing much
Victorian art had been loosened, chiefly owing to Whistler's influence,
by an aestheticism that cared more what a picture looked like than
what it said. Nicholson's reduction of the fierce and dumpy Queen to
a black pyramid, alleviated by the attention to her head, hands and
dog, was gently humorous: *risqué* but affectionate. Like much Ed-
wardian art, it broke with former conventions but had sufficient
restraint to make its challenge acceptable.

Nicholson was himself the quintessential Edwardian. In his por-
traits and still-lifes he brought to his portrayal of appearances a studied
elegance. In keeping with his belief that a painting 'isn't a real thing –
it's an illusion, a grouped thing', he rid his subjects of all redundan-
cies. He might concentrate on a single gold jug, a lustre casket or
mushrooms on a plate, but he brought to these still-lifes that fluent
handling which the Edwardians admired. It carried with it suggestions
of ease and luxury, a seeming effortlessness, and is to be found in the
elongated highlights and reflections that grace Nicholson's portrait of
the actress Marie Tempest (National Portrait Gallery). It also carried a
suggestion of class, giving an aristocratic air to much Edwardian art.
This fluent brushwork never became a decorative feature in its own
right, as it had done in Van Gogh's expressionistic paintings, but
always remained decorous and understated.

The tonal acuity found in Edwardian painting owed much to the
example of Velásquez, the subject of an influential book by R. A. M.
Stevenson which had been published in 1895. Ostensibly an account
of Velásquez's life and work, it extolled an 'impressionistic' technique,
which Stevenson claimed to see in his painting, and which was
diametrically opposed to the conventions of English teaching. Instead

2 William Nicholson, *Girl with Tattered Glove*, 1909

of tight, detailed modelling, Stevenson praised Velásquez's 'running, slippery touch'; he urged the 'placing' of a figure on the canvas, the consideration of subtle differences within large planes, a broader sweep of line. The book began a fashion for Velásquez which chimed with a growing admiration for *les tons justes* of Corot, and the legacy of Whistler.

Whistler died in 1903, at the height of his reputation. He too admired Velásquez and is frequently mentioned in Stevenson's book. Like Velásquez, he abjured naturalistic detail and concentrated on the

relations between a restricted number of tones, bringing a subtlety and vigour to his handling of paint. He was highly revered in Scotland by the Glasgow School, his influence appearing in certain portraits by John Lavery (1856–1941) and James Guthrie (1859–1930). Guthrie and E. A. Walton (1860–1922), who, like Lavery, were closely associated with Whistler during the 1890s, had been instrumental in persuading the Glasgow Corporation to buy Whistler's portrait of Carlyle. Its example helped strengthen the Glasgow School's rejection of academic values in favour of a more expressive handling of paint.

During the first decade of this century Whistler was a dominant influence on young artists. His concentration on the aesthetic or formal content of a picture paved the way for an understanding of Post-Impressionism; but at the same time his emphasis on tone militated against acceptance of French Impressionism and reinforced Britain's 'splendid isolation'. A sharpened sense of tone, derived from 3 his work, helps to still the early portraits of his pupil Gwen John (1876–1939). She attended his Académie Carmen in Paris where it was said that he occasionally spent more time looking at his pupils' palettes than their pictures. His emphasis on method led Gwen John to conceive of a system of numbered tones. This, however, did not develop until the artist was almost in her forties and her torturous affair with the sculptor Rodin had ended. After 1913 her colours grew closer in tone, and owing to the addition of white, took on an ashen look. But her method, though partly scientific, was also intuitive, placing as much emphasis on what she called 'the strangeness' of form.

Both Whistler, through his selectivity, and the Royal Academy, with its love of sentiment, encouraged a tenacious grasp of the subject. Many Victorian traditions still lingered on in the Academy's annual summer exhibitions. Arthur Hacker (1858–1919), Herbert Draper (1864–1920) and J. W. Waterhouse (1849–1917) pursued classical or mythological subjects. A convincing flair for narrative, in Waterhouse's case, was made still more vivid by his adoption of loose, 4 descriptive brushwork. Ever since John Millais's retrospective at the Grosvenor Gallery in 1886, there had been a revival of interest in Pre-Raphaelitism and medievalism. Evelyn de Morgan (1855–1919), James Byam Shaw (1872–1919), and E. Reginald Frampton (c.1850–1923) were among those who reworked this vein, continuing well into the twentieth century undisturbed by the radical developments that in 1910 began to arrive from abroad. The Edwardian period also saw a vogue for 'problem' pictures in which human drama invited various interpretations. A love of story-telling in the Victorian period had encouraged a moral didacticism: vitiated by the more pleasure-loving taste of the Edwardians, it now sank to the level of sentimental anecdote. Marcus Stone (1840–1921), for instance, was highly

esteemed for his courtship scenes, made picturesque by garden settings and Regency dress. Like other successful pictures shown at the Royal Academy, they were engraved, printed and widely distributed, thereby bringing the artist still greater popularity, wealth and fame.

The study of modern life, which had earlier inspired the Pre-Raphaelites as well as W. P. Frith's *Derby Day* and *The Railway Station*, still stirred intermittently. It had fired Walter Sickert (1860–1942) to extol the 'magic and poetry' to be found in everyday urban surroundings. But Sickert had gone abroad in 1899 and remained the

3 Gwen John, *Dorelia by Lamplight at Toulouse*, 1903–04
4 John William Waterhouse, *Destiny*, 1900

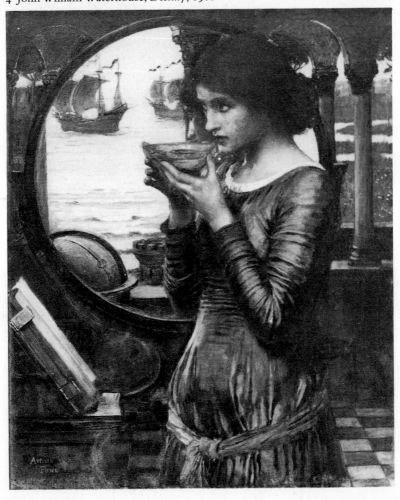

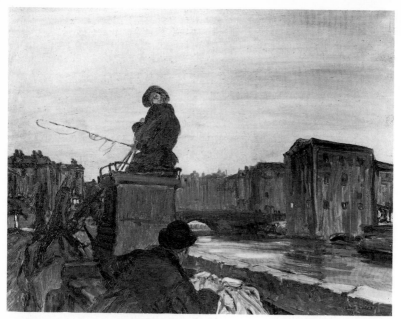

5 Jack Butler Yeats, *A Lift on the Long Car*, 1914

king over the water until his return in 1905. In his absence London did not have any artist to record its life and landscape, as Jack Butler Yeats (1871–1957) was to do for Dublin after his return to Ireland in 1910. Isolated works remain, such as the desolate study of the London underground at Oxford Circus by Maxwell Armfield (1881–1972). But for the most part the radical developments then transforming London, formerly a cluster of villages around a central nub, into a modern metropolis, went unrecorded.

Another phenomenon at this time was the growth of Jewish ghettos resulting from economic pressures and anti-semitic pogroms in Europe. These brought artists such as Jacob Epstein (1889–1959), Mark Gertler (1891–1939), Jacob Kramer (1892–1962) and Bernard Meninsky (1891–1950) to England, and enriched British culture with the introduction of foreign traditions. In order to assimilate these immigrants, educationalists began a programme of anglicization. But the experience of growing up in an alien country seems only to have driven many of these artists back to their cultural roots: Gertler, on arriving at the Slade School of Art, began a series of family portraits; Kramer, though not a practising Jew, made a speciality of Jewish subjects. When William Rothenstein (1872–1945), himself the Brad-ford-born son of Jewish immigrants, came across the Machzike Adass Synagogue in London's East End by chance, he considered it a subject

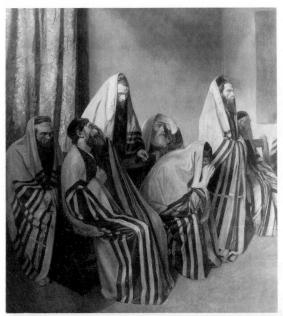

6 William Rothenstein,
Jews Mourning in a Synagogue,
1906

7 Jacob Kramer,
The Day of Atonement, 1919

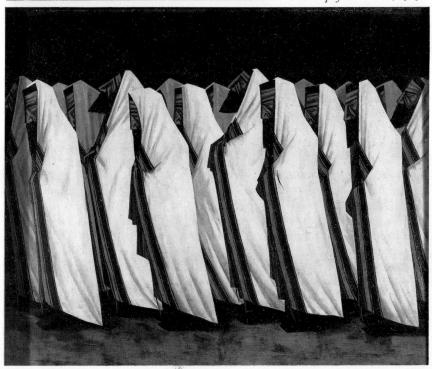

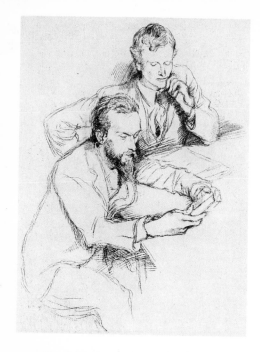

8 William Rothenstein,
*Charles Ricketts and Charles
Shannon*, 1897

9 Philip Wilson Steer,
The End of the Chapter, 1911

worthy of Rembrandt. He rented a room nearby and produced over
the next three years eight paintings, one of which was *Jews Mourning
in a Synagogue*. Shortly after it was completed, it was presented to the 7
Tate Gallery where, as Roger Fry observed, it shamed 'by its gravity
of design, its clear realization of form, the high plausibilities and clever
sentimentalities with which it is surrounded.'

Roger Fry (1866–1934), critic, painter and later to become the
apostle of modern art, was at this period an entrenched reactionary,
aptly described by another critic, D. S. MacColl, as 'a pastichist of the
ancients and opponent of modern French painting'. Disliking the
sentimentalities purveyed by the Royal Academy, Fry also found
himself antagonized by the more painterly methods exhibited at the
New English Art Club (NEAC), founded in 1886 in opposition to the
Academy. Looking at the work of his contemporaries he detected a
lack of structural design; as if to rebut this superficiality, he turned his
attention to the Italian Renaissance and the Old Masters.

Fry was not alone in his belief that progress lay in retreat to pre-
Impressionistic styles of painting. One fashionable interest at this
time, which seems to have originated with Charles Ricketts (1866–
1931) and Charles Shannon (1863–1937), was the desire to revive the 8
surface quality of Old Master paintings. 'Shannon and Ricketts
directed my attention to the traditional technique of oil painting and to

design,' wrote the artist C. J. Holmes (1868–1936), 'as exemplified in the old masters which were visible in London.' Fry also 'sat at the feet of these two men', as Rothenstein recalled, read Eastlake and painted landscapes indebted to seventeenth-century models. Charles Shannon sought to revive in his portraits and allegories the technique of oil painting used by the great Venetian painters. He also produced lithographs and, with Ricketts, set up the Vale Press as a further outlet for their love of craftsmanship. Their attempt to revive the Pre-Raphaelite tradition, subtly transformed by their interest in Symbolism, brought praise from their contemporaries but had little following.

Reflecting past styles, Edwardian art, in the years leading up to 1910, appeared to make no advance. Its portraiture drew unashamedly upon the current love of aristocratic elegance, a taste reflected in the steady rise in sale-room prices for eighteenth-century portraits. Even Philip Wilson Steer (1860–1942), whose paintings in the late 1880s and early 1890s had reflected a vigorous, if isolated, response to French Impressionism and Seurat, now turned back to the classic British landscape tradition and, with a style subservient to Constable's example, repainted sites associated with Turner.

9

Those who continued with an 'impressionist' style of landscape painting did so with scant regard for the multi-faceted colour and

comma-like brushstrokes of true French Impressionism. The British were less animated by scientific enquiry than by a love of naturalistic effects, of sunshine and breeze, as found in *The Beach* by Laura Knight 14 (1877–1970). They were also inspired by the French artist Jules Bastien-Lepage, whose overall grey tonality derives from the even light created by an overcast sky. His chief apologist in Britain was George Clausen (1852–1944) who praised his 'studied impartiality'. It 10 was felt that this impartiality could only be achieved if the artist went and lived among his or her subjects, as Bastien-Lepage had done in the village of Damvilliers. In this way, from the 1880s onwards, artists' colonies had started up, at Grès-sur-Loing in France, at Brig O'Turk and Cocksburnpath in Scotland and among the fishing communities at Newlyn in Cornwall and Staithes in Yorkshire.

British Impressionism dominated the exhibitions held by the New English Art Club, which favoured those artists whose work displayed French influence. Formed in protest and rebellion against orthodox practice, it had mellowed with age. It was now at the height of its reputation, enjoying a cachet not far behind that of the Academy. In fact the differences between them were now slight; many NEAC artists had either been attracted into the Academy or exhibited at both institutions. Laura Knight's *The Beach* was perfectly acceptable to the Academy, where it was exhibited in 1909, while the New English Art Club displayed subjects of extreme conservatism. 'There is an over-insistence on two motifs,' Sickert observed in 1910. 'The one the august-site motif, and the other this smartened-up-young-person motif.'

Nowhere is the artistic conservatism of the Edwardian period more evident than in the response to the exhibition of French Impressionism brought to London by the dealer Durand-Ruel in 1905. Work by Degas, Monet, Manet, Pissarro, Renoir, Sisley, Cassatt and Morisot had been shown in London before, but never had so many paintings by these artists (some three hundred) been brought together in one place. The public, however, should have been prepared for this event; the movement was now some thirty years old and books were available on it: Camille Mauclair's *The French Impressionists*, which appeared in translation from the French in 1903, and Wynford Dewhurst's *Impressionist Painting* (1904) which stressed the French artists' debt to British painting, in particular that of Turner. Yet Durand-Ruel's show was scorned in the press and few paintings sold.

One who was aware of their importance was the critic Frank Rutter. Anxious that a painting should be acquired for the nation, he opened a 'French Impressionist Fund' subscription list in the pages of *The Sunday Times*. He succeeded in raising sufficient money for his purpose, but the National Gallery declared that Boudin was the

10 George Clausen, *The Boy and the Man*, 1900

furthest limit of modernity that they would be prepared to accept. The work which entered the national collection as a result of Rutter's effort was Boudin's *The Harbour of Trouville*.

One of the first to send Rutter a cheque was the American artist John Singer Sargent (1856–1925). He had enjoyed friendship with Monet in the 1880s and on a visit to Giverny had painted the French artist at his easel out of doors, adopting in this picture a suitably Impressionist style. Sargent's passing interest in Impressionism helped loosen his style and contributed to the directness and ease which he brought to his portraits. He excelled at social types, earning from Rodin the soubriquet 'the Van Dyck of our times'.

Born in Florence, of American parentage, and trained in Paris, Sargent was a cosmopolite, able to bring a natural urbanity to his grasp of character. He settled in London in 1886 and was at first regarded with suspicion as a clever foreigner; his style was too obviously French for an English audience and his characterization, as Henry James observed, had a 'knock-down insolence'. But in 1893 his portrait of Lady Agnew (National Gallery of Scotland) took the Royal Academy by storm. Commissions poured in until he had more than he cared for, and he developed a distaste for the art that had made his reputation. Nevertheless his opulent portraits have helped stamp the Edwardian period on popular imagination. Still today we see its luxury through his eyes, for his brush, working semantically with a series of marvellous hints, picked out the highlights on silk, satin, pots, pearls, gilt frames and silver candelabra. This was the last great period of portraiture, and Sargent's swashbuckling, cavalier method managed, with apparent nonchalance, to convey a great deal. As Osbert Sitwell cannily observed of Sargent and his sitters: 'He showed them to be rich; looking at his portraits they understood at last *how* rich they really were.'

Two younger artists who were also to make their reputations through portraiture were Augustus John (1878–1961) and the Irishman William Orpen (1878–1931). Both became renowned personalities within the art world: Orpen, famed for his glittering success, his Rolls-Royces and absence of any intellectual curiosity; John, for his bohemianism, womanizing and admiration for gypsies. John's example set a new code for artistic behaviour. With the Oscar Wilde trial a thing of the past, it was now socially acceptable for the artist to be an amoral, free individual, outside the bounds of convention. Something of this uninhibited boldness is reflected in John's portraits, with their largeness of form and strong contours. One of his finest is the portrait of William Nicholson in which the position of the curtain, cane, raised finger, indeed of every detail, upholds the sitter's dandyism and the balance of the design. There is, however, nothing particularly innovatory about this picture – a fact which is at first obscured by the artist's confident assurance. 'We admired John,' Frank Rutter recalled, 'not because he was doing new things, but because he was doing old things superbly well.'

Both John and Orpen made a close study of the Old Masters. They were also skilled draughtsmen, adopting a style which, in the vivacity with which pose, gesture and drapery are caught, ultimately descends from Rubens. These drawings earned them reputations while they were still students at the Slade School of Art.

Ever since Alphonse Legros had been made the Slade's first professor of drawing, the school had been associated with the French

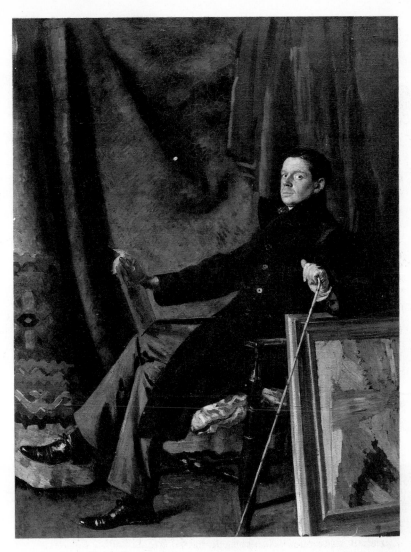

11 Augustus John, *William Nicholson*, 1909

method of art teaching. Students were taught to draw from the model
with a swift, decisive use of line, in a style that has aptly been
described as 'precise and yet free, intelligent but nevertheless a little
13 sentimental'. One of the teachers, Henry Tonks (1862–1937), had a
particular admiration for Watteau and directed his students' attention
to the Frenchman's expressive effects. Tonks had joined the staff at the
Slade in 1893, as assistant to Fred Brown (1851–1941), his former

teacher at Westminster School of Art, and in 1918 was raised to a professorship. He had originally trained as a surgeon, yet brought to his art, not the sharpness of the scalpel, but a dry and fussy technique at odds with his severe, commanding manner. The First World War united his medical and artistic interests: for Sir Harold Gillies, specialist in plastic surgery, he drew in pastel the deformed heads of

12 William Orpen, *Lady on a Couch*, 1900

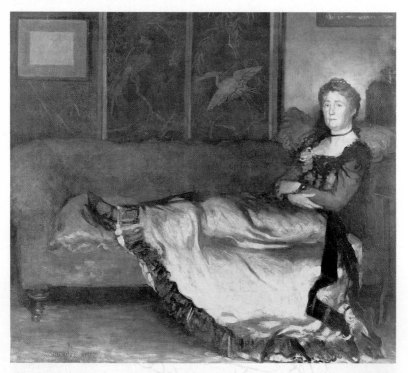

wounded soldiers. Tonks's phlegmatic character is reflected in his attitude to this work: 'It is a chamber of horrors, but I am quite content to draw them as it is excellent practice.'

Tonks's dedication impressed many, and he appears in almost every artist's memoir of the period. Something of a snob (he was said to dine out in Mayfair every night), he encouraged a socialite element at the Slade which nevertheless went unchallenged at this time, as the leading London art school. Steer and Walter Russell (1867–1949) were also on the staff and they, together with Brown and Tonks, impressed their views on successive generations of students and had far-reaching influence. This fact was demonstrated by the hold that Slade-trained artists had on the New English Art Club. Elsewhere, art teaching

tended to be traditional and complacent; emphasis was still placed on the study of the antique in the form of plaster casts. In provincial art schools women were often denied access to life classes or, as at the Royal Academy Schools, were segregated. The latter institution, though more conservative than the Slade, was its chief competitor. Its system of visiting professors brought its students into contact with

13 Henry Tonks, *Half-length Study of a Seated Girl*

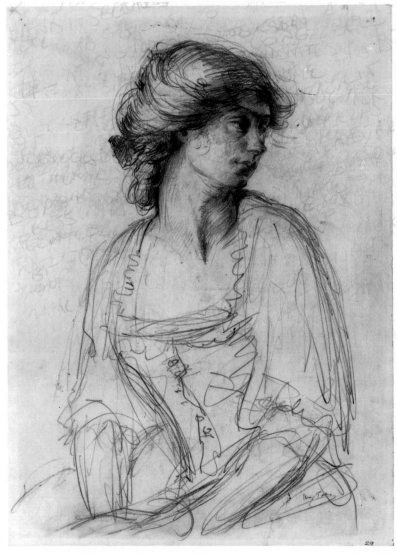

several eminent Academicians, John Singer Sargent and Marcus Stone among them.

The Royal Academy, formerly the most prestigious art institution in Britain, had for some years been under attack. The now widespread interest in the effects of light undermined the importance attached to subject matter and the hierarchy of genres which Sir Joshua Reynolds had outlined in his *Discourses* (1769–90). The Academy was also criticized for its maladministration of the Chantrey Bequest. D. S. MacColl led the offensive, making weekly onslaughts on the Acad-

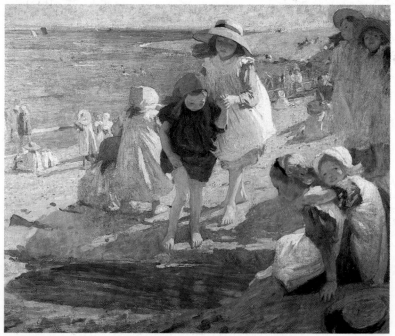

14 Laura Knight, *The Beach*, 1908

emy's policy in his column in the *Saturday Review*. He received support from others within the art world and the Chantrey Bequest became the subject of an enquiry in the House of Lords in 1904. Many felt that the money from the bequest had been employed by Academicians to support Academy exhibitors, and that the Tate Gallery (recipient of Chantrey purchases) had been used as a dumping ground for pictures by mediocre artists purchased from the bequest. The enquiry did result in some improvement in the Chantrey purchases, but there remained a feeling, expressed by Wilson Steer, that the Academy was a body of men elected to keep other men out. Despite this, it was still the most powerful art institution in England, and was

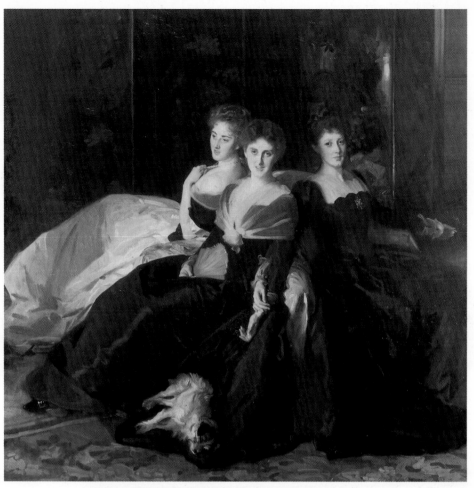

15 John Singer Sargent, *The Misses Hunter*, 1902

made additionally so by the fact that its President Sir Edward Poynter (1836–1919) was also, for a period of ten years, concurrently the Director of the National Gallery.

As an artist, Poynter continued to promote those domestic incidents set in ancient Greece or Rome which had been popular in the late Victorian period. His colleague Lawrence Alma-Tadema (1836–1912) excelled in this field and earned himself immense rewards: a knighthood in 1899, the Order of Merit in 1905 and a substantial house in St John's Wood, in London, where he frequently entertained. His pictures, mostly small, were finely crafted; the Mediterranean, marble and maidens were all exquisitely rendered, often in settings that

16 Lawrence Alma-Tadema, *A Favourite Custom*, 1909

allowed for daring perspectival effects. He indulged Edwardian taste,
bringing a note of titillation, barely veiled by antiquarianism, to
subjects such as *A Favourite Custom*, exhibited at the Academy in 1909. 16
 Edwardian sculpture was also capable of mawkish sentiment.
When, however, it served as architectural decoration, it was restrained

by the need to harmonize with its surroundings. A close relationship existed between artists and architects, and no large commercial building or public office was thought complete without the addition of figurative detail. The emphasis on decoration led Ezra Pound to declare that most sculptors of this period were 'engaged wholly in making gas-fittings and ornaments for electric light globes' or in producing 'large, identical ladies in night-gowns holding up symbols of Empire or Commerce or Righteousness'. This last remark referred to the mass production of Queen Victorias, for expanding industrial towns and universities. Chief of these was the 1901 Victoria Memorial by Thomas Brock (1847–1922), situated outside Buckingham Palace.

Much Edwardian sculpture is preferable in maquette form, for on this intimate scale it can display a fluency and subtlety of modelling,

17 Thomas Brock, model for a seated figure of Queen Victoria, 1901

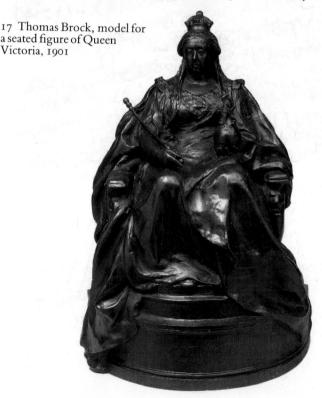

inspired by Rodin's example. The revival of the lost-wax method of bronze-casting had further encouraged the use of sensitive detail, as well as a certain finicky love of linear arabesques; *Peace Leading St George to Victory* by Alfred Gilbert (1854–1934) is a-flutter with swallow-tailed banderole, curlicued helmet plumes and fancy-dress

armour. In other sculptures Gilbert further enriched his work by adding semi-precious gems, ivory, tin or mother-of-pearl, combining skilled craftsmanship with narrative flair.

As with much Academy painting of this period, Edwardian sculpture could be teasing and coy, playful and slight. It was also fabulously eclectic, drawing upon French examples, fusing classical and Renaissance sources into a union that was often tenuous and high-strung. But a less prominent vein, begun in the 1890s, was the revival

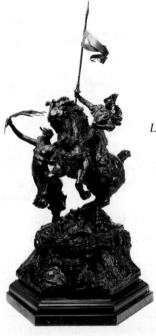

18 Alfred Gilbert, *Peace Leading St George to Victory*, 1906

19 Hamo Thornycroft, frieze for the Institute of Chartered Accountants, 1889–93

of interest in genre scenes taken from everyday domestic and working life. After the rhetoric and posturing found in much High Victorian sculpture, such as G. F. Watts's *Physical Energy* which shortly after the artist's death in 1904 was prominently situated in Kensington Gardens, it is a relief to discover the honest respect for labour expressed in the frieze for the Institute of Chartered Accountants by Hamo 19 Thornycroft (1850–1925).

At regular intervals this tendency towards realism continues to resurface in twentieth-century British art, a fact that modernist histories of this period have underplayed or ignored. The documentary value of realism can be appreciated in *Bank Holiday* by William Strang (1859–1921) where, with a blond tonality reminiscent of Manet, he portrays the awkwardness of a young couple making an

outing to a restaurant. Strang had a rumbustious personality and enjoyed hosting literary and artistic friends. He is no less assertive in his art: in *Bank Holiday* he daringly off-sets the woman's purple hat against the green pillar, the red menu against the man's buff suit. His drawing is always clearly stated; the information given is never fudged. However, if compared with the art of Walter Sickert, Strang's paintings, though striking and dramatic, are strangely unrewarding, full of facts but mute in feeling.

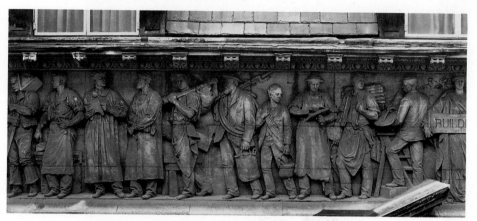

Between 1898 and 1905 Sickert had divided his time between Dieppe and Venice, painting townscapes and immortalizing prostitutes in the San Trovaso area of Venice, not by concentrating on precise details, as Strang was to do, but by attending to passing effects, reflected light, shadows, a momentary pose, gesture or look. He also began working with the nude or semi-nude, a subject that was to become one of his major themes. Found among tumbled bedclothes in seedy north London interiors, these nudes offered, as Sickert observed, 'a gleam of light and warmth and life'. He titled his pictures only after they were completed, sometimes arbitrarily changing the titles for different versions of the same picture. 'The real subject of a picture,' he wrote, '. . . is the plastic facts it succeeds in expressing, and all the world of pathos, of poetry, of sentiment that it succeeds in conveying. . . . If the subject of a picture could be stated in words there had been no need to paint it.'

All Sickert's subjects are located in space by the fall of light. When he visited a music hall and turned his head away from the stage, what absorbed him was the flicker of light on the ornate architecture and the glow of the pale faces as they hung over the railings of a balcony. He had a fondness for dim but rich harmonies: dingy greens, yellows and maroons. On top of these he placed his highlights, in such a way that

31

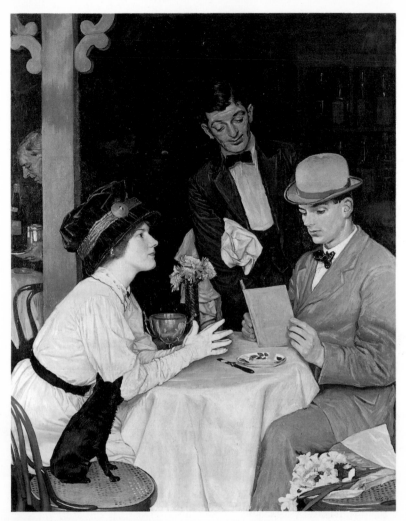

20 William Strang, *Bank Holiday*, 1912

they swim and dance in a liquid space. Another of his talents was an ability to discover rhythm and visual excitement in the mundane or unobvious.

Shortly after his return to England in 1905 Sickert rented rooms at 6 Mornington Crescent in the borough of Camden, a once high-class area that had rapidly degenerated when the railways cut through to three large termini: Euston, St Pancras and King's Cross. Regency houses were turned into bed-sits to house a shifting population and a workforce of roadmen. Sickert felt at home in the area, but to suggest

that he took a delight in shabbiness is to suggest only one aspect of his character. He was by nature a chameleon: he had originally trained as an actor, dressed with panache in surprising outfits, had a charm and wit and was as much at home in the higher echelons of society, having tea with his artist-friends Nan Hudson and Ethel Sands, in the exclusive environs of The Vale, Chelsea, as he was in sleazy lodging-house interiors. Not only was he an artist to his fingertips, he also had an audacious personality that few could resist.

Compared with Wyndham Lewis's later attempts to assert his authority, Sickert assumed leadership without any apparent effort. He simply kept open house at his studio in 8 Fitzroy Street on Saturday afternoons. This arrangement was a convenient one and so in 1907 he regularized it, formed a definite group, called it the Fitzroy Street Group and as a base rented the first floor and a store-room in the house opposite, number 19. Each artist contributed an easel on which to display a picture, the rest of their paintings remaining in the stacks behind. The informality of the proceedings (tea was offered) attracted a small group of loyal clients and collectors. Sickert was frank about his motives:

I do it for 2 reasons. Because it is more interesting to people to see the work of 7 or 9 people than one and because I want to keep up an incessant proselytizing agency to accustom people to mine and other painters' work of a modern character . . . I want . . . to get together a milieu rich or poor, refined or even to some extent vulgar, which is interested in painting and in things of the intelligence . . .

There were eight original members: William Rothenstein and his brother Albert (1881–1953), who later changed his name to Rutherston, Walter Russell, Spencer Gore (1878–1914), Harold Gilman (1876–1919), Sickert, Nan Hudson (1869–1957) and Ethel Sands (1873–1962). In the autumn of 1907 Lucien Pissarro, the son of the Impressionist painter Camille Pissarro, also joined.

Lucien Pissarro (1863–1944) specialized in intimate views of rural England, its cottage gardens, copses and orchards, and membership of the Fitzroy Street Group had little effect on his choice of subject. It was not until this circle evolved into the Camden Town Group in 1911 that Sickert and his friends really began to concentrate on a certain type of London scene. For the moment Sickert's chief concern was to rebut the dilettantism and good taste vitiating English art. He had begun his career under the aegis of Whistler, but had turned critical of this master's legacy. 'Taste is the death of a painter', Sickert now declared, in iconoclastic mood; and elsewhere:

The more our art is serious, the more will it tend to avoid the drawing-room and stick to the kitchen. The plastic arts are gross arts,

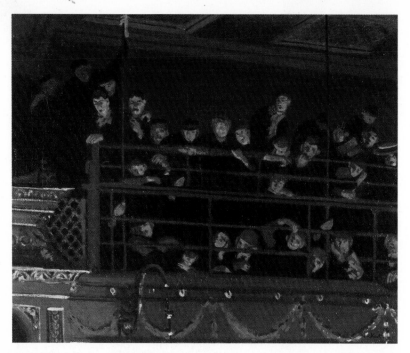

21 Walter Sickert, *Noctes Ambrosianae*, 1906

dealing joyously with gross material facts ... and while they will flourish in the scullery, or on the dunghill, they fade at a breath from the drawing-room.

Two things that Sickert promoted were the discovery of the essentials in a scene and the use of a systematic, and therefore professional, technique. One can sense his example behind Harold Gilman's *The Kitchen*, in which every detail contributes to the stability and coherence of the whole. Typical of Gilman is the oblique approach to his subject, for often his figures are turned away from the spectator or cut off from us by their absorption in their tasks. Owing to a series of personal disappointments, he developed a dread and mistrust of society, which is perhaps why his paintings are primarily concerned with private worlds, with glimpsed moments recreated in compositions often so tautly designed as to create an element of claustrophobia. When the Fitzroy Street Group transformed itself into the more robust Camden Town Group, Gilman, like others, began employing stronger and brighter colour. But in *The Kitchen* he is still very much an Edwardian, in his fluent handling of paint, his control of tonal values, in the ease and grace with which he situates the figure in space, but above all in his detachment, control and restraint.

22 Harold Gilman, *The Kitchen*, *c.* 1908

23 S.J. Peploe, *Still Life with a Melon, c.*1919–20

CHAPTER TWO
POST-IMPRESSIONISM:
ITS IMPACT AND LEGACY

Modern art in Britain is often said to date from 1910, the year in which Roger Fry's 'Manet and the Post-Impressionists' exhibition opened at the Grafton Galleries. London was shocked to discover that one of its most distinguished critics had created a show in which Robert Ross detected 'the existence of a widespread plot to destroy the whole fabric of European painting'. Fry was convinced he had done no such thing, for he discerned in the work of the Post-Impressionists a rediscovery of that constructive design which he admired in Italian Renaissance art and which the Impressionists had lost sight of in their concern to render the flux of nature. Because the 1910 exhibition coincided with the Welsh coal-miners' strike, the growing violence of the Suffragettes and continuing fear of German invasion, the public saw in these paintings a violence related to general political unrest. Fry, however, saw the exhibition as a call to order, a return to formal principles rooted in tradition. It did in fact make a sharp break with the recent past: as Clive Bell later recalled, 'to many of us post-impressionist meant anti-impressionist'. As a result, those who failed to respond but continued to paint in vaguely impressionistic or naturalistic styles, found themselves suddenly *passé*. Like the Whistler v. Ruskin trial, the exhibition represented a watershed and, as Eric Gill wrote to William Rothenstein, it sharply divided the sheep from the goats.

It was also very well timed. It provoked a reaction against the tired verisimilitude fostered by much Edwardian art, and gave direction to an already discernible sense of protest. In 1905 Vanessa Bell (1879–1961), in an attempt to create in London an atmosphere more conducive to painting, had founded the Friday Club, drawing upon an odd mix of amateur and professional artists and her associates within the Bloomsbury circle. Sickert's Fitzroy Street Group had been similarly motivated and was well represented at the New English Art Club's twice-yearly exhibitions. In 1910 he noted that there had emerged a style employing 'a clean and solid mosaic of thick paint in a light key'. Post-Impressionism, with its fresh emphasis on formal means, on line, colour, scale, interval and proportion, encouraged this 'solid mosaic of thick paint' to take on a still sharper role.

In addition there had in recent years been a revolt against the dominant art institutions. This had taken the form of the Allied Artists

Association, a non-jury exhibiting *salon* based on the French example of the Salon des Indépendants. Frank Rutter had been the force behind its organization. More than three thousand exhibits filled its first exhibition at the Albert Hall in July 1908, for on payment of a subscription each artist was allowed to show five works (subsequently reduced to three). Inevitably a mass of amateur work got in, making it difficult for the more avant-garde artists to make a significant impact. But the AAA served an important purpose, bringing to Sickert's attention new recruits for the Fitzroy Street Group. The most important of these was Charles Ginner (1878–1952) who entered this circle in 1910.

Ginner had trained in Paris and had confronted Post-Impressionism before Roger Fry's exhibition opened in London, as had a handful of other English artists, almost all of whom had so far failed to incorporate its influence into their art. Duncan Grant (1885–1978), for example, had been in Paris in 1906 when Matisse's *Bonheur de vivre* caused an outcry at the Salon des Indépendants; he had also seen the Matisses belonging to Gertrude and Leo Stein, but had closed his mind, temporarily, to their implications. The only British artists to have responded to Post-Impressionism prior to the 1910 exhibition were Robert Bevan (1865–1925), who had paid several visits to Brittany and had absorbed the influence of the Pont-Aven school; Roderic O'Conor (1860–1940), an Irish artist domiciled in Paris who had also spent some time at Pont-Aven; and the Scottish Colourists J. D. Fergusson (1874–1961), S. J. Peploe (1871–1935), Leslie Hunter (1879–1937) and F. C. B. Cadell (1883–1937). The last three originated from Glasgow, which was closer in sympathy with France than London at this date, due to historical links that encouraged students to bypass London for Paris. Like their predecessors in the Glasgow School, the Scottish Colourists trained in Paris where they gradually shed Whistler's influence for that of the Fauves. Fergusson was the first to adopt Matisse's rich colour which, with an abbreviated method of drawing, came to distinguish their art. 'Paris is simply a place of freedom,' he later recalled. 'It allowed me to be Scots as I understand it.' Despite the importance of these four artists, none was included in Roger Fry's Second Post-Impressionist Exhibition of 1912, an omission that reflects on the English tendency to relegate Scottish art to a secondary, peripheral position.

The Second Post-Impressionist Exhibition successfully reinforced and extended the impact made by the first. Whereas in the 1910 show Gauguin, Van Gogh and Cézanne had been the chief representatives, the 1912 exhibition was dominated by the work of Picasso and Matisse. The combined effect of both events meant that a London audience had to catch up, in the space of two years, with artistic

developments that had taken place in France over the last thirty. The public derided Post-Impressionism and the critics did little to disperse prejudices. Most had been outraged by the first exhibition and liked the second no better, finding the deformation of the human figure an insult to preconceived standards of beauty. To an eye accustomed to *trompe l'oeil* productions, Post-Impressionist paintings looked crude, brash in colour, perspectively incorrect, unfinished and unreal. The chief shift of emphasis lay in the turning aside from the tradition, begun with the Renaissance, that regarded a picture as a window onto the world and which had culminated in the Impressionist attempt to imitate even the most fleeting and evanescent effects of nature. The Post-Impressionists, no longer content to record the shifting pattern of appearance, sought more durable and more subjective effects, either by making more emphatic the underlying structure, as in the work of Cézanne, or by emphasizing their own expressive response and therefore selecting and to some extent rearranging the visual facts. Roger Fry put the difference succinctly in the catalogue to the Second Post-Impressionist Exhibition:

These artists do not seek to give what can, after all, be but a pale reflex of actual appearance, but to arouse the conviction of a new and definite reality. They do not seek to imitate form, but to create form; not to imitate life, but to find an equivalent for life.

A painting was now to have a vitality that was no mere reflection of external reality but inherent: the picture was to have a reality of its own.

The two Post-Impressionist exhibitions left in their wake turmoil and confusion. Roger Fry, whose career as a painter had so far been shaped by his interests as critic and scholar, now abandoned the Old Masters and essayed the style of Gauguin, then Cézanne, then Cubism, before briefly experimenting with pure abstraction. Several who had hitherto seen only isolated examples of Post-Impressionism, now had the opportunity to study it at length. A rapid assimilation of ideas took place. The reaction they caused is best illustrated by the comparison of two Duncan Grants, one painted early in 1910, before the arrival of the Post-Impressionists, the other painted in 1912, in time to be included in the English section of the Second Post-Impressionist Exhibition.

24 His portrait of James Strachey shows the Edwardian love of elegant restraint. The tonal shading and receding pattern in the Persian carpet help situate the figure within a convincing space. His relaxed pose finds an echo in the positioning of the motifs on the screen behind. The apparent informality distracts attention from the careful deliberation that guides the whole. The qualities to be admired are precisely

24 Duncan Grant, *James Strachey*, 1910

those that Grant rejects in *The Tub*; instead of the artful delineation of 26
texture, the same crude hatching serves to indicate the floor, the
curtain or screen on the right, the curtain on the dresser behind and the
nude's ribs; space is suggested and then deliberately denied by the
black line which travels, without break, around the nude's raised arm
and the mirror behind, uniting the two on the picture surface. Every
stroke and line now contributes to the whole, for what *The Tub* loses
in illusionistic skill it gains in formal vitality. When Grant was asked
on the radio programme Desert Island Discs which of his pictures he
would most like to be remembered by, he replied '*The Tub*'.

Post-Impressionism taught that painting was not a trick dependent
on skill and craftsmanship, but a language, the grammar and syntax of
which were in themselves expressive. Line, colour, shape, space,
rhythm and design were now to be assessed and valued in their own
right. Inevitably this concentration on formal means encouraged a
tendency towards abstraction which, in 1914 and 1915, led to
experiments with non-representational art. But, paradoxically, a more
immediate effect of Post-Impressionism was to encourage a more
expansive and fresh interest in subject matter. 'It was', Vanessa Bell
recalled, looking back on the 1910 Post-Impressionist exhibition, 'as if

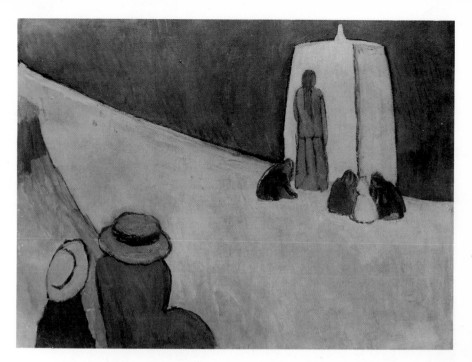

25 Vanessa Bell, *Studland Beach*, 1912

one might say things one had always felt instead of trying to say things that other people told one to feel.' Having previously confined herself chiefly to portraits and still-lifes, she now painted the arbitrary configurations created by, for example, a street-corner conversation
25 or figures on a beach. In general, portraits became more informal, less posed; subjects were seized upon with greater immediacy, images cropped like snapshots, unexpected views taken.

An important influence on this period was Degas, who, surprisingly, was not represented in either of the two Post-Impressionist exhibitions. It was Degas's example that taught Sickert always to look
28 for the unconventional in a pose or a setting, in order to obtain new harmonies of colour and design. When Sickert's friend Spencer Gore sent the amateur painter John Doman Turner a series of lessons by post, advising him, among other things, to 'draw anything that interests you' and to measure the figure against its surroundings, he admitted, 'Nearly everything I have told you comes through Walter Sickert from Degas.' Gore himself showed his acceptance of this
27 teaching in his *Gauguins and Connoisseurs at the Stafford Gallery*, in which the conveniently high viewpoint helps spread the interest of the scene across the entire canvas.

26 Duncan Grant, *The Tub*, 1912

Up to this point Sickert, Gore and others of the Fitzroy Street Group had been content to send to the twice-yearly exhibitions of the New English Art Club. But this institution, alarmed by the threat of Post-Impressionism, had turned reactionary, obliging Sickert and his circle to break away and form the Camden Town Group which organized its own public exhibitions. In an attempt to make it a tighter, more rigorous body than the Fitzroy Street Group, Gilman,

27 Spencer Gore, *Gauguins and Connoisseurs at the Stafford Gallery*, 1911–12

who was its chief instigator and whose marriage had recently broken down, insisted that women should be excluded. If this removed the more amateur artists' wives and Sickert's 'lady-friends', it also cut out artists of talent, such as Sylvia Gosse (1881–1968), Nan Hudson and Ethel Sands.

It was Sickert who invented the name of the group, arguing, with mock seriousness, that the Camden district had been so watered with

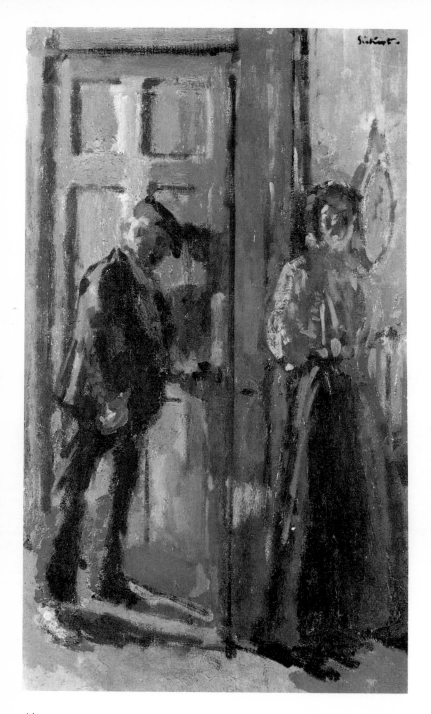

his tears that something important must sooner or later spring from its soil. Its formation coincided with a growing commitment to the ordinary and workaday, and to the urban landscape. Charles Ginner now transformed Van Gogh's brushstroke into small, tight, regular touches of thick paint and with this impersonal, almost mechanical technique he rendered the prosaic poetry of city life, delineating row upon row of bricks, the march of railings or the clutter of a timber

28 Walter Sickert, *Off to the Pub (The Weekend)*, 1912
29 Charles Ginner, *Leeds Canal*, 1914

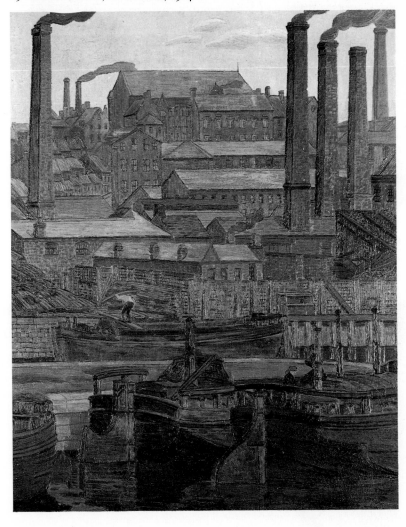

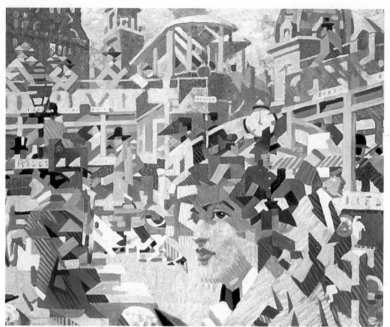

30 Stanley Cursiter, *The Sensation of Crossing the Street – The West End, Edinburgh*, 1913

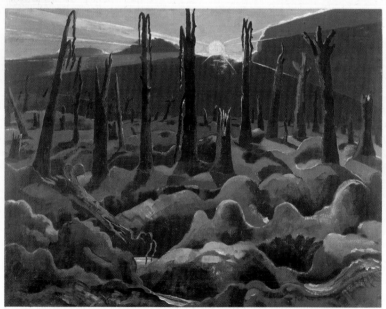

31 Paul Nash, *We Are Making a New World*, 1918

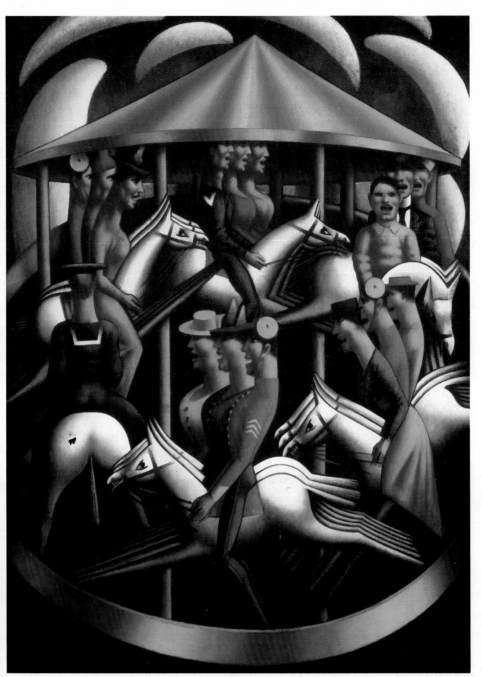

32 Mark Gertler, *Merry-Go-Round*, 1916

33 Harold Gilman, *The Eating House, c.* 1914

factory's backyard. His example may have encouraged another
Camden Town painter, Robert Bevan, to specialize in cab-yard scenes
and horse sales, subjects that he found in the Swiss Cottage neigh-
bourhood where he lived. Gilman also began to make occasional
forays into the London streets, finding one of his best subjects in *The
Eating House,* of which two versions exist. Its anonymous setting, cut 33
off from the viewer by the foreground barrier, expresses something of
Gilman's misanthropic temperament. In *The Eating House* the substan-
tial handling and control of the design is matched by the insistent
grasp of the subject, form and content holding equal importance.

In 1914 Gilman and Ginner drew a little apart from Sickert's circle
and began calling themselves Neo-Realists. They held an exhibition
together at the Goupil Gallery in that year and reprinted in the catalogue
the manifesto that had appeared in the magazine *New Age* on 1 January:
'Realism, loving life, loving its Age, interprets its Epoch by extracting
from it the very essence of all it contains of great or weak, of beautiful or
of sordid, according to the individual temperament.' Both looked for
patterns in their surroundings, shapes related to reality but which also
conveyed a sense of the artist's emotional response to his subject.

Their insistence on realism did not prevent Gilman from joining forces with the more abstract wing of the avant-garde in the winter of 1913–14, to form the London Group, for they were united in their revolt against naturalism. (A naturalist, according to Ginner, was a person who copied nature with a dull and common eye and with no personal vision.) Wyndham Lewis (1882–1957), David Bomberg (1890–1957), William Roberts (1895–1980), Frederick Etchells (1886–1973), C. R. W. Nevinson (1889–1946), Edward Wadsworth (1889–1949), Cuthbert Hamilton (1885–1959) and Lawrence Atkinson (1873–1931), who at this time called themselves the English Cubists, reduced their subjects to a harsh geometric patterning, forming energetic compositions out of a conflict of lines and shapes. Unlike their French counterparts, they were not interested in dissolving form into a spatial continuum, but dealt in more brittle images that rested firmly on the picture surface.

They were also alert to the implications of Futurism. Marinetti, its founder, had first canvassed this movement on his visit to London in 1910. Two years later a large display of Italian Futurist paintings had gone on show at the Sackville Gallery, and the following year the Marlborough Gallery gave Severini a one-artist exhibition. The press got much copy out of Futurism and when Marinetti reappeared in London in the spring of 1914 his lectures were again packed, his audiences, for the most part, entertained if unconvinced. Though Lewis and others gave Marinetti their support, the English love of irony and detachment kept this aggressively avant-garde movement at bay. Roger Fry did not include any of the Italian Futurists in his Second Post-Impressionist Exhibition, for he argued that they had so far failed to produce a visual language capable of registering their interest in speed and movement. Only the Scottish artist Stanley Cursiter (1887–1976) and C. R. W. Nevinson adopted their use of 'simultaneity', the former attempting to recreate, in kaleidoscopic terms, the sensation of crossing a street in Edinburgh's West End, the latter describing an impression of a London tube journey or the noise and jostling excitement of a Bank Holiday crowd. Both these last two paintings by Nevinson are sadly lost. His most convincing, extant work in a Futurist style is *The Arrival* (Tate Gallery) which, when exhibited at the London Group's exhibition in 1914, was said, by one critic, to resemble 'a Channel steamer after a violent collision with a pier'.

It was Nevinson who took the wrong step and alienated the rest of the English Cubists from Futurism. In *The Observer* on 7 June 1914 (and subsequently in *The Times* and the *Daily Mail*) he published 'Vital English Art. Futurist Manifesto', written in collaboration with Marinetti. It deplored the passéism of much English art, called for work

that was 'strong, virile and anti-sentimental' and ended by listing those currently injecting vitality into the art scene: Atkinson, Bomberg, Jacob Epstein, Etchells, Hamilton, Nevinson, Roberts, Wadsworth and Lewis. None of these artists had given permission for their names to be used in this way, nor had Lewis been warned that the Rebel Art Centre, recently founded by him, would appear as the address given at the end of the Manifesto.

The Rebel Art Centre had opened in the spring of 1914 in competition with Roger Fry's Omega Workshops, begun the previous year. Fry had wanted to introduce the Post-Impressionists' use of strong design and rich colour into the applied arts. To this end he employed artists to decorate furniture, design rugs, fabrics and marquetry. He had initially succeeded in attracting to this venture several of the avant-garde – the sculptor Henri Gaudier-Brzeska (1891–1915), Roberts, Wadsworth, Hamilton, Etchells and Lewis, but the last four left after Lewis fell out with Fry and composed a 'Round Robin' letter of abuse which he sent to friends and patrons of the Omega. With financial assistance from his friend and fellow-painter Kate Lechmere, he set up the Rebel Art Centre at 38 Great Ormond Street. Among those attracted into its ranks (despite Nevinson's wish not to have 'any of these damned women') were the artists

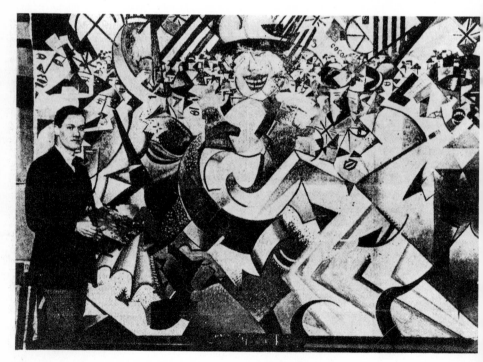

Helen Saunders (1885–1963) and Jessica Dismorr (1865–1939). Both painted and wrote. And neither was a mere imitator of Lewis, despite their devotion to him. Dismorr's description of Piccadilly – 'Towers of scaffolding draw their criss-cross pattern of bars upon the sky, a monstrous tartan' – instances the Vorticists' commitment to urban subjects and finds illustration in Saunders's *Atlantic City*.

The term 'Vorticism' did not itself come into existence until after Nevinson's 'Vital English Art' had united the rebel artists with indignation and thus enabled Lewis to assert his hegemony over them. He was already preparing a new magazine, *Blast*, and now wrote the Vorticist Manifesto for its first issue which, though dated 20 June 1914, appeared a little late, on 2 July. The message put across by the magazine, with its puce cover and abrupt changes of typography, was that England, one of the first countries to be industrialized, should face up to the modern mechanized world in its art. Lewis was not, however, eulogizing the machine age with the hysterical enthusiasm of the Futurists. The art he sought to inspire would be harsher and less romantic, having the formal sobriety of Cubism but not restricting itself to the Cubist repertoire of still-lifes and portraits.

Lewis did not receive unreserved support for his manifesto. Roberts, though he signed it, later declared emphatically that neither

34 C.R.W. Nevinson, *Tum-Tiddly-Um-Tum-Pom-Pom*, 1914

35 Helen Saunders, *Atlantic City*, c. 1915

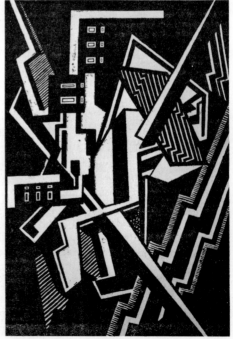

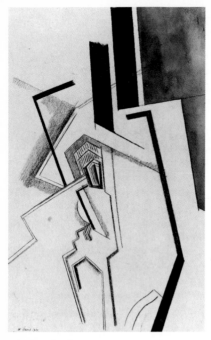

36 Wyndham Lewis, *Composition in Blue*, 1915

37 David Bomberg, *The Mud Bath*, 1914

he nor Bomberg had ever been Vorticists. Bomberg, Etchells, Epstein and the philosopher T. E. Hulme, all associated with Vorticism, refused their signatures, and Etchells is on record as saying that he thought of the movement as faked and manufactured. Nevertheless for a short period lasting just over a year, a style did exist to which the term 'Vorticist' can be applied. It is spare and architectonic, verging on pure abstraction; lines and bars of colour are arranged often around a central nugget of interest (the still centre of the vortex) as in Lewis's *Composition in Blue*. The style is exact, concrete and anti-humanist. 36 However, even when the title suggests no representational content, there are usually allusions either to the human figure or the urban landscape. One of its most impressive creations is Bomberg's *The Mud Bath*, inspired by Schevzik's Steam Baths in the East End of 37 London. The artist steadily honed his idea for this large oil in a number of preliminary studies. In the final work, the figures, swimming and diving, standing or running around the edge of the pool, are reduced to simple geometric elements held in taut relationship.

The Vorticists were fortunate in having among their supporters the philosopher T. E. Hulme and the poet Ezra Pound. During the spring and summer of 1914, Hulme wrote a series of articles on modern art for the magazine *New Age*, in which he became the spokesman for

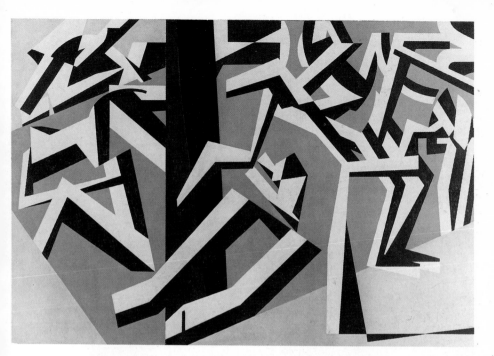

these artist innovators. He praised the hard and durable, arguing that art should imitate the principles and organization that governed machinery. Man, he said, put into a geometrical shape is lifted out of 'the transience of the organic'. Hulme, like Pound, belonged to the Imagist movement which was bringing to poetry an objectivity, succinctness and concreteness comparable with Vorticist art. Their association with Vorticism must have encouraged these artists in their rigorous elimination of inessentials. Pound also shared Lewis's didacticism and his manic, revolutionary hostility to the English establishment. Both adopted an attitude of political and social élitism, scorning the smugness of the age, the bourgeoisie, the philistines and the ordinary man in the street, above all invoking rage against mediocrity.

It was Pound who introduced Hulme to Lewis and Epstein in 1912. In Epstein's carvings, especially those done during late 1912 and 1913, after a visit to Paris where he had met Picasso, Modigliani and Brancusi, Hulme found a stiff, formalized geometry similar to that which he had admired in the mosaics at Ravenna and which he saw as opposed to the classical humanist tradition of the Renaissance. 38 Epstein's sculptures, such as *Mother and Child*, with its conceptual approach partly inspired by African art which he collected, confirmed Hulme in his belief that the Greco-Roman tradition was being overturned in favour of a new geometric art, terse, clean, clear-cut,

mechanical. It was possibly owing to Hulme's influence that Epstein began drawings which led ultimately to the making of his *Rock Drill*. 39 Here, a robot-like creature sits on top of an actual rock drill, carrying within itself, as Epstein points out, 'its progeny, protectively ensconced' but in dangerous proximity to the drill. Instead of straddling the machine in triumph, the figure seems, as the critic Richard Cork observes, 'haunted by responsibilities', his head turned away in sightless gaze and one arm amputated as if to underline his limited control over the shattering force of the drill. Epstein's ambiguous attitude to the machine later caused him to get rid of the drill, truncate the figure and exhibit only the top half, which was afterwards cast in bronze (Tate Gallery).

Epstein, Pound and Hulme all helped shape Henri Gaudier-Brzeska's concentrated, brief career (he died in 1915, aged twenty-three). A Frenchman, he had settled in London in January 1911, bringing with him a profound admiration for Rodin and for his capacity to discover movement even in a still face. Following

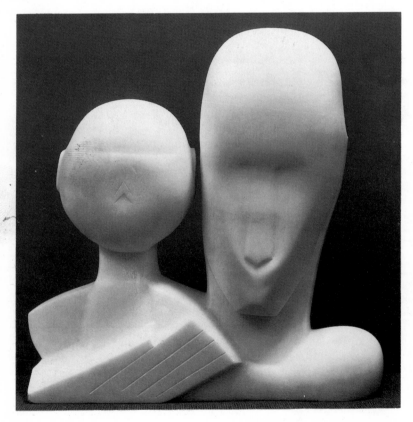

Epstein's example, he revived the technique of carving, and derived ideas from Polynesian, Chinese, Assyrian and Egyptian art, as well as from Brancusi and the Vorticists. His former fluent naturalism was replaced by a semi-geometric treatment of form and a more emphatically rhythmic orchestration of the parts. In his animal sculptures the results can be pungent and witty; but in both his Vorticist drawings and figure sculptures the stylization occasionally takes on an inexpressive rigidity. Sophie Brzeska, with whom Gaudier lived and whose name he appended to his own, suspected *arriviste* motives behind his more abstract work. Gaudier himself seems to have doubted its validity, for in the trenches, shortly before his untimely death, he predicted that he would return to a more humanistic style.

With hindsight, both Lewis and Epstein felt that the aggressive nature of Vorticist art and theory had been in some way prophetic of war. At the time Nevinson believed that the holocaust unleashed in the autumn of 1914 would help advance their art: 'This war will be a violent incentive to Futurism, for we believe there is no beauty except

38 Jacob Epstein,
Mother and Child, 1913

39 Jacob Epstein, *The Rock
Drill*, 1913–15

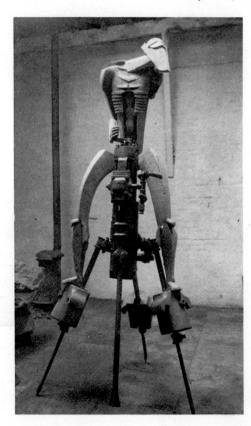

in strife, and no masterpiece without aggressiveness.' He did not, however, share Marinetti's belief that war was healthy, for his experience of working with the Red Cross, which he had joined at the earliest opportunity, taught him otherwise. In his earliest war paintings, in which the splintered language of Cubism serves brilliantly to portray the harsh anonymity and monotony of modern warfare, he left a savage indictment of jingoistic heroism. Commenting on these paintings, he wrote: 'My obvious belief was that war was now dominated by machines and that men were mere cogs in the mechanism.'

41

The war demoralized the Vorticists. Though 1915 produced a Vorticist exhibition and the second and last issue of *Blast*, it also brought the death of Gaudier-Brzeska. Two years later T. E. Hulme was killed fighting, and his monograph on Epstein, on which he was

42

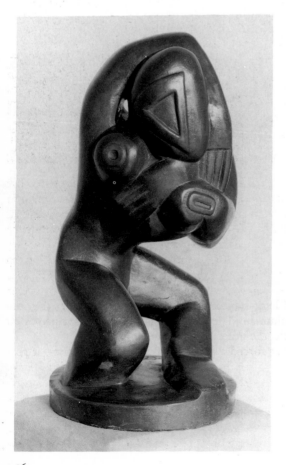

40 Henri Gaudier-Brzeska, *Redstone Dancer*, 1913

41 C. R. W. Nevinson, *Troops Resting*, 1916

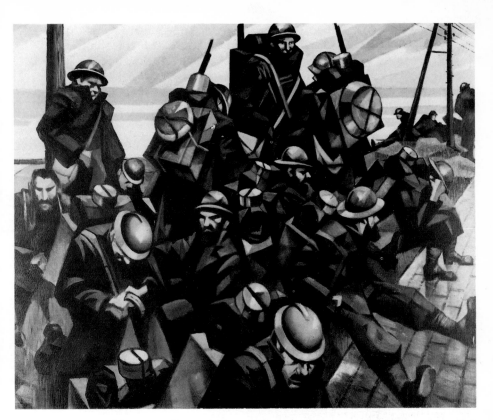

working, was lost. With Lewis and Roberts at the Front, those left behind in London were unable to keep the movement alive. Then in 1917, commissions from the British Government and the Canadian War Memorials Fund had an insidious effect, undermining confidence in progressive styles by insisting on the artists' need to 'record' scenes of war. Bomberg, Lewis and Roberts allowed representation to modify the brittle dynamism of their pre-war work. And as the war progressed, the widespread destruction in Europe suggested that their own destruction of long-standing traditions in art had been, in some way, callous and inhuman. They, too, began to reject fragmentation in favour of the static, the solid and whole.

If the 1914–18 war forced a compromise on the Vorticists, it also enabled other artists to produce some of their most striking work. Sydney Carline (1889–1929), sent to Italy as an official war artist, 43 caught the sensation of machines silently hovering over the Brenta Valley; Eric Kennington (1888–1960), painting on glass, caught the weariness of troops, recently emerged from the trenches and waiting to form up for a five-mile route march to their billets in *The*

Kensingtons at Laventie; Orpen, sent in 1917 to the Somme battlefields, 44 observed how in the summer sunshine the chalky mud created by the smashed drainage system dried into a dazzling whiteness (*La Butte de Warlencourt*; Imperial War Museum). The vacant landscape had an eery stillness and a poignant beauty, for wild flowers grew among the debris of war. At home, Mark Gertler, who, like Bomberg, was one of a talented group of artists to emerge from the Jewish ghettos in London's East End, expressed the sense of pessimism and futility aroused by war in the *Merry-Go-Round*, in which rows of serried 32 figures spin forever in a mechanistic nightmare, made inescapable by the extreme fixity that controls every part of its design.

The slaughter caused by this war created horrifying statistics, to which the mind, after spiralling down through layers of moral outrage, pity and perturbation, reacts with emotional paralysis. What touched the nerve more acutely in the case of the artist Paul Nash (1889–1946), was the destruction wrought upon the countryside. Like Orpen, he too juxtaposed scenes of devastation with sensations of rebirth, giving a bitterly ironic title to one of his most famous paintings: *We Are Making a New World*. For it is in confrontation with 31 landscape that British artists have repeatedly felt a quickening of spirit, a challenge or a release that has pointed to new directions.

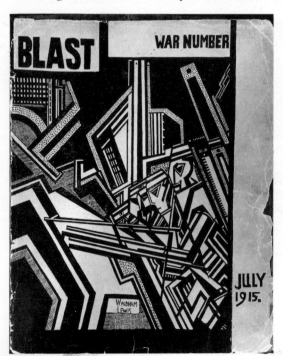

42 Wyndham Lewis, cover of *Blast* No. 2: *Before Antwerp*, 1915

43 Sydney Carline, *The Destruction of an Austrian Machine in the Gorge of the Brenta Valley, Italy*, 1918

44 Eric Kennington, *The Kensingtons at Laventie*, 1915

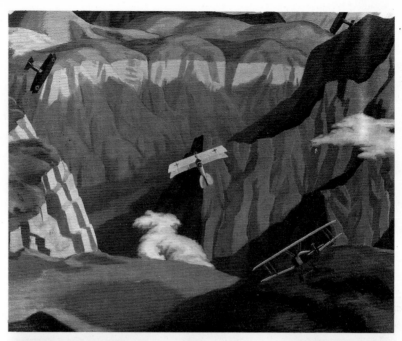

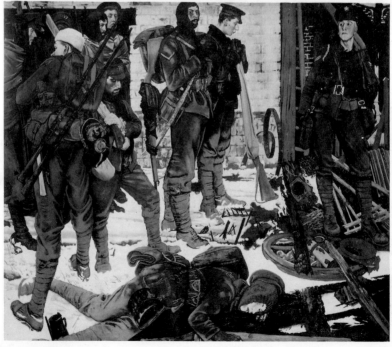

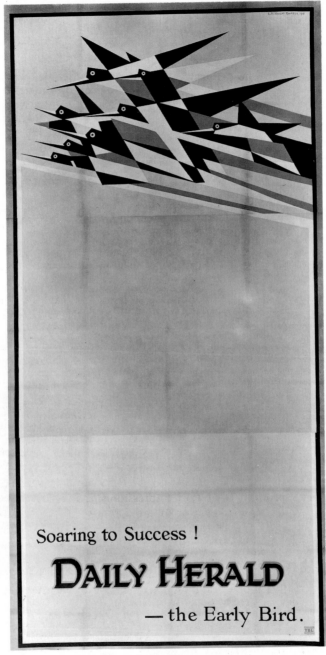

45 E. McKnight Kauffer, poster for the
Daily Herald, 1918–19

CHAPTER THREE
PAINTING AND PRINTMAKING
IN THE 1920s

The battles that had raged back and forth across France during 1914–
18 had never reached Britain. In the aftermath of war both countries
underwent social and economic reorganization, but the problems
facing France were far more severe. Artists in both countries felt a
need for a return to order and in France this took the form of Purism, a
style promoted by Amédée Ozenfant and Edouard Jeanneret (better
known as the architect Le Corbusier). They wanted to resolve the
fractured image created by Cubism into a new unity. It was a
detached, intellectual style, formulaic and rule-bound. In Britain the
reaction against pre-war experimentation took a very different form.
There was very little group effort, and instead a pursuit of the personal
and idiosyncratic. Because there was a widespread return to traditional
methods of representation and traditional subjects, this post-war
period is often regarded as reactionary. But it was also a period of
great diversity, producing in some instances a richly imaginative art,
inventive and original. It also saw a revival of the British landscape
tradition, its sense of place now made poignantly fragile by the more
rootless nature of twentieth-century life.

Paradoxically, a return to traditional subject matter was accompa-
nied by the ascendancy of formalist theory. It was now accepted that a
subject, whether it be a still-life, landscape or portrait, was to be
considered primarily for the formal interest it contained, for the
qualities it could be made to display through the handling of shape,
line and colour. The autonomy of form had been a key issue in Roger
Fry's promotion of Post-Impressionism. Precisely because this art
relied for its effect on formal strength rather than associated ideas, it
achieved, he said, 'classic concentration of feeling'; it arrived at a more
durable representation of appearance than Impressionism or academi-
cism and therefore had 'lasting hold on the imagination'.

The history of this idea must be traced in brief. Fry, who had almost
certainly absorbed Matisse's famous *Notes d'un peintre* of 1908, made
his first sustained attack on the notion that art is mimetic represen-
tation in his 'An Essay on Aesthetics' in the *New Quarterly* in April
1909. For him, the chief import in art was whether or not the
'emotional elements of design' inherent in the subject had been
adequately discovered. Clive Bell, taking Fry's ideas a step further in

his book *Art* (1914), roundly declared that 'significant form' was at the root of all aesthetic experience, and that representation was irrelevant.

The chief weakness in Bell's thesis lay in the use of a circular argument: significant form was defined as 'lines and colours combined in a particular way, certain forms and relations of forms, [which] stir our aesthetic emotions'; and aesthetic emotion was described as that which is aroused by significant form. Bell's *Art* did, however, put the case for formal appreciation in easily assimilable terms. The book was a deliberate piece of polemic; it sold widely and by 1930 had entered its ninth impression.

Because of the basic similarities in Fry's and Bell's arguments, critics and historians have often failed to perceive their differences. Fry's more qualified thought, in Bell's book, took on a dogmatic note. For instance, Fry argued that because of the insistent story–telling in British art, the aesthetic sensibility in most people was 'comparatively weak': Bell, for the sake of provocation, declared the mass of mankind incapable of making an aesthetic judgment. Though Fry adopted Bell's phrase 'significant form', he never ceased to question it and towards the end of his life reassessed the role played by representation. Even when *Art* was published, Fry, in his review of it, pointed out that form alone is unlikely to be the source of aesthetic emotion: something had to be fused with it to give it significance, and this something, this 'x' in the equation was probably variable. Six years later, when he added a chapter entitled 'Retrospect' to his collection of essays, *Vision and Design*, he again admitted that he could only approximate to a definition of significant form. Such capacity for intellectual doubt was not a characteristic of Bell's thought.

Fry's *Vision and Design* appeared in 1920, and in 1923 a cheaper, revised edition was published. The book was widely read. The young sculptor Henry Moore (b. 1898) chanced upon a copy in the Leeds Art Reference Library and was profoundly indebted to its essays on Negro, Bushmen and Ancient American art. These contributed to the move, occurring in Britain and elsewhere, away from the hegemony of the Greco–Roman tradition. Fry enabled his readers to look at cultures that had previously been regarded chiefly for their archaeological or anthropological significance. It was this sudden expansion of relevance that later caused Henry Moore to recall: 'Once you'd read Roger Fry, the whole thing was there.'

Vision and Design, therefore, related specifically to the needs of the historical moment. Its simple directive – to look at form – cut through the tangled confusion that had formerly surrounded modern art, and made the most distant culture accessible. Fry's straightforward prose was addressed to the layman and helped bring about a widespread change of attitude: no longer was art the concern solely of an educated

élite, for Fry showed it to have democratic appeal. Ironically, his formalist approach, with its inherent limitations, is nowadays criticized for its exclusiveness. In fact, very little of what he wrote adopts a strictly formalist approach and cannot be simply categorized.

Inevitably the emphasis on form narrowed art's role. Fry had only limited interest in the work of art as an embodiment of history; and for the greater part of his life he undervalued its capacity to document and inform. During the 1920s certain artists felt slighted by the critical attention insistently given to formal qualities, and by Fry's praise of French art or art that reflected French influence. Wyndham Lewis regarded Fry as a malign presence, deflecting dealers' and collectors' attention towards only those artists of whom he approved. But though Fry's influence upon public opinion was considerable, his immediate contact with dealers and collectors was slight. Nor did he occupy a prominent role as art critic, but during the 1920s often spent months at a time abroad, happily painting landscapes that are replete with non-formal interest.

Fry's influence is an important ingredient in the 1920s but one that can be easily exaggerated. The revolutionary period of modernism was now over. There was little that any critic or artist could do to subvert the conservativism that swept in with the return to peace. The most successful new development at this time was the founding of the Seven and Five Society (so called because it originally contained seven painters and five sculptors) in 1919. In 1920 it held its first exhibition and published in the catalogue a manifesto that sets the mood for this period. 'There has been of late too much pioneering along too many lines in altogether too much of a hurry. . . . The object of the "SEVEN AND FIVE" is merely to express what they feel in terms that shall be intelligible, and not to demonstrate a theory nor to attack a tradition.' What looks like a failure of nerve was perhaps, more positively, a period of recuperation and reassessment. Nevertheless when Wyndham Lewis brought together certain of the Vorticists, Charles Ginner, the sculptor Frank Dobson (1886–1963) and the poster designer Edward McKnight Kauffer (1890–1954) in an attempt to reformulate the avant-garde, the result was a failure: 'Group X', an anonymous title that did not bode well, folded after its first exhibition in March 1920. Lewis himself later said of Vorticism: 'The geometrics which interested me so exclusively before, I now found bleak and empty. They wanted *filling*.'

If the splintered language of Cubism dwindled away in the fine arts, it lingered on in the field of design, in fabric, rug and carpet design, becoming an essential aspect of twentieth-century surface decoration. It contributed to the making of Art Deco and helped formulate the 45 terse images which McKnight Kauffer brilliantly introduced into

poster design. But this clipped style seemed harsh and out of place in the field of painting and was now avoided. Artists like Lewis and William Roberts not only fleshed out their forms in the search for a new style, they also looked round for new subjects. For one problem attendant upon the return of peace was what to paint, draw or sculpt; Paul Nash was not the only person who suddenly found himself 'a war artist without a war'. For many this sense of vacuum was allayed by a flight from the machine age and a return to landscape.

One artist who went to the countryside partly to recover from war was Matthew Smith (1879–1959). Wounded and shell-shocked, he had returned to London in 1919 and for a period led a reclusive existence in a Fitzroy Street attic, making copies of Delacroix's illustrations to *Faust*. He was still in a state of nervous tension when in the summer of 1920 he went with his wife (from whom he separated in 1922) and two sons to St Austell in Cornwall. Smith stayed on, moving to St Columb Major, after his family returned to London. The summer and autumn were wet, and Smith said that the landscapes he painted reflected these conditions. He did not, however, record his immediate sensory perceptions, as he had for a brief period trained under Matisse and knew that in order to condense his sensations in front of nature he had to transpose the colours that he saw into an expressive harmony. Impressed by the dour nature of the Cornish landscape, he painted its skies blue or black. His own personal anguish seems to have inspired these strangely livid harmonies which are lit by accents of searing red. 55

Even certain Vorticists who had previously praised modern urban life now fled the metropolis. Edward Wadsworth exhibited at the Leicester Galleries in 1920 a series of drawings of the industrial Black Country. The following year his father, a mill owner, died, leaving Wadsworth from then on free to travel as he wished. He spent much time in the South of France and Italy, abandoned oil for tempera and with a pointillist technique brought to his paintings of harbours, 46 ships, jetties, shells, anchors and buoys a surreal calm, matched by the perpetual stillness of his seas.

During the immediate post-war period another Vorticist, David Bomberg, strove to make a living by turkey farming and rabbit breeding. A country existence dissipated the urban rhythms of his pre-war work. He also listened to the artist-printmaker Muirhead Bone (1876–1953) who advised him to try a 'franker naturalism', to see 'how much of design and powerful simplified feeling you can get in that'. Bone also provided money which enabled Bomberg to leave for Palestine in the spring of 1923, as unofficial artist for the Zionist Organization. He remained abroad for four years and during this time worked in two styles: topographical realism and a more subjective

46 Edward Wadsworth, *Dunkerque*, 1924

approach which was fully realized on subsequent visits to Spain and
elsewhere. With broad, full brushstrokes he caught not only the
57 character of the landscape but also gravitational effects and the sweep
of light; he registered not static facts but the dynamics of vision,
conveying how the eye sees as it moves from one point to another,
additively composing knowledge. In keeping with this expressive
approach, he heightened his colours which, though often subtle,
achieve effects of saturated richness.

The move back to more traditional methods of representation was
instinctive, achieved without any coercion on the part of a group,
movement or leader. Even influences from abroad temporarily
abated, for after an exhibition of modern French art, organized by
Osbert and Sacheverell Sitwell at Heal's in August 1919, as well as the
Matisse and Picasso shows at the Leicester Galleries in 1919 and 1921,
there were no major exhibitions in London of contemporary Con-
tinental work until the de Chirico exhibition at Tooth's in 1928.
Perhaps it was freedom from the weight of the French example that
allowed a northern, Gothic quality to emerge in the drawings and
paintings that Paul Nash produced between 1921 and 1925 at Dym-
church where he went to recuperate from a breakdown. His choice of
47 view was bleak; he concentrated on the unvarying length of sea wall,
built to protect Romney Marsh from flooding by the sea. As a leading
authority on Nash, Andrew Causey, has observed, the image of the

47 Paul Nash, *The Shore*, 1923

sea and the wall evokes ideas of 'vulnerability, attack, pursuit and defence'. Nash himself said that his drawings and paintings of Dymchurch represented a curious record, formally and psychologically.

At Dymchurch, Nash was visited in 1923 by Ben Nicholson (1894–1982). Both painted the coastline, but Nicholson, instead of adopting the oblique view favoured by Nash, confronted the sea straight on. 56 Horizontal bands of colour are tied down by the near vertical created by the jetty. Blocks of pale colour suggest the sudden glimmer of light on sand and water, while over head clouds scud by.

The simplicity and freshness of Nicholson's method was in part a reaction against his background. He had been born into a family of artists and had begun painting in imitation of his father Sir William Nicholson's skilled naturalism. The legacy of good taste that he inherited created in him a desire to 'bust up the sophistication all around me'. He looked instead at Vorticism, and in 1920 married the artist Winifred Dacre (1893–1981) whose unaffected directness and musical sense of colour provided valuable inspiration. Because of Ben's bad health, they spent the winters of 1920–24 in Lugano, Switzerland. They also made visits to Paris and to Bankshead, their house near Brampton in Cumberland.

48 Christopher Wood, *China Dogs in a St Ives Window*, 1926

Bankshead influenced the lives not just of these two painters but also that of the young artist Christopher Wood (1901–30). After one visit he wrote to Winifred, 'The Banks Head life is the painter's life'. Impressed by the Nicholsons' single-minded dedication, Wood found in Cumberland a more constructive alternative to the charmed existence that he led in Paris and the South of France, among an artistic and moneyed élite. He originally modelled his style on the draughtsmanship of Picasso and Cocteau, adding their tough sophistication to his admiration for the work of the naïve artist Henri (Le Douanier) Rousseau. As his style developed, the flatness of Rousseau gave way to a more genuinely conceptual approach. By emphasizing his response to the physical nature of objects, Wood succeeded in conveying a sense of heightened awareness. Drugs may have played their part, for under Cocteau's influence Wood had taken to opium which may have indirectly caused his death in 1930: at the age of twenty-nine he fell under an express train at Salisbury station.

Wood's feeling for place, combined with his brilliant colour sense, enabled him to produce some of the most concise, yet lyrical, landscapes of this century. With Ben Nicholson, he encountered by chance Alfred Wallis (1855–1942), a retired Cornish fisherman who at

48

the age of seventy had taken up painting. The intuitive skill with
which Wallis fitted his designs into the odd scraps of cardboard on
which he painted, his innate feeling for rhythm, translated in pictorial
terms in the rocking of his boats or the clustered arrangement of his
harbour scenes, impressed the sophisticates Wood and Nicholson. 61
Wallis's paintings confirmed them in their search for pictorial imme-
diacy, in their rejection of tired naturalism. Wood, in particular,
shared Wallis's fondness for boats and the sea, and found, through his
example, a way of expressing his own unshielded sensitivity to
experience which left him often restless and prone to the maelstrom of
his emotional life. He spent the summers of 1929 and 1930 at Treboul
in Brittany. The white cottages, narrow streets, the fishing boats and
harbours reminded him of Cornwall. They, and the sailors, often full
of songs and drink, and the religious fêtes, appeared in paintings at
once simple, mystic and pungently coloured. 'Blue was his colour,'
wrote Winifred Nicholson, 'and the evolution of the use of blue in his
work is the evolution of the driving power of his life.'

Landscapes and still-lifes by Ben and Winifred Nicholson and 62
Christopher Wood figured prominently at the Seven and Five
Society's exhibitions in the late 1920s. This society had originally been
founded by a group of artists more anxious to find an outlet for sales
than to assert any progressive group identity. By 1926, however, only
a handful of the original members remained. Ben Nicholson had
joined in 1924, Winifred in 1926 and Christopher Wood and Cedric
Morris (1889–1982) in 1927, David Jones (1895–1974) in 1928 and 49
Frances Hodgkins (1870–1947) in 1929. All these artists practised a 63
painterly lyricism, a *faux-naïf* approach that disguised an aesthetic
sophistication.

The only original member of the Seven and Five Society to stay
with it until it folded in 1935 was Ivon Hitchens (1893–1979). It was
he who, after a visit to a Ben Nicholson exhibition in 1923, asked this
artist to join the society. His own painting, however, did not develop
an original course until the late 1930s. His early landscapes aim at
displaying 'significant form'. For a period he did homage to Braque's
use of linear fracturing and spatial ambiguities, and during the mid
1930s, while interest in non-representational art was prevalent, he
briefly experimented with pure abstraction. In 1937 he returned to
landscape painting. After his London studio was bombed in 1940 he
moved down to Sussex, at first living in a caravan, then buying a tract
of woodland and building on it a house, where he lived until his death.

He developed a notational approach, employing large sweeps of
colour to suggest light and shade, reflections on water, distance, 64
atmosphere and seasonal change rather than the actual look of
landscape. His preferred canvas size was twice as wide as it was tall.

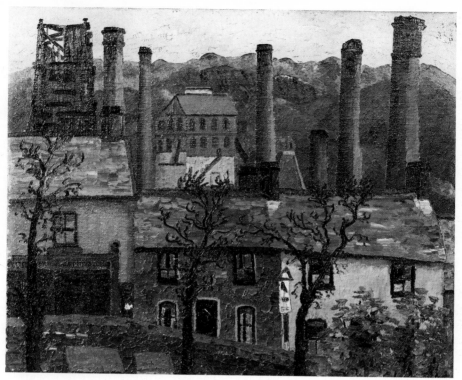

49 Cedric Morris, *Caeharris Post Office, Dowlais*, 1935

After the Second World War, his palette brightened. He also allowed glimpses of the white ground to appear between areas of colour, creating a splintered or crystalline effect. His method evolved into a formula during the 1960s, while his colour, further heightened, verged on the synthetic. Nevertheless Hitchens, perhaps more successfully than any other British artist, has caught nature at its most evanescent.

Landscape painting was also prominent at the New English Art Club, where Steer, William Nicholson and Lucien Pissarro continued to enjoy popularity, and at the exhibitions of the London Group, now largely dominated by Roger Fry's taste for art reflecting French influence. Vanessa Bell and Duncan Grant exhibited garden scenes, Sussex landscapes or views painted at Cassis where they had taken the lease on a farm-worker's cottage. Roger Fry also spent much time painting in France, particularly in the area around St Rémy-de-Provence where he bought a house which he shared with two left-wing intellectuals, Charles and Marie Mauron. The 1920s also found two of the Scottish Colourists, Peploe and Cadell, making regular

50 F.C.B. Cadell, *Rocks, Iona, c.* 1920

visits to Iona. They concentrated mostly on the north shore, where
rocks broke through the pale sand, off-set by the green sea and blue 50
sky. But even gales and storms did not quell Peploe's love of this
island: 'That kind of weather suits Iona,' he declared, 'the rocks and
distant shores seen through falling rain, veil behind veil, take on an
elusive mysterious quality ... It is an immaterial thing, emotional,
lyrical.'

Behind this desire to get back to nature in its untamed state lay a
reaction against the city. The suburbs, which attempted to bring
town-dwellers closer to the amenities of nature, were gradually
eroding the countryside. One side effect was an increase in nostalgia
for the pastoral, and a boom in guide and travel books: Hodder and
Stoughton published the 'King's England' series, a county by county
survey; Batsford produced their 'British Heritage' and 'Face of
Britain' series. There was also a vogue for country cottages as
weekend retreats, which could often be obtained at cheap rents.

While bicycling in Essex looking for just such a cottage, Edward Bawden (b.1903) and Eric Ravilious (1903–42) came across Brick House at Great Bardfield in Essex. They took a joint rent on it from 1929 until 1935, when Ravilious and his wife moved out to nearby Castle Hedingham. Both men had competed as students at the Royal College of Art where they came under the influence of Paul Nash who had been appointed, on a part-time basis, by William Rothenstein, to teach design. Both Bawden and Ravilious had a nimble sense of humour and a keen eye for any oddity of shape or detail in their surroundings. Both, in the course of their careers, ranged widely over the applied arts, designing book illustrations, linocuts, posters, murals, wallpapers, furniture, glass and ceramics. The taut control that animates even the smallest of their designs owes much to their experience of wood-engraving, an interest fostered at the Royal College by Paul Nash and which underwent a revival in the 1920s.

The Society of Wood Engravers, to which Nash belonged, had been founded in 1920. It was troubled by disagreements and in 1925 51 Leon Underwood (1890–1975), Blair Hughes-Stanton (1902–81) and Gertrude Hermes (b.1901) seceded, forming the English Wood-Engraving Society. The wood-engravings of Thomas Bewick (1753–1828) were widely admired at this time, but,when Ravilious sought to imitate his celebration of rural life, he replaced Bewick's earthiness 52 with a crispness, an underlying sense of geometry that reflected the legacy of Cubism. Much of the work done in this medium was directed towards the private presses. Robert Gibbings took over the Golden Cockerel Press, one of the most famous, and enlisted Eric Gill as his chief collaborator. He also gave work to Ravilious after meeting him through the Society of Wood Engravers.

Both Ravilious and Bawden allowed their experience of wood-engraving to direct their handling of watercolour. Often the brush 53 drives its way over the white paper, creating striated patterns much like those found in wood-engraving. In Ravilious's watercolours angular recession often enhances their tautness. He strains conventions, introducing to landscape painting an understated melancholy. 54 His scenes are usually lit by a chill winter light; even when the sun does appear, it does not warm the scene. This use of light gives to his pictures a severe beauty, a detachment that excludes not only the viewer but also the artist, and which allows for a predominantly mental grasp of landscape.

If any artist of this period surpassed Bawden and Ravilious at book illustration it was Eric Gill (1882–1940). He reinvested religious 58 images with emotional strength and originality, and often used the art of wood-engraving to propagate his beliefs. He had originally trained as a stone carver under Edward Johnston at the Central School of Art,

51 Leon Underwood,
The Cathedral, c. 1931

52 Eric Ravilious,
illustration to *The
Writings of Gilbert White
of Selbourne,* 1938

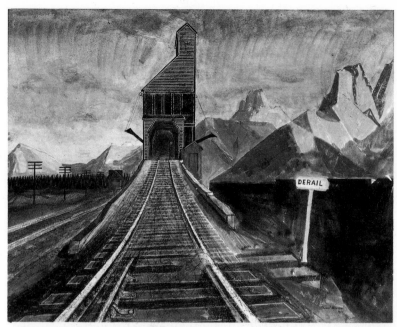

53 Edward Bawden, *To Winnipeg*, 1950
54 Eric Ravilious, *Norway*, 1940

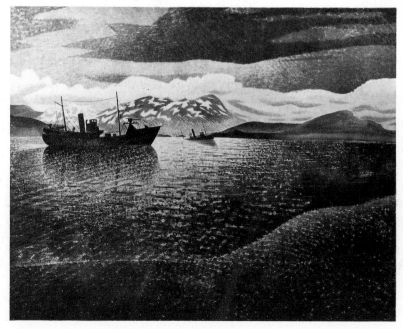

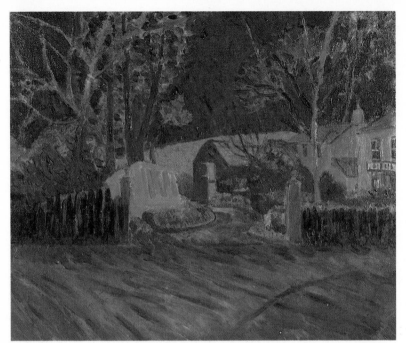

55 Matthew Smith, *Winter Evening*, 1920

and with Johnston was responsible for popularizing the sanserif and block-letter forms in typography, today used ubiquitously in railway 59 stations or wherever maximum clarity is required. Gill also worked as a sculptor, pioneering a return to carving. Between 1914 and 1918 he carved the Stations of the Cross for Westminster Cathedral, working in a stilted, semi-Byzantine style, partly because he knew very little about anatomy.

It is tempting to regard Gill as an anachronism, a throwback to the twelfth century in the unholy era of the first machine age. He looked like a medieval craftsman, for he never wore trousers but a loose-fitting belted smock. He shared with Ruskin and Morris a belief in the importance of craft and of joy in labour: art for him was the making well of whatever needed making. He despised the 'Daily-Mail mind' and much else in twentieth-century Britain, and with others he set up the Ditchling community in 1907 where work and worship mingled. Gill was converted to Roman Catholicism in 1913, and in 1918 he and his associates were invested as novices in the Third Order of St Dominic. His fervent religious views were matched in strength by his sexual desires. Like William Blake and Stanley Spencer (1891–1959), he believed that all desire was holy and was prepared to misread, over-select or ignore aspects of Catholic teaching in order to prove it. He

56 Ben Nicholson, *Dymchurch*, 1923
57 David Bomberg, *Valley of La Hermida*, 1935

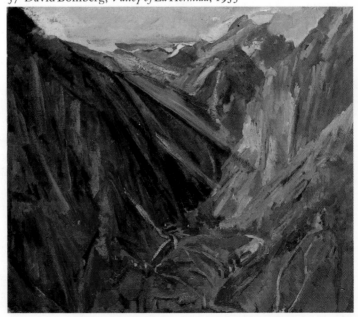

58 Eric Gill, *St Mark*
from the Aldine Bible,
1934, vol. 1

59 Eric Gill, *Christ
before Pilate*, 1913–18

I. JESUS IS CONDEMNED TO DEATH

used an image of copulation to symbolize Christ's love for his Church, and his literal illustration of *The Song of Songs* aroused a Catholic controversy. He carved a pair of lovers for Roger Fry who regretted that 'till we're much more civilized in the real sense', it could not be publicly exhibited.

If Gill's sculpture sometimes edges towards pornography or the absurd, David Jones achieved a more convincing integration of matter and spirit. He went to live with Gill and his family after being received into the Roman Catholic Church in 1921, and for a period he was engaged to Gill's daughter, Petra. At Ditchling he learnt wood-engraving and later produced work for the Golden Cockerel Press. Jones also composed two literary masterpieces, *In Parenthesis*, an epic poem based on the 1914–18 war, and *The Anathemata*, an exploration of the relationship between Roman Imperialism and its heir, Christianity. Religious symbolism is directly or indirectly present in almost everything he drew or painted. He worked mostly in watercolour, casting across the white paper small descriptive accents. These hover in a shifting space which, because of the transparency of watercolour paint, seems to interpenetrate form and thus becomes a metaphor for the fusion of matter with spirit. His objects and figures often appear to

60 David Jones, *Flora in Calix-light*, 1950

61 Alfred Wallis, *St Ives Harbour, Hayle Bay and Godrevy and the Fishing Boats*

62 Winifred Nicholson, *Rock Roses in Shell*, 1936

63 Frances Hodgkins, *Wings over Water*, c. 1931–32

64 Ivon Hitchens, *Damp Autumn*, 1941

be independent of gravity, as if caught up in some more fluid relationship with each other. This unorthodox, unacademic style is used to convey a mood of exultation.

A faith in the potency of imagery was shared by religious eccentrics and reformed Vorticists alike. When Wyndham Lewis declared that after 1918 the Vorticists' use of geometrics needed filling, he added: 'They were still as much present to my mind as ever, but submerged in the coloured vegetation, the flesh and blood that is life.' He also talked of this period as representing for him a new start. He began concentrating on portraiture and deepened his grasp and understanding of the figure by producing many life drawings. In these his whiplash line helped create a style that was intelligent, incisive and somewhat mannered. His portraits are among some of the most chilling ever produced. Caring little for the idiosyncracies of human character, Lewis presents us with a stylized carapace, a rigid façade 69 which rigorously conceals or ignores the sitter's mind and personality. His barely concealed contempt for others was released in his novel, *The Apes of God* (1930), where many leading social and artistic figures are lampooned with relentless sarcasm.

Likewise in his imaginative drawings and watercolours, vitality and meaning are imprisoned in the complex organic structures that compose his figurative and abstract designs. Lewis admitted the influence of his literary imagination on these works. He occasionally drew his titles from past history, literature or myths, further teasing the eye with this suggestion of narrative. He admired some of the Surrealist painters and allowed a certain strangeness and creative dreaming to direct his own imagery. But the guiding force behind his art, as he observed, was 'some propensity for the exactly defined and also, fanatically it may be, the physical and concrete'.

Various accounts of Lewis suggest that he suffered from paranoia. He was convinced that he was the victim of a malevolent conspiracy engineered by the Bloomsbury group to wreck his career. After conversation with Lewis, John Rothenstein repeated this view in his book *Modern English Painters* (1952), but there is very little evidence to substantiate the artist's grievance, which was fuelled by his deep-seated hatred of homosexuality and privilege. More detrimental to his career as a painter was the fact that he was also a prolific writer, channelling much of his creative energy into his books. As a result his semi-abstract compositions inspired by mythology, historical events or by his fascination with concepts of immortality, heaven and hell, have been given relatively little critical attention.

A less distracted talent can be found in the work of William Roberts. A reminiscence of Vorticism lingered on in his work until the mid 1920s when the brittle elegance of his earlier designs was

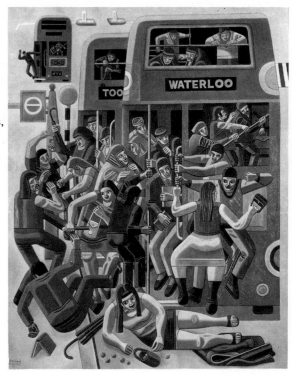

65 William Roberts,
Rush Hour, 1971

exchanged for a bluntness well suited to his workaday proletarian subjects. He evolved a distinctive style, giving to his tubular figures an almost mechanical regularity, arranging them like a frieze in order to extract from their poses and gestures a rhythmic pattern. Occasionally this delight in picture-making becomes an end in itself but, in his best work, drama and design cohere, transforming the most everyday scene into a ritual activity. Once formed, his style did not change for the next half-century and it remained consistently popular.

Almost anything in the London environment could become the subject of a Roberts painting: people in a pub, at the market or on the
65 river; the rush hour, private views of exhibitions, the changing of the guard. In his art the Victorian love of incident and anecdote is revived, for, like Stanley Spencer, he managed to recreate a narrative tradition in modern terms.

Spencer's originality lay in his merging of the descriptively literal with the visionary and imaginative. Behind his entire career lies a consistent purpose: to see the wholeness of things, to unite body with spirit, the sacred with the profane. His upbringing, restricted to the village of Cookham in Berkshire, enabled him to preserve into adulthood a child-like vision. Familiar with the Bible stories, which

81

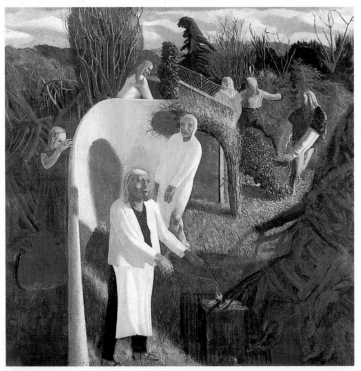

66 Stanley Spencer,
Zacharias and Elizabeth,
1914

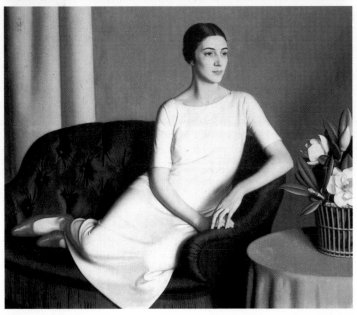

67 Meredith Frampton
Marguerite Kelsey, 1928

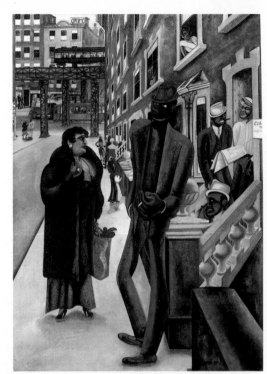

68 Edward Burra,
Harlem, 1934

69 Wyndham Lewis,
Edith Sitwell, 1923–35

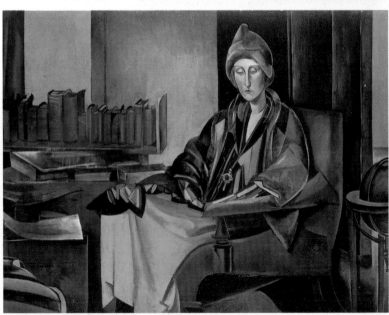

his father read aloud each day, he saw them enacted in his mind's eye in Cookham. Walking beside the high garden walls, he retained the impression that he had only to look over the other side to find a religious scene. In his compositions walls are often used to separate the divine from the everyday. In his painting of Zacharias and Elizabeth 66 sacrificing in the temple, one of the most original religious works of this century, a child peeps over the wall, expressing Spencer's own sense of the nearness of the spiritual world.

If Cookham gave Spencer the impression that he was walking in an earthly paradise, which remained unbroken even when he travelled daily to London to study at the Slade, the First World War shattered his insularity. He continued, however, to search for the supernatural in the local and particular. Drawing upon his war-time experiences, 70 first as a hospital orderly and then as a soldier on the Macedonian front, he worked on decorations for the Burghclere Chapel between 1923 and 1932. The chapel had been built to house Spencer's decorations by Mr and Mrs J. L. Behrend and it was dedicated to the memory of Mrs Behrend's brother who had died in the war. None of the scenes reflect the violence and horror of war, but instead generate a mood of well being. The figures are shown map-reading, making beds, washing, laundering, filling tea urns or buttering bread. During the early part of the war Spencer had been given a copy of Saint Augustine's *Confessions* from whence he took the idea that God is glorified by even the smallest and most menial of tasks.

During the late 1920s and 1930s Spencer's desire to hallow the ordinary could lead to strained and strange effects. His everyday figures became more rotund (cherubs in tweeds) and his use of distortion for expressive purposes more dramatic. The naïvety and gaucheness in his work was now deliberately calculated. At the same time his personal life was troubled by his divorce from Hilda Carline and his unhappy marriage to Patricia Preece. The unsatisfactory nature of his personal relationships aggravated his obsession with sex. He believed that all desire is holy and painted pictures portraying love, between husband and wife, old men and young girls and figures of different nationalities. Likewise he believed that everything is a part of God's creation, that even rubbish was to be hallowed and dustmen cherished. His obsessions and unceasing energy sometimes led to a 71 claustrophobic use of pattern. His colours also became more close-toned and airless, giving a deadness to some of his work. He seldom read a newspaper, talked incessantly and wrote his first wife hundreds of letters, even after she died. These he hoped would complement his art and form an autobiography. 'I don't want', he once admitted, 'to lose sight of myself for an instant.'

Spencer was not the only artist at this period to sustain a decidedly

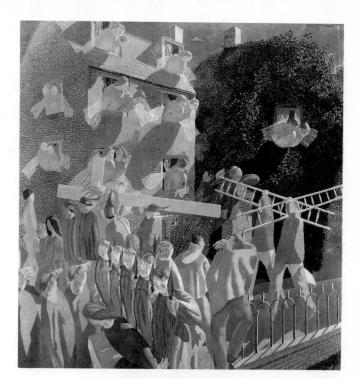

70 Stanley Spencer,
Christ Carrying the Cross,
1920

71 Stanley Spencer,
The Dustman (The Lovers),
1934

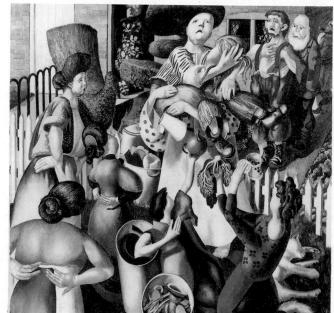

eccentric vision. Edward Burra (1905–76) developed a similar descriptive tenacity and a subtle, expressive use of distortion. He, too, emerged from restricted circumstances, having suffered an attack of rheumatic fever combined with anaemia at the age of thirteen which left his health permanently impaired. Cut off by illness from life, he retained a fascination with it, particularly the more exotic and colourful world found in bars and cafés in red-light districts in Mediterranean cities. He had a sardonic, camp humour and pounced gleefully on the bizarre, on ugly fashions and quirks of human behaviour. He also moved in theatrical circles and saw life in general as if lit up, on a stage. He would seize on a moment of crude banality and transfix it in an image, once seen, not easy to forget.

Unlike Spencer, Burra was more open to external influences. He mostly worked in watercolour but immediately saw the humorous potential in the Surrealists' use of collage and around 1930 pieced together *Venez avec Moi* (Leeds City Art Gallery) with its hybrid figures and unexpected juxtapositions. But he did not remain a Surrealist for long, caring more for the visible world than for the subconscious. In 1934–35 he made a trip to Harlem and Mexico with the poet Conrad Aiken and his wife, and this experience released a vivid series of paintings based on the jazz clubs they visited. He 68 exhibited with the short-lived group organized by Paul Nash, Unit One, in 1934 and at the International Surrealist Exhibition held in London in 1936, though he had by then lost sympathy with this movement. The Spanish Civil War inspired the cruel, baroque allegories that he produced in the late 1930s, for he feared its effect on this country's art, architecture and customs. Quotations from El Greco and the Italian masters entered his work, giving a new impulse to his macabre imagination.

Burra's use of line owes much to Signorelli and at times it takes on a tautness and brittle energy reminiscent of Lewis's figure drawings and Erté's cover designs for *Vogue*. It is related to the stylishness that animates many designs of this period, from murals by Rex Whistler (1905–44) for the Tate Gallery restaurant (then a tea-room) to Edward Bawden's decorations for Fortnum and Mason catalogues. In the 1920s 'amusing' was a word of high praise, and much decoration inclined towards the fatuous and lightweight. A climax was reached in the decoration of the R.M.S. *Queen Mary* in 1935–36 which gave work to a host of artists, then fashionable but now largely forgotten, including Anna Zinkeisen, MacDonald Gill, Bainbridge Copnall, Margot Gilbert, James Woodford, Herry Perry, Charles Pears, Kenneth Shoesmith and Rebel Stanton. Reviewing their work, Clive Bell observed: 'The artistico-comical creeps all over the ship. . . . The whole boat giggles from stem to stern.'

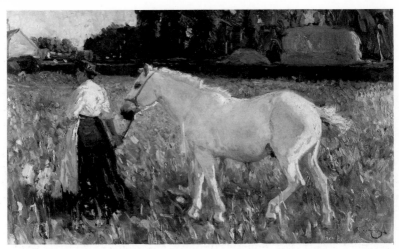

72 Alfred Munnings, *The Poppy Field*, 1905–06

Exhibitions at the London Group continued to focus attention on the Bloomsbury painters and their followers: R. V. Pitchforth (1895–1982), Keith Baynes (1887–1976), Raymond Coxon (b.1896), Bernard Adeney (1878-1966) and Edward Wolfe (1897–1982). Though Roger Fry declined from occupying any position of official importance, he frequently sat on its selecting jury and had a dominating influence. As a result, the exhibitions favoured paintings in which subject matter was on the whole subservient to aesthetic content. Less experimental than in its early days, it upheld a kind of fluent naturalism that overlaid a twentieth-century awareness of design. When, in 1928, it mounted a retrospective exhibition, Roger Fry observed:

What these artists brought back from those years of experimental effort was distinctively a feeling for more rigorously planned construction, for a more close-knit unity and coherence in pictorial design.

London Group painting was on the whole more painterly, more indebted to the example of French art than that shown at the Royal Academy in the annual summer exhibitions. At the Academy one might find pictures of horses by its President, Sir Alfred Munnings (1878–1959), painted with a similar brio to that which he brought to his vituperative attacks on the degenerate nature of modern art. Equally popular were Dame Laura Knight's paintings of circus characters and those by the Cornish artist Dod Proctor (1891–1972). In 1926 she exhibited a painting of a fish merchant's daughter found dreaming on her bed in the dawn light. The painting, entitled

72

Morning, aroused such a pitch of interest that in a fit of national 73
fervour the *Daily Mail* bought it for the Tate Gallery.

Much Royal Academy art was characterized by an uninflected
realism and a love of polished detail. Meredith Frampton (1894–1984)
achieved an airless, marmoreal perfectionism in his portraits and still- 67
lifes. Every detail is fashioned with the same evenness. His paintings
aspire to a classical stillness but remain disquieting, for the insistent
particularity of every part wars against the harmony of the whole.
Nor does the clarity of definition destroy the impression that his
portraits are, like a mirror reflection, infinitely remote.

According to the pundits of significant form, factual detail detracted
from the aesthetic experience offered by a work of art. Nor did it
allow sufficient freedom to manipulate the given, to reinforce a
vertical or bring out a particular touch of colour if the picture
demanded it. Likewise, anything that smacked of anecdote or story-
telling was frowned on. Sickert, aware of this distrust and the extent
to which it had become a fashionable attitude, turned deliberately in
the late 1920s to Victorian illustrations and painted a series of cameos
based on them called 'Echoes'. He also found source material in
photographs, painting Edward VIII stepping out of a car, in one of the
most informal poses that the Royal Family has ever been portrayed.
Sickert had lost none of his former daring, but the quality of paint in
his late work is often starved, the execution hasty, the result
sometimes arid and thin. What unites his early and late work is an
ability to pounce on a momentary gesture, and his great technical
brilliance in the portrayal of light, particularly the glare of footlights.

Sickert may have been laughing at Roger Fry and other upholders
of pure form in these late works, but the humour is also at his own
expense: the man who once declared that art fades at a breath from the
drawing-room spent much of his time at the end of his life painting

73 Dod Procter, *Morning*, 1926

74 Walter Sickert,
Viscount Castlerosse, 1935

society portraits. They are extremely various, abrasive and surprising.
His approach was wholly unorthodox: for his portrait of Lady Fry he
sent his photographer to invade the privacy of her bedroom so that he
74 could paint her reading in bed; and Viscount Castlerosse, the gossip
columnist, was delivered to the Royal Academy Summer Exhibition a
toasted pink.

75 Charles Jagger, relief from the *Royal Artillery Memorial*, 1921–25

CHAPTER FOUR
SCULPTURE BETWEEN THE WARS

Over a million lives had been lost by the British Empire forces in the First World War, and after the return to peace memorials were erected in England, Belgium and France. In order to stimulate ideas the Victoria and Albert Museum mounted a two-part exhibition in 1919, first showing earlier examples of memorial work and then a large display of new ideas. The Royal Academy followed suit, exhibiting a wide range of commemorative items. It also set up a committee to vet proposals for memorials. It advised, among other things, care in the choice of site, use of local stone wherever possible, clear lettering, simplicity, scale and proportion.

Every parish in Britain and a great many institutions commemorated their dead. Memorials ranged from simple variations on the theme of the cross to the architectural monuments built by Sir Edwin Lutyens in France to commemorate the battles of the Somme and Arras. The general level of this work drew from Roger Fry the observation: 'The tradition that all public British art shall be crassly mediocre and inexpressive is so firmly rooted that it seems to have almost the prestige of constitutional precedent.' War memorials made little contribution to the developing language of sculpture in the 1920s. And, as so often happens once the unveiling ceremony is over, these monuments, while remaining ever present, rapidly dwindled from public notice. Even the *Royal Artillery Memorial* by Charles Jagger (1885–1934), prominently sited (though now isolated by traffic) on Hyde Park Corner and surmounted by a gigantic howitzer, is today little celebrated. Around its base, however, are reliefs portraying trench warfare in which, using heroic naturalism, Jagger skilfully blends descriptive detail with fluent design.

If limited in their achievement, war memorials nevertheless fostered the notion that sculpture was *par excellence* a public art form. It was thought not only to commemorate but also educate, to demonstrate ideal posture and moral virtue; its high ideals were expected to assail the passer-by, to inspire and elevate thought. For Jagger, it had a definite social role and was to portray 'the peoples, customs and great achievements of its time'. However, twentieth-century British sculpture is on the whole not well suited to the expression of patriotism, civic pride or political propaganda. Works by Barbara Hepworth or

75

Henry Moore appeal to the emotion aroused by the contemplation of static forms, as their rhythmic, plastic and tactile relationships are gradually perceived. Emphasis is also placed on secondary associations, on correspondences between, for example, the outline of a reclining figure and the undulation of hills. But the primary appeal is to our capacity to observe and empathize with a physical language. As this relates to our own biological make-up, argued Moore, Hepworth and others, it spoke universally and was not hindered in its capacity to communicate by place, period or class.

Therefore although sculpture now turned aside from national and civic themes, it was still addressed to a wide audience. The much closer links that existed at that time between patron and artist also helped sustain its social role. If a public commission failed to satisfy the expectations of its audience, it was loudly abused. Controversy was aroused in 1925 by Epstein's *Rima*, a memorial to the naturalist and author W. H. Hudson, which was installed in Hyde Park and commissioned by the Royal Society for the Protection of Birds, and again in 1929 by his *Day* and *Night* figure groups carved for the 76 London Underground's headquarters building in Broadway. During the 1930s Epstein continued to attract notoriety with his original and superficially pagan interpretation of Christian themes, *Genesis* (1931), *Ecce Homo* (1935), *Consummatus Est* (1937) and *Adam* (1939). Today the

76 Jacob Epstein, *Day*, 1928–29

77 Jacob Epstein, *G.B. Shaw*, 1934

vituperative disgust these works aroused in the press seems out of proportion to the amount of distortion used by Epstein for expressive effect. Such controversies, often seen as an indication of the philistine nature of the British public and press, in fact remind us of the contemporary public conviction as to what art should do and be.

If Epstein still turned to carving for his more avant-garde ideas, he secured financial success by reviving the technique of modelling, in portrait busts and figures that were subsequently cast in bronze. His earlier interest in form, honed to its essentials in imitation of machine rigour, now gave way to a romantic pursuit of the particular. His 77 heads have a striking vitality, though on close inspection the emphatic modelling often tells us more about Epstein's personality than that of the sitter. The emotionalism, evident in the often exaggerated size of the eyes, sometimes borders on vulgarity, but the undeniable vitality of these portrait busts helped raise the standard of this genre.

One of the first to exhibit carvings after the war was Frank Dobson, whose one-artist show at the Leicester Galleries in November 1921 78 included *The Man Child*. In this, ideas earlier discovered in the art of Gaudier-Brzeska (notably his *Birds Erect* and *Maternity*) are brought into the 1920s and married with the desire for a new expressiveness in the portrayal of the human figure. Dobson was, however, soon to

93

78 Frank Dobson,
The Man Child, 1921

79 Frank Dobson,
Sir Osbert Sitwell, Bt, 1923

exchange the primitive influence discernible in *The Man Child* for a serene classicism inspired by the French sculptor Aristide Maillol. His

79 portrait bust of *Sir Osbert Sitwell* has a suave fluency and was praised by the critics Clive Bell, Roger Fry and Raymond Mortimer. But others regretted in his art a loss of articulation, a sameness that suggested, as William Rothenstein observed, that his figures had been squeezed from a tube into a mould. Nevertheless during the 1920s Dobson's reputation was equal with that of Epstein. He was invited to join the Bloomsbury-dominated London Artists' Association, run by the economist Maynard Keynes, and between 1924 and 1928 acted as President of the London Group. But it was his friend Stephen Tomlin (1891–1937) who made busts of key figures within Bloomsbury, of

80 Lytton Strachey, Duncan Grant, David Garnett and Virginia Woolf.

Both Epstein and Dobson in their early work contributed towards the breakdown of the hegemony of the Greco-Roman tradition which, descending via the Italian Renaissance, had for centuries set ideal standards of human proportion and beauty. The artists who during the 1920s were to redirect and expand the language of sculpture were those who combined an interest in carving with the study of archaic or primitive cultures. To an eye trained to appreciate the subtleties of Edwardian modelling, Henry Moore's admiration for Mexican art and its expressive power seemed the worship of ugliness.

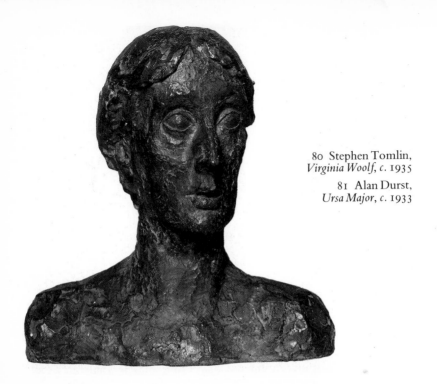

80 Stephen Tomlin,
Virginia Woolf, c. 1935

81 Alan Durst,
Ursa Major, c. 1933

And though African carvings could be seen at the British Museum and the Horniman Museum in South London, they were not seriously considered as art by any but the few until two exhibitions were mounted, one at the Chelsea Book Club in April 1920, the other at the Goupil Gallery in 1921. The idea that an anonymous 'savage' could capture the aesthetic interest of a sophisticated European was, in Britain, still new and surprising. Virginia Woolf, after visiting the 1920 exhibition, confessed to finding the carvings 'impressive', adding the aside, 'that if I had one on the mantelpiece I should be a different sort of character – less adorable ... but somebody you wouldn't forget in a hurry.'

By December 1928 the example set by African sculpture had been fully assimilated, as an exhibition held at the dealer Sydney Burney's in St James Place, set out to prove. Work by Dobson, Epstein, Barbara Hepworth (1903–74), Alan Durst (1883–1970) and John Skeaping (1901–80) was shown alongside Yoruba and other carvings from Benin, Gabon and the Congo. Another source of ideas and inspiration was Mexico which, partly through D. H. Lawrence's and Aldous Huxley's association with it, became fashionable, Aztec and Mayan motifs forming an essential ingredient in Art Deco. Henry

81

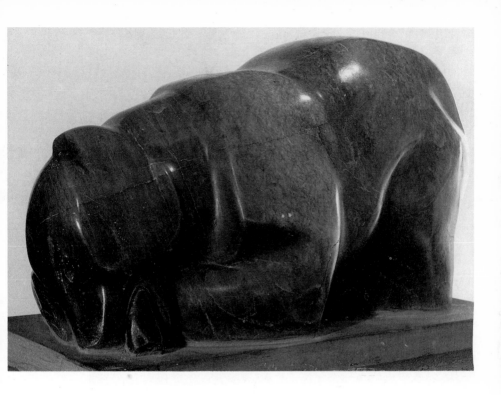

Moore first became interested in Mexican art as an art student in Leeds when he read the chapter on 'Ancient American Art' in Roger Fry's *Vision and Design*. This sent him to the British Museum to study and draw ancient Mexican art in its collection. He shared this interest with the painter and sculptor Leon Underwood whose life classes he attended for a time. Underwood visited Mexico in 1928 and in the period immediately following his return allowed Mexican themes and imagery to dominate his work. In 1929, the year that Moore produced 82, 83 his first reclining figure, inspired by the Toltec-Mayan *chacmool* from Chichén Itzá, Underwood painted *Chacmool's Destiny*.

Because work in less durable materials has been lost, most ancient cultures have come down to us chiefly in the form of carvings, either in wood or stone. But this was only one of several reasons why young sculptors, anxious to reinvigorate the European classical tradition through the assimilation of primitive influence, turned to carving, and why much was said and written about its advantages over modelling. The importance of carving was associated with a belief in honest labour; for Gaudier-Brzeska it was inextricably linked with the virtues of craftsmanship in that every stroke of the carver required physical and mental effort; for Eric Gill it satisfied his Ruskinian belief in the

97

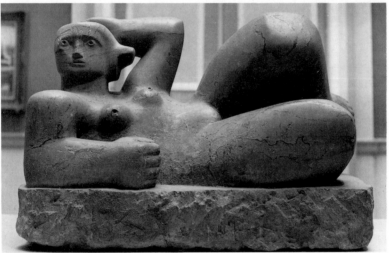

82 (Top) Toltec-Mayan *chacmool*, *c*. 900–1224. 83 (Above) Henry Moore, *Reclining Figure*, 1929

integrity of craftsmanship, because, unlike modelled work which is handed over by the artist to a technician to be cast in bronze or mechanically measured and copied in stone, carving involved no division of labour. It was also popularized by Brancusi, the Rumanian sculptor living in Paris and whose influence came to Britain chiefly through the example of Gaudier-Brzeska. Their names were linked in

an article on Brancusi by Ezra Pound, published in 1921, in which he attributed to Gaudier that which was central to Brancusi's aesthetic: 'that the beauty of sculpture is inseparable from its material and that it inheres in the material.' This led to the doctrine of 'truth to materials' which became a catch-phrase among sculptors in the 1920s and was attendant on the belief in carving.

Brancusi also encouraged a preference for timeless subjects or themes. In his own art he sought not the particular but the essential, and had been one of the first to react against the achievement of Rodin. Instead of an impressionistic likeness, Brancusi reduced representation to its essence; he portrayed not the shape of a bird on the wing but the sensation of flight. The concept behind each piece grew out of a dialogue between his understanding of the subject and the qualities inherent in the material used – veined marble, for example, suggesting the flicker of light on water in one of his fish sculptures. All extraneous detail was cut away, Brancusi insisting, as Moore has observed, on 'shape for its own sake'. Still more important, Brancusi's aesthetic combined the vitality of 'primitive' art with the idealization of classical art, a union that remained a central challenge for Moore. Both Moore and Hepworth visited his studio during the 1920s, as did the curator H. S. Ede who was later to turn his house and collection at Kettle's Yard, Cambridge, into a monument to an aesthetic that Brancusi did much to inspire.

Ede also helped secure Gaudier-Brzeska's reputation. After a memorial show of his art at the Leicester Galleries in 1918, his work was passed around art experts and dealers until left unwanted in the Board Room at the Tate. Ede, who used this room as his office, showed the sculpture to all who were interested, and was responsible for its eventual dissemination. Gaudier's influence was also sustained by Pound's book on the artist, published in 1916, which incorporated Gaudier's writings on art. His stated beliefs were bold and forthright. Henry Moore found this book 'a great help and an excitement', and it is reasonable therefore to suggest that Gaudier's comparison of sculptural energy with mountains helped shape Moore's analogy of the human figure with landscape.

Moore and Hepworth are the two sculptors whose work must dominate any account of this period. Both have admitted a debt, in their understanding of form, to the Yorkshire landscape in the areas where they grew up. Both attended Leeds College of Art and won scholarships to the Royal College of Art. Both, after completing their diplomas, went to Italy on a travelling scholarship. With wide-ranging eclecticism, they assimilated ideas from a variety of European and non-European sources, and became committed to direct carving. Their friendship encouraged an exchange of ideas, and in the late

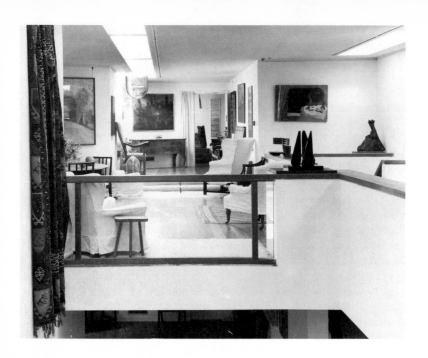

1920s each began living and working in one of the Mall Studios, Hampstead. Both were at the forefront of the avant-garde during the 1930s when ideas about abstraction were coming in from the Continent and being assimilated into an international style. Yet despite their shared interests and similar background, their work is fundamentally different; Moore's sculpture works outwards from the inside, through the rhythms and tensions situated within the central mass, while in Hepworth's sculpture the play of movement is to be found closer to the surface, in the intimate correspondence between the larger rhythmic movements and the surface changes of direction.

While in Italy in 1924 Barbara Hepworth had met and married the sculptor John Skeaping. The two artists studied under an Italian master carver and made this medium the vehicle for their ideas. Skeaping specialized in animal sculpture, and this may have encouraged Hepworth to pursue the bird motif, for their work of the late 1920s suggests a close working relationship. But in 1930 they 85, 86 separated and the following year Hepworth met Ben Nicholson whom she was later to marry. In 1932 she made a rewarding trip in his company to France, visiting the studios of Braque, Brancusi, Picasso and Jean Arp, and travelling on to St Rémy-de-Provence where she was profoundly moved by Les Alpilles, the craggy line of hills rising pale above the olive trees and crossing the Durance valley. She was to

84 Interior of Kettle's Yard, Cambridge
85 John Skeaping, *Blood Horse*, 1929

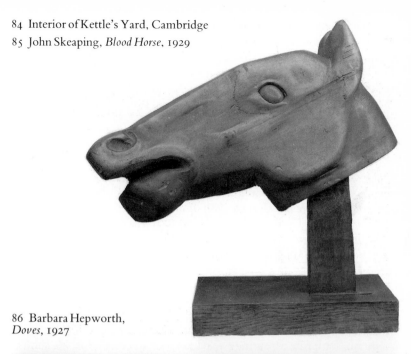

86 Barbara Hepworth,
Doves, 1927

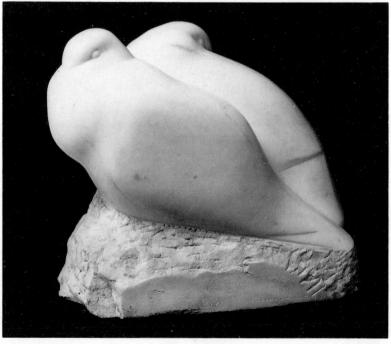

describe her memory of these hills in the book *Unit One*, published in 1934, adding as her conclusion:

It is the relationship and the mystery that makes such loveliness and I want to project my feeling about it into sculpture – not words, not paint nor sound ... Carving is interrelated masses conveying an emotion; a perfect relationship between the mind and the colour, light and weight which is the stone, made by the hand which feels. It must be so essentially sculpture that it can exist in no other way, something completely the right size but which has growth, something still and yet having movement, so very quiet and yet with a real vitality.

The qualities she describes here are those found in her work of the mid 1930s which, under the influence of European modernism, had become non-representational. This kind of abstract art is theoretical and hieratic, displaying, above all, a logical intelligence and extreme sensibility. In *Two Forms* solids are made to suggest weightlessness; 87 the egg appears to float because its shadow makes translucent the alabaster base; and the rectangular form, shaved into a soft wedge-shape to bring it into relation with the egg, rises like a sail.

Hepworth and Moore play upon the conscious and unconscious memories that we bring to our experience of form. Moore often employs metaphor to enrich the associations aroused. Whereas in Victorian sculpture meaning was held in direct relation to subject matter, with Moore's art a part of the content remains latent; it can be

87 Barbara Hepworth, *Two Forms*, 1934

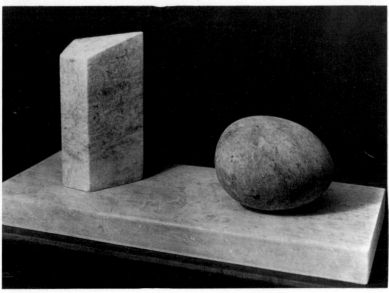

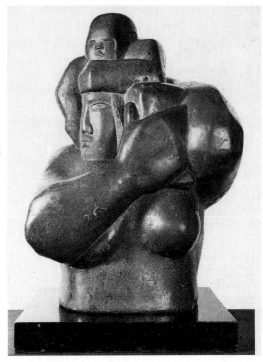

88 Henry Moore,
Mother and Child, 1924–25

felt but is often falsified by articulation. His themes are few but the responses they arouse complex and many-layered.

Moore began as a pioneer of 'direct carving' and 'truth to materials'. Working mostly with the human figure, he strove for an expression of power rather than conventional beauty or elegance and for the suggestion of energy pent-up within static forms. For him a sculpture has vitality if the shapes suggest the pressure outwards of internal forces, like knuckles protruding through the skin of a clenched fist. His *Mother and Child* of 1924–25 is stiff and encumbered compared with his later work but succeeds in conveying tenderness without sentimentality. Its brooding earthiness may have been inspired by literature: Moore, in his late teens, spent one year of his life immersed in the novels of Thomas Hardy and between the ages of twenty and twenty-two read everything of D. H. Lawrence that he could find. As he has admitted, 'it's been novelists if anything who have had the biggest influence on me.'

The stockiness and squareness of his early 1920s art grew out of his admiration for primitive sculpture. As he has said, 'early Mexican art formed my view of carving.' The turning aside from the Greco-Roman tradition also helped him realize 'the intrinsic emotional

88

significance of shapes' and not just their representational value. But from the start Moore rejected the Mexican use of symmetry, finding this static quality antagonistic to the suggestion of organic growth. Around 1928 or 1929 Moore began collecting pebbles, shells and bones, and from then on derived his principles of form and rhythm from natural objects, admiring the effects of weathering on stone or the easy passage from one section to the next in a tree trunk. Moore shared Gaudier-Brzeska's belief that concepts and emotions can be expressed through shape, and he has spoken of the sculptor's need to develop 'form-knowledge' or 'form-experience'. But if he developed his understanding of form through his study of inanimate nature, he did so only in order to work more effectively with human, psychological content. Even his abstract art of the 1930s, at first biomorphic in a manner akin to the contemporary work of Arp, Tanguy, Miró and Picasso, and later, from 1934 onwards, more rigid and angular, is an attempt to arrive at this content with greater directness and intensity. Always the human or emotive idea is held in tension with its formal realization.

Compared with Hepworth's subtle control of outline and nuances of form, Moore's transitions can seem abrupt and less sophisticated. Though Hepworth has been credited as the first of the two to pierce form and introduce the hole into sculpture, they were both responding to the implications reverberating from the decision made by the Russian Constructivists, in particular Naum Gabo, to open up the closed form and reveal the space within it. For Moore, the hole immediately gave fresh emphasis to the three-dimensional nature of the work by helping the eye to connect one side with the other. It also reminded him of 'the mysterious fascination of caves in hillsides and cliffs'. At first he used it only where it might actually be found, in the space left by a bent arm as it supports the body of a reclining figure. But in 1936 in an elmwood version of this theme he used the hole to 89 puncture the thorax, immediately creating a more surprising and fluid relationship between space and form.

The reclining figure has provided Moore with a motif through which he can display both his versatility and his concern with human expression. These figures are always distanced from us, detached and metaphorical. They appear to have a far-seeing gaze which gives them a command over the gallery space or landscape in which they are situated. With their arches, slopes and plateaus, they themselves evoke landscape, flowing, majestic and time-worn. Noting in one of his sketch books his response to an Egyptian head of a woman in the Archaeological Museum in Florence, Moore revealed his ambitions by admitting that he aimed at 'the same amount of humanity and seriousness; nobility and experience, acceptance of life, distinction and

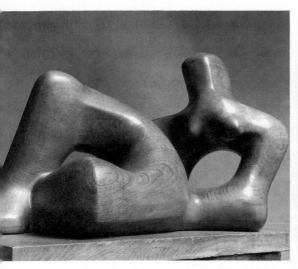

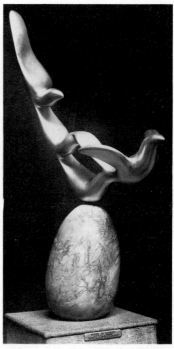

89 Henry Moore, *Reclining Figure*, 1936
90 Maurice Lambert, *Birds in Flight*, 1926

aristocracy. With absolutely no tricks, no affectation, no self-con-
sciousness, looking straight ahead, no movement, but more alive than
a real person.'

Moore successfully reinvigorated the European classical tradition
through the assimilation of primitive influence. However, when he
first confronted Italian Renaissance sculpture in 1925, particularly the
work of Michelangelo, he realized immediately that it challenged the
vocabulary of forms that he had previously acquired from his study of
primitive cultures in the British Museum. The tense conflict between
these two interests, which had falteringly inspired Epstein, at first
depressed Moore, but after a period of six months became a challenge
which has sustained his whole career.

In the hands of lesser artists this attempt to absorb the achievements
of archaic and primitive art into the mainstream classical tradition of
European art often ended in a compromise. Maurice Lambert (1902–
64), though he related his art to the work of prehistoric cave painters,
did not allow the rude force of primitivism to distract from his
schematic evocation of flight. If he had one eye on the example set by
90 Brancusi, his other rested on the potential buyer: his *Birds in Flight*, for
example, has an ingratiating elegance, a vitiating desire to do no more
than please.

91 Paul Nash, *Harbour and Room*, 1932–36

CHAPTER FIVE
ART AND POLITICS IN THE 1930s

If the 1920s were a period of retrenchment, recovery and individual endeavour, the 1930s were progressive and dedicated to communal effort. The term 'modernism', implying a search for the modern underpinned by a conscious theoretical stance, now takes on meaning. British art, formerly seen as inferior to French, moves into a position at the forefront of the 'modern movement', a term signifying a dominant trend within European modernism, one dedicated to the unification of the visual arts through the growing commitment to a classical notion of universal order. The 1920s, by comparison, were insular, with relatively little exchange between British and foreign artists. Not until 1926 did the Tate Gallery (originally entitled the National Gallery of British Art) display contemporary European art, after which there was a noticeable increase in assimilation of foreign ideas. There began a period of internationalism, fostered by the arrival of émigrés fleeing totalitarian régimes or religious persecution. By the end of the 1930s, London, or more specifically Hampstead, had become the centre for an international avant-garde.

One artist who played a significant role during the early 1930s was Paul Nash. He first saw a substantial collection of contemporary French and Italian art at Léonce Rosenberg's gallery in 1930, while pausing in Paris *en route* for Toulon. He was impressed chiefly by the Surrealists, learning from them, as he said, 'the extension of liberty of the subject'. At Toulon he and his wife took a room overlooking the harbour. Catching sight one day of the boats in the harbour reflected in the mirror, Nash had the idea for his painting *Harbour and Room*, in which sea and boat invade the rational confines of the room's space, creating an image symbolic of some subconscious threat or fear.

Because sales of his work had declined, Nash was at this time supplementing his income by illustrating books and undertaking design work for textiles and the stage. He also wrote regular art criticism for the *Weekend Review* and for *The Listener*, where he alternated with Herbert Read. This obliged him to follow contemporary developments, by visiting exhibitions and reading art magazines, both British and French. Aware of a trend towards abstraction, he himself experimented with this style between 1929 and 1931, eventually realizing that it was ill-suited to his interests and temperament.

He remained primarily a landscape artist, though he abstracted and remoulded nature according to his needs. The experience of abstraction left him concerned that the meaning of his pictures should reside in the forms *as forms*, as well as in their representational content.

The issue of abstract art, however, grew more divisive as the decade progressed. It undermined the cohesiveness of Unit One, a group of eleven artists whose existence was announced by Paul Nash in a letter to *The Times* on 2 June 1933. Two years earlier he had been asked to advise on the exhibition 'Recent Developments in British Painting', held at Tooth's in London. He first began to talk of the need for an artists' group with Henry Moore, Edward Wadsworth and the architect Wells Coates, a founder member of MARS (Modern Architectural Research Group) in the winter of 1932–33. As Nash said in his *Times* letter, he wanted to bring together artists in whose work could be found 'the expression of a truly contemporary spirit'. He also wanted to present a challenge to one recurrent weakness in English art: 'the lack of structural purpose'. He wrote: 'This immunity from the responsibility of design has become a tradition. . . . Nature we need not deny, but art, we are inclined to feel, should control.'

92 Tristram Hillier, *La Route des Alpes*, 1937

The eleven members were Nash, Moore, Wadsworth, Coates, Hepworth, Ben Nicholson, Burra, John Bigge (1892–1973), John Armstrong (1893–1973), the architect Colin Lucas, and Tristram Hillier (1905–83), who soon after Nash's announcement replaced Frances Hodgkins. Its headquarters was the Mayor Gallery in London's Cork Street and in 1934 it mounted an exhibition which, after being shown in London, toured the provinces. A book, also called *Unit One*, was published to coincide with this exhibition. Composed of artists' statements, it was introduced by Herbert Read who neatly explained the choice of title: 'Though as persons, each artist is a unit, in the social structure they must, to the extent of their common interests, be one.' Quite what those common interests were was less easy to discover, for each artist's statement disclosed differences of stance. Nicholson, arguing in favour of metaphysical abstraction, compared painting with religious experience and declared that what they were all searching for was 'the understanding and realisation of infinity'. Moore, on the other hand, did not want to lose sight of the particular and humane; for him, abstract qualities of design had to be balanced with 'the psychological human element'. For the architects, the dominant concern was functionalism; in Coates's opinion, 'the word has a modern ring about it, it's smart and hard'. The absence of any underlying unifying principle, and the varying attitudes towards abstraction, brought Unit One to a close in less than two years. When it attempted reconstruction, early in 1935, and decided that each member had to be unanimously re-elected, only Moore and Nash passed the test.

This same year saw the first entirely non-representational exhibition in England. It was engineered by Ben Nicholson who since 1926 had been chairman of the Seven and Five Society. In 1934 he proposed that it should change its name to the 'Seven and Five Abstract Group' and that all the exhibits in the 1935 show should be abstract. This successfully antagonized a number of artists whom Nicholson was anxious to be rid of, but it also caused the society's demise: the 1935 exhibition, at which only eight artists were represented, was its last.

It was during this decade that Ben Nicholson was able to concentrate in his art a number of crucial experiences. He had first recognized the abstract potential of colour in 1921, when on a visit to Paul Rosenberg's gallery he saw a Picasso. The picture (which has never been precisely identified) was a Cubist work of around 1915 but seemed to him entirely abstract:

And in the centre there was an absolutely miraculous green – very deep, very potent and absolutely real. In fact, none of the actual events in one's life have been more real than that, and it still remains a standard by which I judge any reality in my own work. . . .

In 1924 and again in 1929 Nicholson produced canvases that appear to be entirely abstract, but it was not until the early 1930s that he progressed logically through an investigation of Cubism to a pure and sustained abstract style.

Nicholson had an unusual capacity for absorbing the ideas of others. During the first years of the decade, after the breakdown of his marriage to Winifred Nicholson, he shared a studio with Barbara Hepworth in Hampstead and accompanied her to France in the spring of 1932, spending Easter at Avignon and St Rémy-de-Provence. Besides calling on Picasso at Gisors and Braque at Dieppe, they visited the studios of Brancusi and Jean Arp, and met Alexander Calder, Alberto Giacometti and Joan Miró in Paris. Either on this visit or a year later Nicholson saw a Miró that struck him as 'the first free painting' that he had seen: 'a lovely rough circular white cloud on a deep blue background, with an electric black line somewhere'.

In 1933 Nicholson and Hepworth were invited to join 'Abstraction-Création', a Paris-based exhibiting society dedicated to non-figurative art. They were also given an introduction to Piet Mondrian by László Moholy-Nagy. The following year (and again in 1936) Nicholson visited Mondrian's studio in the rue du Départ in Paris, where the artist had lived since 1919. The experience of this white-painted studio, and of Mondrian's paintings, left an indelible impression on Nicholson. As he sat afterwards at a kerb-side café table, while incessant traffic went in and out of the Gare Montparnasse, he retained 'an astonishing feeling of quiet and repose'.

It was a similar quiet exaltation that Nicholson now sought in his own art. The stumbling, self-conscious naïvety of his 1920s landscapes gives way to a display of formal confidence. His line, often incised into plaster-covered board, has an animated flourish, an elegance that looks back to his father Sir William Nicholson's dandified style. Fascinated by the mirror image, Ben Nicholson frequently used it in the early 1930s to further his interest in shifting 93 depth and ambiguous planar relationships. His use of line, shape and colour, like the mirror, begin to operate both as objects in their own right and as illusion. Sometimes the lines describing the shape of musical instruments take off in the background with an independent life of their own. When he eventually moved into reliefs, in late 1933, the guitar's circular sound-hole became a central motif. In *White Relief* it is given buoyancy by the weight of the nearby rectangle which 94 hangs as if suspended from the top edge of the base.

Nicholson's white reliefs are often regarded as the high point within the history of early modernism in England. Shorn of all extraneous matter, they have a purity sustained by idealism. Nicholson believed that the liberation of form and colour achieved by abstract art

93 Ben Nicholson, *Saint Rémy, Provence*, 1933

paralleled, or was linked to, other forms of freedom. For him abstract art, far from representing a retreat from reality, compared in spirit with contemporary design and, like good design, offered a vision of order and was therefore a potential agent for change. Art, for Ben Nicholson, was not a luxury but a central condition of daily existence: 'A Raphael is not a painting in the National Gallery – it is an active force in our lives.'

Historical circumstances fostered this attitude. In Russia during the 1920s, and now in Germany, where the Bauhaus was closed by police in March 1933, abstract and experimental art had been found unacceptable to totalitarian régimes. Artist refugees arriving in Paris had

94 Ben Nicholson, *White Relief*, 1935

begun to contribute to the Abstraction-Création exhibitions where non-figurative art became increasingly associated with a 'free', international style. Gradually émigrés began to arrive in Britain. In 1934 the architects Walter Gropius and Eric Mendelsohn and the designer Marcel Breuer arrived in London and took up residence in Hampstead, in Wells Coates's recently completed Lawn Road Flats. In 1935 95 Moholy-Nagy arrived in England, in 1936 the Russian Constructivist Naum Gabo settled here, and in 1938 a studio was found for Mondrian near those occupied by Moore, Hepworth, Ben Nicholson, Cecil Stephenson (1889–1965) and Herbert Read, in Parkhill Road, Hampstead.

There now began a period dominated by a desire for unity and clarity. Both can be observed in photographs of the 'Abstract and Concrete' exhibition organized by Nicolete Gray in 1936. Work by 96 British artists – Hepworth, Nicholson, Moore, John Piper (b.1903) and Eileen Holding (1906–83) – was exhibited alongside that by leading European artists – Mondrian, Moholy-Nagy, Hélion, Léger, Miró, Gabo and Calder. Behind much of this abstract art lay the Platonic belief that formal relationships reflected a metaphysical ideal; that the simplicity and clarity of means pointed to an underlying model of construction reflective of some larger vision of social organization. During the course of this exhibition (it ran from February to June 1936 and was shown at Oxford, Liverpool, Cambridge and in London), Naum Gabo became friendly with Nicholson and the architect Leslie

95 Wells Coates, Lawn Road Flats, 1933–34

Martin. The International Surrealist Exhibition held in London in June 1936 (to be discussed later in this chapter) led these three men to retaliate by advertising the 'constructive attitude' in art, architecture and design. This they did by jointly editing the book *Circle*, published in 1937.

In its collection of essays and photographs, *Circle* was representative of current trends rather than a manifesto for a new movement. It contained contributions from leading European architects, designers and artists and discerned in their work 'a new cultural unity'. Gabo's

96 The 'Abstract and
Concrete' exhibition, 1936

97 Naum Gabo,
Linear Construction No. 1,
1942–43

essay, 'The Constructive Idea in Art' sought to explain this phenomenon. Drawing upon ideas that he had first put forward seventeen years before, in his 'Realist Manifesto', he argued that lines, colours and shapes are immediately and organically bound up with human emotions. Therefore Constructivist art belonged not to any period or class but was rooted in life itself, and 'sees and values Art only as a creative act'. It was, moreover, a means by which existence could be enriched, for its aim was to construct, co-ordinate, perfect.

If the ideology of Constructivism was vague and confusing, it did encourage artists to see their art in relation to the environment. It was also positive and inspiring. For Hepworth, it reflected 'an absolute belief in man, in landscape and in the universal relationship of constructive ideas'. Under its influence, art, for Henry Moore, became 'an expression of the significance of life, a stimulation to greater effort in living'.

In practice Constructivism meant an architecture which has a nautical air, makes use of modular units and reflects the designer's idea about people's needs rather than the sociologist's. In art it meant the honing of an idea into relatively small-scale work in which form and content are one. It aimed at objectivity and therefore favoured an impersonal treatment. It aspired, with varying success, towards a universal idea of abstract beauty which, in its harmony and balance, was intended to make the viewer critical of the disorder in everyday life.

For the most part this art only awakens the spectator to the exquisite sensibility that has gone into its making. Certain of Barbara Hepworth's carvings of this period have an acute subtlety. But the difference between them and a Mondrian is that between an art that cuts away in order to refine and one that intensifies and goes on adding to the sensation evoked. There is a theatrical element to much 1930s abstraction: paintings by John Piper, for example, are arranged like scenic flats, and much of the sculpture is given a stage-like base. It is as if this art required a platform on which it could withdraw from life. It is contemplative and remote, and though it was hoped that such rigorous purity would become popular taste, this art retains, even today, a high-brow seriousness that limits its appeal.

Surrealism in England developed contemporaneously with abstract and Constructivist art. Ernst, Miró and Dali had exhibited in private galleries in London before 1936, the year of the International Surrealist Exhibition, but this event still came as a shock, to press and public alike. Even Herbert Read, around whom the English Surrealists were now gathered, had made only passing reference to it in his book *Art Now*, published in 1933 (revised in 1936). Nevertheless it was he who loudly and clearly introduced Surrealism in the catalogue to the 1936

exhibition with the following warning: "Do not judge this movement kindly. It is not just another amusing stunt. It is defiant – the desperate act of men too profoundly convinced of the rottenness of our civilisation to want to save a shred of its respectability.'

Almost from its inception Surrealism had sustained some links with the proletarian cause and thus with revolution. If the Constructivists sought to inspire social improvement by uncovering clarity and order, the Surrealists stripped away conventional logic and received ideas, and challenged the belief in man's capacity to be in control, of himself and others. It laughed at and belittled bourgeois vanities, particularly moral righteousness. By shocking the mind and eye with their incongruous, surreal images, by jarring their audience out of habitual ways of seeing and thinking, the artists hoped to create a shared, 'primitive' state of mind, free of society's conventional inhibitions. The Surrealists' chief weapon was the imagination, released or stimulated by unexpected conjunctions or by the combination of methodical detail with disordered logic, in order to achieve the 'marvellous'.

The two people chiefly responsible for bringing Surrealism to England were the artist and collector Roland Penrose (1900–84) and the poet David Gascoyne. When they met in Paris both were already friends with several of the leading Surrealists, and Gascoyne was about to publish his *Short Survey of Surrealism* (1935). They returned to London and began gathering support from poets and painters, among them Hugh Sykes–Davies (b.1909), Humphrey Jennings (1907–50), Moore, Nash and Eileen Agar (b.1904). Penrose made frequent return visits to Paris and persuaded André Breton and Paul Eluard to collaborate. Breton and Eluard selected the work from abroad, Penrose and Gascoyne the English representation. Mixed in with these works were items by children, mental patients as well as primitive and tribal art.

Events associated with this exhibition were designed to create 98 sensation. Salvador Dali, dressed in a diver's suit, lectured on his life and love for his wife, Gala, while holding on leads two Irish wolfhounds. A young woman wandered around the gallery with her face obscured behind a mask of roses, clutching in one arm a model of a leg filled with roses, in the other a raw pork chop. Very few of the critics took the movement seriously, despite the appearance of a book of essays, entitled *Surrealism*, edited by Herbert Read. And once the excitement and furore had died down, the extent of its impact was not great. It encouraged Nash to work with the *objet trouvé* and convinced Moore that our conscious control often shuts us off from responding to familiar shapes in a spontaneous, direct way. Among English critics, always hostile to foreign importations, the suspicion remained

98 The International Surrealist Exhibition, 1936. *Back row, left to right*: Rupert Lee, Ruthven Todd, Salvador Dalí, Paul Eluard, Roland Penrose, Herbert Read, E.L.T. Mesens, George Reavey, Hugh Sykes-Davies. *Front row*: Diana Lee, Nusch Eluard, Eileen Agar, Sheila Legge and friend.

that Surrealism was less desperate than romantic, its hatred of respectability less revolutionary than socially irresponsible.

Nevertheless English Surrealism continued to appear in exhibitions over the next few years. It had as its base the London Gallery in Cork Street run by the Belgian Surrealist E. L. T. Mesens, who also edited the *London Bulletin*, with the assistance of Humphrey Jennings, Penrose and others. Magazine and gallery ran until 1940, giving focus to, among other things, Surrealist objects which were often some of its most successful products. These made use of *objets trouvés* in surprising relationships, thereby satisfying Lautréamont's definition of beauty as 'the chance meeting of a sewing machine and an umbrella on a dissecting table'. Penrose's *Last Voyage of Captain Cook*, for example, combines erotic connotations with suggestions of violence and imprisonment. Eileen Agar's blindfolded *Angel of Anarchy*, based on an earlier version which was lost, was made in 1938 and alludes to, among other things, an uncertain future.

What caused the movement to collapse in England, however, was not war but Breton's attempts to extract greater political allegiance

from the British contingent. During the winter of 1938–39, the *London Bulletin* carried the manifesto 'Towards an Independent Revolutionary Art'. Although signed by Breton and the Mexican artist Diego Rivera, it was written by Breton in collaboration with Leon Trotsky. At a meeting called to discuss this, it was clear that loyalties were severely tested, and strained beyond endurance when the artists were asked not to exhibit or publish except as Surrealists.

In March 1938, at a debate on Realism versus Surrealism, the Surrealists came into confrontation with two members of the Euston Road School. This had been founded in 1937 and centred around the teaching of four artists: Victor Pasmore (b. 1908), William Coldstream (b. 1908), Claude Rogers (1907–79) and Graham Bell (1910–43). 101 Reports of the debate (at which Coldstream and Bell upheld the School's ideas) emphasize the 'humility and honesty' of the realists in opposition to the 'vociferation and pretentious flourish' of the Surrealists. Likewise, in their teaching, the Euston Road painters were opposed to bombast and display. They did not seek to impose a style,

118

99 Roland Penrose,
Last Voyage of Captain Cook, 1936

100 Eileen Agar,
Angel of Anarchy
(second version), 1940

but encouraged observation, which, they argued, was the facility most open to training. All ideas about the need to be progressive were rejected. 'Measuring' became the operative word, and was used to encourage a deliberately unrhetorical, objective appraisal of the subject. Inspiration was drawn, not from Picasso and Matisse, but from Sickert's choice of subject matter, the brushwork of Degas, and Cézanne's searching analysis. The result was a lyrical realism, socially
110 inspired but aesthetically conceived, and which, in its economy and restraint, is peculiarly English, reticent yet poetic.

The outbreak of war brought to an end this short-lived school. But the nub of its teaching became the basis of William Coldstream's approach to the figure, which made him an influential figure, first at Camberwell School of Art and then at the Slade where he taught from 1949 to 1975. He was succeeded as Slade Professor of Fine Art by
102 Lawrence Gowing (b. 1918), painter and author of a number of distinguished publications on art. As a pupil at the Euston Road School, Gowing had been a close friend of Adrian Stokes (1902–72),

119

101 Claude Rogers, *The Cottage Bedroom*, 1944

who likewise combined painting and writing. Stokes is best known for his use of the terms 'carving' and 'modelling' to distinguish between two different approaches in art. This idea he elaborated first in his books *Quattro Centro* (1932) and *Stones of Rimini* (1935), applying it to painting in *Colour and Form*, published in 1937, the year that he attended the Euston Road School. He described his own paintings as 'fuzzy', cared little for drawing, and strove for a gentle luminosity.

Behind the existence of this school lay a growing dissatisfaction with modernism. In the harsh economic climate of the early 1930s, Coldstream and Bell in particular were aware that modern art was failing to reach a lay audience. In 1937 Coldstream wrote:

The 1930 slump affected us all very considerably.... One painter I knew lost all his money and had to become a traveller in vacuum cleaners. Everyone began to be interested in economics and then in politics. Two very talented painters who had been at the Slade with me gave up painting altogether, one to work for the Independent Labour Party, and the other for the Communist party.... I became convinced that art ought to be directed to a wider public; whereas all ideas which I had learned to regard as artistically revolutionary ran in

102 Lawrence Gowing, *The Artist's Wife*, 1941–42

the opposite direction. It seemed to me important that the broken communication between the artist and the public should be built up again and that this most probably implied a movement towards realism.

Around 1935 Coldstream had given up painting and gone to work for the documentary film-maker John Grierson, co-operating with his friend W. H. Auden on the film *Coal Face*. Grierson described his documentaries as 'anti-aesthetic'; they were made not with studio sets but actual life, which he then dramatized and interpreted in order to avoid naïve realism. Contact with this man, obsessed with social usefulness, led Coldstream to reassess painting. He returned to it in 1937 convinced that to be good it had to be not merely 'artistically' but also 'humanly' interesting. He began painting subjects taken direct from life, as he had done before, but instead of subjecting them to an 'abstracted' or 'modernist' treatment, he painted them 'straight', by means of accurate transcription.

Of all the Euston Road School teachers, Graham Bell was politically and intellectually the most active. He had reacted against what he saw

to be the decadence of modern art, blaming this largely on the influence of the complacent middle-class patron. With Coldstream, he visited Bolton at the suggestion of the anthropologist Tom Harrisson, who had made it a subject for his Mass-Observation project – which, through a workforce of untrained volunteers, sought to compile information on contemporary life and culture, particularly that of the working class. In Bolton, Bell and Coldstream painted the city from 110 the vantage point of the roof of the City Art Gallery. Though the city aroused Bell's pity and indignation, he, like the other teachers at the Euston Road School, avoided social realism. They did occasionally paint mundane aspects of urban life, but they were equally committed to traditional subjects: still-lifes, landscapes and the nude. To these they brought a method that was rigorous, disciplined and impartial. It gives a classic deliberation to Pasmore's and Rogers's nudes, a melancholy introspection to Bell's land- and townscapes, while the simplicity and ordinariness of Coldstream's vision invites a parallel 103 with the colloquial diction of W. H. Auden.

Social, or more particularly, 'socialist', realism obtained more purchase with the Artists International Association. Founded in 1933 as the Artists International, it extolled art as a weapon in the class struggle and was determinedly Marxist. One of its founders, Clifford Rowe (b.1904), had visited Russia, and all were inspired by a feeling of social responsibility, in the face of poverty and unemployment in Britain, and the growing threat of Fascism abroad. The hard-line approach with which it began, however, gave way to broader objectives in 1935 when 'Association' was added to its title. It now became a Popular Front standing for 'Unity of artists against Fascism and War and the suppression of culture'. In 1935, the year in which Italian Fascists invaded Abyssinia, it mounted the exhibition 'Artists Against Fascism and War' and drew wide support, many of its exhibitors having considerable reputations but who had previously displayed no strong political beliefs.

The Association published a regular Newsletter or Bulletin as well as the book 5 on Revolutionary Art (1935) with essays by Francis Klingender, Eric Gill, Herbert Read, A. L. Lloyd and Alick West. Klingender, a Marxist art historian who was to become author of, among other titles, *Hogarth and English Caricature* (1944), was the chief spokesman for the Association, helping to foster the belief that art is a form of social consciousness, and that as long as there are different classes, no single scale of aesthetic values will prevail. AIA exhibitions demonstrated this. Work by amateurs mingled with that of pro-fessionals; fine artists jostled with illustrators, cartoonists, commercial artists, designers and photographers. The binding factor was not any standard of aesthetic unity but a concern with facts. As Auden

103 William Coldstream, *W.H. Auden, c.* 1938

reminded Coldstream, in *Letters from Iceland* (1937): 'We'd scrapped Significant Form, and voted for subject.'

Though the AIA tolerated a wide variety of styles, it promoted realism. On a large scale, in murals, AIA artists tended to produce agit-prop, while on a smaller scale the work upheld their slogan, 'conservative in art and radical in politics'. Realism was, of course, the style best suited to the proletarian cause, and worker-artists, such as the coalminers' Ashington Group, were encouraged because lifelong experience of industry was felt to bring more realism to a subject than anything professional training could supply. Clive Branson (1907–44), though Slade-trained, adopted the earnest literalism of a naïve painter for his painting *Selling the Daily Worker outside the Projectile* 104 *Engineering Works*. Others turned their propaganda skills to the making of posters and banners to raise funds for Spain after the Spanish Civil War began in July 1936. The AIA also had skilled satirists in James Boswell (b.1906) and James Fitton (1899–1982)

104 Clive Branson, *Selling the Daily Worker Outside the Projectile Engineering Works*, 1937

105 Percy Horton,
Unemployed Man, 1936

whose work illustrated the *Left Review*. And when war broke out, a number of the AIA were given war artists' commissions and thus had further opportunity to concentrate on proletarian and industrial subjects.

It was the vicissitudes brought by peace not war that weakened the Association. Anxiety over Soviet intentions in Eastern Europe troubled its allegiance to the Peace Movement from 1947 until 1953, when the political clause in its constitution was deleted. It continued as an artist's organization until 1971, but was chiefly reduced to an exhibiting body and had little significance or direction. During the first twenty years of its existence, however, it had achieved a considerable amount: it drew attention to the artist's social role and broadened the audience for contemporary art; it fostered an interest in art in the provinces by touring exhibitions and forming regional associations; it executed murals on boarded-up shop windows and in government-run canteens; it published 'Everyman Prints', thereby making art as cheap and as easily available as a Penguin paperback. Above all, it created a climate in which realism could reassert itself. It exhibited portraits of unemployed men by Percy Horton (1897–1970). Low-key and unemphatic, they achieve dignity through restraint, affirming this artist's stated belief that 'one must paint from reality and with a human concern.'

106 John Minton, *Recollection of Wales*, 1944 (detail of 108)

CHAPTER SIX
NEO-ROMANTICISM
AND SECOND-WORLD-WAR ART

While interest in abstract art in Britain was still in the ascendant, Myfanwy Evans, in January 1935, produced the first issue of the magazine *Axis*. She had been encouraged to do so by the French abstract painter, Jean Hélion, and was assisted by John Piper whose second wife she became in 1937. Originally the magazine was to be the organ for the modern movement, paralleling the concerns of the Paris-based Abstraction-Création exhibition group. Eight issues were published in all. The list of its contributors was impressive and included Herbert Read, Geoffrey Grigson, Paul Nash and the architectural historian J. M. Richards. But the editorial policy, though intelligent, was inclined to waver. The magazine co-operated with the organization of the 'Abstract and Concrete' exhibition in the spring of 1936 and at the time seemed wholly committed to abstract art. Its next issue, produced during the summer of 1936, took account of the International Surrealist Exhibition and carried the sub-heading 'Abstraction? Surrealism?' In the editorial, Myfanwy Evans asserted her right to admire the work of both Nicholson *and* Max Ernst 'for itself – not as an act of faith or as a commitment to a line of behaviour'. From the abstract artists' point of view, there was still greater treachery in store. The seventh issue, which appeared in the autumn of 1936, carried an article entitled 'England's Climate', composed in two parts by Grigson and Piper. It openly declared battle on both abstraction and Surrealism. In their place, it asserted the virtues of the National Gallery, of Constable, Blake and Turner. What was needed, it said, was an art based on common humanity and made for the present: 'The point is fullness, completeness: the abstract qualities of all good painting together with the symbolism (at least) of life itself.'

The following year, 1937, Myfanwy Piper edited *The Painter's Object*, a confused and confusing publication, containing essays by Hélion, Sutherland, Ernst, Kandinsky, Léger, Nash and others, and which, in their different ways, upheld objective abstraction, a socially committed figuration and Surrealist disquiet. The impasse reached by these warring ideologies, and their effect on artists' behaviour, is satirized by Myfanwy Piper in her introduction:

Introduced to all the boys last night, to Picasso, Miró, Ernst and so on. No not Cocteau, not these days, because, of course, its not the

same (Diaghileff's dead) ... We are more serious now, not really playboys but agents ...
... we have got into the middle of not one but a thousand battles. Left, right, black, red (and white too, for the fools who won't take part and so constitute a battle line all of their own), Hampstead, Bloomsbury, surrealist, abstract, social realist, Spain, Germany, Heaven, Hell, Paradise, Chaos, light, dark, round, square. 'Let me alone – you must be a member – have you got a ticket – have you given a picture – have you seen *The Worker* – do you realize – can you imagine – don't you see you're bound to be implicated – it's a matter of principle. Have you signed the petition – haven't you a picture more in keeping with our aims – *intellectual freedom*, FREEDOM, *FREEDOM* – we must be allowed, we can't be bound – you can't, you must fight – you *must*. That's not abstract, sir – that's not surrealist, sir – that's not – *not*. Anything will do – send it along – the committee will hang it – sit on it – no, not him, he'll want his friends in – it's a matter of principle.'

What had been overlooked in all this mêlée of opinion? In John Piper's view it was the subject itself. He entitled his contribution to *The Painter's Object* 'Lost, a Valuable Object', and asked for a return, not just to representation but to objects *seen in their context*. 'It will be a good thing', he concludes, 'to get back to the tree in the field that everybody is working for. For it is certainly to be hoped that we shall get back to it as fact, as a reality. As something more than an ideal.'

Axis and *The Painter's Object*, therefore, heralded a return to the English landscape tradition modified by the experience of Surrealism. In *The Painter's Object* Paul Nash wrote on 'Swanage, or seaside surrealism', and praised it for having 'a strange fascination, like all things which combine beauty, ugliness and the power to disquiet'. Nash's heightened sense of atmosphere and feeling for place, his love of strange juxtapositions, his ability to perceive presences in natural objects and to uncover symbolic or associative meanings in landscape all contributed to the rise of neo-romanticism. He was praised by Myfanwy Piper in the last issue of *Axis*, published in the winter of 1937, for having a personal idiom, for standing apart from group pressures. This openly avowed belief in individualism was not restricted to the Pipers, who had the previous summer lent their house to the left-wing Group Theatre. Even the chief designer of the Group Theatre, Robert Medley (b.1905), felt, looking back on the period immediately following the 1930s, that 'the time for major commitment to co-operative ventures was gone'. When in January 1940 the magazine *Horizon*, which was to provide a platform for neo-romanticism, began, its editor Cyril Connolly bluntly announced: 'Our standards are aesthetic and our politics are in abeyance.'

In John Piper's case, that which helped loosen his allegiance to group efforts and turned him back to native traditions and a 'romantic'

style was an awareness of impending war. His interest in the topography and architectural riches of Britain had begun as a child; by the age of fourteen he had visited every church in Surrey. In 1938 he began to collaborate with J. M. Richards, editor of the *Architectural Review*, and with him travelled England, sketching, taking photographs and making notes for articles, not just on famous monuments but also pubs, lighthouses, harbours, forts and standing stones. He also enjoyed friendship with the poet John Betjeman who furthered his love of the demotic, his ability to find appeal in nondescript places. When Piper was invited to write the Shell Guide to Oxfordshire, he took Betjeman's *Cornwall* as his model, and the two friends collaborated on the guide to Shropshire. Betjeman's Anglicanism was also infectious: Piper became a confirmed member of the Church of England and as an artist has continued to haunt (in Betjeman's words) 'the cool hassock-scented interiors of country churches'.

Piper's return to representation had begun in 1936 with the making of collages. His subsequent move into a style that has been called the 'neo-picturesque' was partly fostered by his fascination with travel books illustrated with aquatints, and by a general revival of interest in past styles that had earlier produced Kenneth Clark's *The Gothic Revival* (1928) and Christopher Hussey's *The Picturesque* (1927). Piper had a strong sense of the historical, but the threat and eventual onset of war gave to his portrayal of Britain's architectural heritage a new drama and intensity. Not surprisingly, the success of these moody and romantic paintings lay in their appeal to patriotic sentiment; also, in Piper's ability to recapture past monuments for present-day imagination. In the hands of Rex Whistler, Algernon Newton (1880–1968) or Tristram Hillier, country houses appear as period curiosities, timeless and unreal. Piper treats them less kindly, shows their decline. ('Pleasing Decay' was the title of one article he wrote for the *Architectural Review*.) He specialized in ruins, finding the glory of Vanbrugh's Seaton Delaval especially suited to his taste. It sits overlooking countryside dotted with slag heaps and scarred with railway lines. 'House and garden', Piper has written, 'are seared by the east wind, and riven with fretting industrialism, but they still withstand the noise and neglect, the fires and hauntings of twentieth-century life.'

In keeping with his nostalgic romanticism, Piper employed a bravura technique. In his 1940s oils he often scratched into the paint so that the black background breaks through with sombre effect. This rough treatment can suggest the movement of wind, spasmodic light and the texture of weather-beaten stone. It also animates his picture surface and creates a spontaneity that some find factitious. There is an undeniably theatrical quality to his 1940s art. This was to

111

be further heightened by his designs for theatre and stained glass, and sometimes devolves into staginess. His facility can also lead to repetitious effects.

Whilst Piper was reviving the picturesque, Graham Sutherland (1903–80) was independently reviving landscape painting by the introduction of an emotional attitude, dark, Gothic and intense. Like Piper, his feeling for a particular place was heightened by an awareness of oncoming war. On 16 September 1938 he wrote to Paul Nash: 'We are in Pembrokeshire, alternating between enjoyment of the superb country and desolation as we scan the European horizon.' Sutherland found in the Welsh landscape not only images and motifs that became part of his personal language, but also an 'exultant strangeness' and 'an emotional feeling of being on the brink of some drama'. This he described in his 'Welsh Sketch Book' letter, first published in *Horizon* in 1942. Because he had already discovered in Wales a personal style, his admiration for the paintings by Miró and Picasso at the 1936 International Surrealist Exhibition did not overlay his debt to the English landscape tradition.

Sutherland had begun his career as an etcher, perpetuating idylls in a style heavily indebted to the example of Samuel Palmer. The collapse of the print market, following the Wall Street crash, had obliged him to change his medium. To earn money, he taught, designed posters, decorations for tea services and even a postage stamp (never used), but he also began to paint. He first visited Pembrokeshire in 1934 and returned every year, making small sketches and watercolour studies, working from these and from memory in the making of his oils, after he had returned to his house and studio in Kent. It is his small notational studies that best convey the urgency of his feeling in front of landscape. Here the stabbing pen and thinning ink or wash create shadows, hills and lanes which are often stitched together with a meandering black line. Foreground and far distance are brought into close juxtaposition, by use of the kind of spatial elisions that Samuel Palmer employed. But instead of Palmer's benign fertility, the mood is one of encompassing disquiet: elation and foreboding converge. Sutherland's Wales, mediated by Surrealism, is closer to Birnam Wood than to the Wales of Richard Wilson or J.D. Innes.

In 1943 John Craxton (b.1922) accompanied Sutherland and the arts patron Peter Watson to St David's Head, Pembrokeshire. He had been deeply impressed by two of Sutherland's watercolours painted around 1938 and now learnt from him, as he has said, 'how to look at landscape: ... his way of scrutinizing landscape showed me ... how to discover myself'. Like Sutherland, Craxton also allowed his awareness of the Surrealists, in particular Miró, Picasso, Ernst and André Masson, to shape his interpretation of nature. He produced a

107 John Craxton, *Poet in Landscape*, 1941

series in which shepherds or poets appear as solitary figures within landscape. 'They were my means of escape and a sort of self-protection . . . I wanted to safeguard a world of private mystery, and I was drawn to the idea of bucolic calm as a kind of refuge.'

This desire to create a timeless, mysterious space became a recurrent feature of war-time neo-romanticism. It surfaces in a key passage in Sutherland's 'Welsh Sketch Book':

To see a solitary human figure descending a road at the solemn moment of sunset is to realize the enveloping quality of the earth which can create, as it does here, a mysterious space, a womb-like enclosure which gives the human form an extraordinary focus and significance.

It also features in the pen and ink drawings of John Minton (1917–57) where the human figure is found almost buried beneath nature which, as in Craxton's drawings, seems to have a supernatural fertility. Minton's art is the more strained and elegiac. Whereas Sutherland's influence on Craxton was conjoined with that of Palmer and Blake, Minton, though he also admired Palmer, had spent eight months in Paris in close association with certain French neo-romantics, studying under Pavel Tchelitchev and admiring the brooding sadness in the art of Eugene Berman. He was for a period closely associated with another neo-romantic, Michael Ayrton (1921–75), who spent the summers of 1945 and 1946 in Pembrokeshire, where he was in contact

108

108 John Minton, *Recollection of Wales*, 1944

with Sutherland. Another artist also associated with this group is
Keith Vaughan (1912–78). Their work was illustrated in *Horizon*, 109
Studio, *New Writing and Daylight* and *Penguin New Writing*, where for a
time John Minton's designs decorated the front covers. Neo-romanti-
cism struck a rich vein in illustration, producing at its finest Craxton's
lithographs for Grigson's anthology, *The Poet's Eye* (1944), and
Minton's collaboration with Alan Ross on *Time Was Away* (1948).

In 1942 John Piper's *British Romantic Artists* was published. In this he
traced a romantic impulse through British art up to the work of Paul
Nash and Frances Hodgkins.

Romantic art deals with the particular. . . . [It] is the result of a vision
that can see in things something significant beyond ordinary signifi-
cance: something that for a moment seems to contain the whole
world; and, when the moment is past, carries over some comment on
life or experience besides the comment on appearances.

To some extent this interpretation reflects on the neo-romantics who,
though inspired by specific locations, were paradoxically concerned to

109 Keith Vaughan, *Fourth Assembly of Figures*, 1956

render the anonymity of place, a sense of aloofness, secrecy and an unlocated melancholy. From specific sites they distilled a universal terrain, less evocative of the countryside than of the artist's mental landscape.

At the time the term 'neo-romantic' was used by critics to refer to a broad spectrum of artists, all of whom identified with nature. For the critic Raymond Mortimer, Ivon Hitchens, Frances Hodgkins, Victor Pasmore and Henry Moore were to be included under this label. Kenneth Clark, writing on 'The New Romanticism in British Painting' in 1947, listed Sutherland, Piper and Moore as the leading figures, Frances Hodgkins, John Tunnard (1900–71), Robert Colquhoun (1914–62), Edward Burra and Francis Bacon (b.1909) as being to some extent under its influence. Only later did the term 'neo-romanticism' take on more specific meaning, referring to a revival of interest in landscape and the influence of Graham Sutherland.

It was a movement fuelled by nostalgia and inclined towards the melodramatic. But it provided an appropriate style for wartime

133

110 Graham Bell, *Bolton*, 1938

subjects, and was used by Sutherland to portray scenes of devastation, the unnatural light conditions in Cornish tin-mines, steel foundries and open-cast quarries. Working on a small scale, on the spot, in media that allowed for swift notations, scratchy and spontaneous, he drew upon a vocabulary of form, line and texture that he had coined in Wales. From these sketches he would work up larger, finished studies. Similarly, the theatrical element in neo-romanticism served John Piper well when he painted the effects of the German 'Baedeker raids' on cities like Bath, rich in architectural history. All of these 'ruin' pictures are devoid of human incident. It is as if the destruction of the British cultural heritage, in all its inverted glory, was too profound to invite narrative treatment. Instead it provided Piper, searching for the melancholy eloquence of place, with his most appropriate subject.

It was hard for war artists to resist this style. William Scott (b. 1913), who had begun painting still-lifes indebted to Parisian examples during the late 1930s, now found himself 'caught up in a wave of the English watercolour nationalist, romantic patriotic isolationist self-

113

111 John Piper, *Seaton Delaval*, 1941
112 Graham Sutherland, *Welsh Mountains, c.* 1938

113 Graham Sutherland, *Tin-mine: Emerging Miner*, 1944

114 Edward Ardizzone, *Naval Control Post on the Beaches, Normandy, 1944*

preservationist movement.' He drew and painted fugitive, personal moments snatched from within the impersonal mechanism of war. Much Second-World-War art was unambitious. Alan Ross has observed, of the work of R. V. Pitchforth: 'What is missing . . . is the human dimension: the tragic sense that questions and analyses.' But if the artist's response was circumscribed, circumstances were largely to blame. Commissions came via the War Artists' Advisory Committee, chaired by Kenneth Clark, which transformed war artists into a privileged breed: they were made honorary Captains, given the use of cars and other forms of travel. For them it was, as the watercolours of 114 Edward Ardizzone (1900–79) suggest, a cosy war. Many commissions ensured that artists were removed from the fighting and only ever saw the home front, depicting factory production, steel and quarry workers. Those that did follow in the wake of army or naval battles did so from a position of relative comfort and security.

Nevertheless three artists did lose their lives: Thomas Hennell (1903–45) disappeared in Burma; Eric Ravilious in 1942 took off on a reconnaissance flight in Iceland on a plane that never returned; and Albert Richards (1919–45) was killed crossing a minefield in a jeep. The dangers, though real, were often deceptively distant: battles were fought at long range and the bomber pilots rarely saw the results of their task. Inevitably this new perspective affected artists' interpretation. As Alan Ross has observed, machines were on the whole regarded with more curiosity than men. The horror and pity of war

137

were now too familiar to make necessary the savage anti-heroic message that Nevinson had put into some of his First-World-War paintings. Most artists regarded the 1939–45 war as a fact and necessity, not a political crusade. Like the poetry of this period, the mood was low-key, the stance not one of protest but passive and celebratory. The war was to be accepted, endured and observed.

The War Artists' Advisory Committee, set up in November 1939, met weekly and was not short of funds. Thirty artists were given full-time salaries, usually for periods lasting six months. A hundred more received specific commissions, and a further two hundred had their work bought. This was then housed in the Imperial War Museum or donated to public art galleries at home and in the Commonwealth. From the WAAC records that exist, also located within the Imperial War Museum, it appears that artists frequently complained at being kept at a distance from crucial events. Though their brief was to 'record the War', they were kept from precisely that which would have given their art relevance and bite. Before long the term 'War' was amended to 'wartime activities' and still gentler subjects became acceptable: the escape of a zebra from the zoo, for example, canteen concerts or the jam-making activities of the Women's Institute.

When a roomful of recent pictures by war artists went on show at the National Gallery in 1943 one critic complained that they lacked

115 Albert Richards, *The Drop*, 1944

war consciousness. Even Kenneth Clark later admitted that the general level of work was mediocre and tame. Albert Richards's oils and watercolours are impressive less for their formal inventiveness than for their immediate, vivid depiction of battle fields and crashed gliders. Other artists, more obviously working with neo-romantic styles – Sutherland, Piper, Frank Dobson, Scott, Keigh Vaughan and Leonard Rosoman (b. 1913) – successfully conveyed nocturnal scenes of the Blitz, the hellish light of furnace or foundry, or the torpor of troops confined to their barracks.

One artist whose work for the WAAC attained both documentary and visionary significance was Henry Moore. Travelling home on the

116 Henry Moore, *Platform Scene*, from *The Shelter Sketchbook*, 1941

117 Charles Cundall, *The Withdrawal from Dunkirk, June 1940*
118 Paul Nash, *Totes Meer*, 1941

London underground one night, he was struck by the sight of rows of figures sheltering from air-raids on the underground platforms and passages. Though Moore made lists detailing the components that made up this scene, his 'shelter drawings', composed from memory, evoke not particularities but some essential human condition. The art critic John Russell has discerned in them a 'dreadful passivity' and notes how the blankets look like winding sheets. In 1942 Moore began another series of drawings for the WAAC, on coal-mining, again responding to direct observation and distilling from it haunting images of harsh labour in cramped surroundings.

At the request of other government departments, the WAAC was obliged to stress the need for accurate records. This favoured the illustrators, among them Edward Bawden, Barnett Freedman (1901–58), Ardizzone and Anthony Gross (b. 1905). As Linda Kitson's recent drawings of the Falklands War demonstrate, a journalistic style of drawing satisfies a love of anecdote which, in time, takes on nostalgic appeal. This particular tradition is best described by Edward Bawden, in relation to the art of Anthony Gross:

Fresh observations and quiet humour; unpretentious and good; the school of Ardizzone and Topolski – the sound tradition of English draughtsmanship and illustration which harks back to Rowlandson and Bunbury, don't you agree?

Those who worked in less obviously illustrative styles were less easy to accommodate. Kenneth Clark and the WAAC's secretary E. M. O'R. Dickey both stressed the need for artistic merit, but the Air Ministry preferred the glacially photographic productions of Frank Wootton (b. 1911) to the affective but technically inaccurate aeroplanes drawn and painted by Paul Nash. The balance required, between the historical and the aesthetic, was not easy to achieve, and much Second-World-War art falls into one camp or the other, leaving us a choice between the documentary realism of *The Withdrawal from Dunkirk* by Charles Cundall (1890–1971) and Paul Nash's symbolist interpretation of wrecked fuselage, *Totes Meer*.

What is noticeably absent in Second-World-War painting is any record of human suffering. As a result, the impression remains that the WAAC, despite its dedication and energy, produced much that remains a mere footnote to the history of this war. As with Vietnam, indelibly linked in people's memories with the image of a fleeing child, naked and sprayed with napalm, the most dramatic visual record of the 1939-45 war is photographic. It was the photographs of concentration camps, such as those taken by Lee Miller, Roland Penrose's wife, that changed human consciousness, and their impact must be registered in the chapter that follows.

119 Lucian Freud, *Narcissus*, 1947–48

CHAPTER SEVEN
REALISM AND ANGST
IN THE POST-WAR YEARS

Austerity and anxiety are words often applied to the decade immediately following the Second World War. Feelings of victory, or of happiness and relief at the return to peace, were overshadowed by the extent of the recent atrocities and by the implications of the atom bomb. Photographs of concentration camps, as found by the liberating troops, appeared in the press, contributing to the pessimism that underlay this period, which was outwardly one of progress, planning and renewal, even though economic difficulties hindered the Labour Government's attempts at social reform.

One important advance for the arts was the transformation of CEMA (Council for the Encouragement of Music and the Arts) into the Arts Council. Under its new constitution of 1946 it was empowered to give money to artists and companies instead of merely providing guarantees against loss. It also mounted exhibitions, some of which toured the provinces. And as its budget increased over the years the extent and influence of its patronage grew. But greater and more consistent support for the visual arts did not allay the depression and unease that began to surface in representations of the human figure. This image was now ~ "ly conceived as noble and authoritative, but anxious, indefensi nomentary and inconsequent. Cyril Connolly closed down *Horizon* in 1950 with an editorial that contained these famously gloomy words: 'from now on an artist will be judged only by the resonance of his solitude and the quality of his despair.'

Two artists Connolly may have had in mind were Francis Bacon and Lucian Freud (b. 1922). Both, in their life and their art, cut away the padding, the accoutrements and conventions of any restrictive orthodoxy. They have concentrated on the human figure found, often alone, in a bare interior, neither diminished nor enhanced by the kind of data which, suggesting social or professional rank, would distract from the raw facts of existence. The approach is merciless, extreme, Bacon in particular excelling at discomfort and observing that nobody has ever bought one of his much-sought-after paintings because he or she liked it. Both artists can be associated with a loosely amorphous group which has been labelled the 'School of London'. This, if it has a centre, can be linked with the Colony Room, a private club over an

124

120 Muriel Belcher

121 Francis Bacon, *Three Studies for Figures at the Base of a Crucifixion*, c. 1944

Italian trattoria in London's Dean Street which, until her death in
120 1979, was presided over by Muriel Belcher, perched perennially on a
bar stool and given to unrelenting abuse. Among her clientèle can be
listed Bacon, Freud, Minton, Craxton, Vaughan, Burra, Michael
Andrews (b.1928) and Frank Auerbach (b.1931).

Francis Bacon began his career as an interior decorator and designer
of steel-and-glass furniture and Art Deco rugs. He first turned to
painting around 1930, and by 1933 had attracted sufficient interest for
a crucifixion of his to be reproduced in Herbert Read's *Art Now*. But
his first one-artist exhibition, held the following year, did so badly
that, discouraged, he largely wasted the rest of the decade. Apart from
three paintings included in a mixed exhibition at Agnew's in 1937, he
did not show again until 1945. By then he had once again become
obsessed with painting, having been released from other obligations
during the war by his asthma.

What caught public attention at the Lefevre Gallery's exhibition in
121 April 1945 was Bacon's *Three Studies for Figures at the Base of a
Crucifixion*, which had been painted the year previously. The figures,
influenced by Picasso's biomorphic forms of the 1920s, become the
Eumenides, the grim, inhuman Furies who pursue Orestes in Aeschy-
lus's *Oresteia*. The animal-like bodies have human mouths, open and
howling, and almost certainly inspired, as the art historian Dawn
Ades has shown, by the writings of Georges Bataille, in particular a

122 Francis Bacon, *Study of Henrietta Moraes*, 1969

short text published in *Documents* (no. 5, Paris, 1930) and illustrated by
J. A. Boiffard's photograph of a screaming mouth. Bataille writes:
'On great occasions human life is concentrated bestially in the mouth,
anger makes one clench one's teeth, terror and atrocious suffering
make the mouth the organ of tearing cries.' To a post-war audience,
these ghoulish celebrants of murderous acts were a horrific reminder
of human bestiality. The art critic John Russell has discerned in these
figures 'a mindless voracity, an automatic unregulated gluttony, a
ravening undifferentiated capacity for hatred'. In this and subsequent

123 Lucian Freud, *Naked Girl with Egg*, 1980–81

examples of Bacon's art, Herbert Read noted a decision, not to create a formal harmony to compensate for spiritual chaos, but to express that chaos itself in images vital and uncompromising. For Read, Bacon uncovered 'symbols of a disintegrating world, of a paranoic consciousness'.

In his work of the late 1940s and early 1950s Bacon frequently made use of an expressive handling which blurs detail and disquietingly muffles his subject. In 1951 he pursued further his obsession with the gaping mouth in a series of paintings based on the pope. In these he

124 Francis Bacon, *Self Portrait* (detail), 1970

drew upon a famous still from the Odessa Steps sequence in Eisenstein's *Battleship Potemkin,* showing the face of the screaming nursemaid, and married this with a memory of Velásquez's *Portrait of Innocent X,* a painting he greatly admires. Other sources for the motif of the open mouth can be traced to Poussin's *The Massacre of the Innocents* and a book on diseases of the mouth which Bacon acquired second hand.

Bacon's popes, like all his figures, are found in a moment of crisis, as if pushed to the edge of endurance. Some are trapped within a glass frame, which heightens their isolation. In other paintings Bacon,

drawing upon another book in his possession – *Positioning in Radiography* – resorts to diagrammatic devices to focus attention on specific parts of the anatomy. His aim is to create images that communicate directly with the nervous system, which 'unlock the valves of feeling and therefore return the onlooker to life more violently'. He dislikes 'illustration' and in order to avoid it places great emphasis on the importance of chance and risk. In an interview with David Sylvester he quoted Paul Valéry's remark that what people want from art is 'the sensation, without the boredom of its conveyance'.

In the late 1950s, in order to keep predictability at bay, Bacon began to contort appearances. For him, this had no semantic relevance. 'I've nothing to say about the "human condition",' he is on record as saying. 'What gives the pictures their desperate look, if they have one, is the technical difficulty of making appearances at the present stage in the evolution of painting. If my people look as if they're in a dreadful fix, it's because I can't get them out of a technical dilemma.' He is equally definite that the occasional use of such details as a Nazi armband or a hypodermic syringe play a purely formal role, in the case of the latter helping to nail the figure into position. For the viewer, the connotations attendant on these details may be less easy to suppress.

It is, however, necessary to accept Bacon's repeated assertion that the violence in his art is not in the subject matter but in the struggle to remake reality on canvas. Because film and photography have appropriated narrative and illustration, Bacon feels it necessary to look for non-illustrational methods, for more extreme solutions. This is most clearly seen in his portraits which, like his figure paintings, often take the form of triptychs. As if testing his sitters, who are usually his friends (friendship being for Bacon where 'two people really tear one another apart'), he pushes likeness away, distorting certain features almost beyond recognition before pulling the image back by the introduction of a recognizable expression or look. Subjected to this treatment, the face appears malleable, as if stilled in movement; the sweep of the brush across a cheekbone acts like the bruising of flesh with a fist.

Freud also prefers to paint only those he knows well. 'If you don't know them,' he has said of the artist in relation to his or her sitter, 'it can only be like a travel book.' A grandson of Sigmund Freud, he came to Britain in 1933 and in his earliest paintings drew upon memory and imagination, recreating that intensity and distinctness associated with childhood experience. In 1939 he became a pupil at the East Anglian School of Painting and Drawing run by Cedric Morris and Arthur Lett-Haines (1894-1978). In keeping with Morris's anti-academic approach, what the pupil felt about appearances mattered

122

125 Prunella Clough, *Fishermen in a Boat*, 1949

126 John Bratby, *Table Top*, 1955

more than what he or she saw: drawing, dictated by feeling, could employ emotive distortion. This Freud developed in his portraits and figure paintings of the late 1940s and early 1950s, bringing to this technique an extreme subtlety and psychological penetration.

The long term development of his work had, however, been signalled in two small paintings executed in 1946: *Lemon Spray* and *Tangerine*. In these, that which unsettles and surprises is the intensity with which he has realized the actual. When, in the second half of the 1950s, he changed his technique, abandoning sable for hog's hair brushes, glazes for paint made dense and opaque by the addition of Kremnitz white, he simultaneously exchanged emotive distortion for

a relentless objectivity, a probing intimacy that unveils every detail of physical existence. Freud has said that he wants his paintings to be *of* 123 people, not *like* them. For Lawrence Gowing they reflect 'a condition of private loneliness'. Rarely nowadays does the sitter's gaze meet the eye of the spectator. Instead they pose with their personalities withdrawn, so that there is no release from the artist's particularization of hair, flesh, veins and skin.

Both Bacon and Freud have pitted themselves, not against their contemporaries, but against the European Old Master tradition. Similarly Graham Sutherland, who in 1947 began spending several months of each year abroad, in the South of France, no longer saw himself as a descendant of Samuel Palmer, but aimed to achieve through his study of nature what Picasso had done with the human figure. Earlier, in 1938, when *Guernica* and studies for it were exhibited in London, Sutherland had learnt from Picasso that in order to bring out the emotive quality of a subject the artist must paraphrase appearances. In his post-1945 work, Sutherland refashions nature, transforming rocks into womb-like conglomerates, thorn bushes into crucifixions or a crown of thorns. Often situated within an indetermi- 127 nate space, his writhing forms create knots of interest, like small stings of hate. A similar undercurrent of brutality can be discerned in his portraiture, in the harsh characterization which, once the initial affront has worn off, is often subtly flattering.

Picasso, with his omnivorous creativity, his humane themes and new-found political beliefs, was the dominating European influence on British art during the post-1945 period. He and Matisse were the subject of an exhibition held at the Victoria and Albert Museum during the winter of 1945–46. This exhibition effectively put an end to the inward-looking melancholy and nostalgia that had characterized neo-romanticism. A new formal and decorative strength, together with an interest in workaday subjects, replaced it. Picasso's influence lies behind John Minton's paintings of Rotherhithe, produced shortly before his tragically early death in 1957. It also stiffened and brought new vigour to the work of two Glaswegians, Robert Colquhoun and 130 Robert MacBryde (1913–66). Their stylized figures and still-lifes, in a semi-Cubist style, derived from Picasso. One form is very consciously locked into the next, playing its part in the whole; even shadows are sharp and substantial. The mood, especially in the work of Colquhoun, is tense and sombre, his colours close-toned and deliberately murky. A similar stringency, a grappling with reality through the medium of design, characterizes the work of Prunella Clough (b.1919). A friend of Minton, Colquhoun and MacBryde, she painted fishermen at Lowestoft, lorry drivers in their cabs, industrial 125 workers in various settings. As her work progressed the figures

127 Graham Sutherland, *Thorn Cross*, 1954

disappeared, but the interest in the industrial landscape remained. Influenced by the ideas from America that infiltrated British art during the late 1950s and 1960s, she turned to abstraction, using as her starting point traces, signs and fragments drawn from the urban wasteland: gates, wire, signals, a discarded industrial glove.

Clough was not alone in her preference for working-class subjects. The Polish refugee Josef Herman (b. 1911) had settled in 1944 at Ystradgynlais, a small mining village in South Wales where he

remained for the next eleven years. He favoured light effects which simplified contours and heightened the monumentality inherent in the landscape. As a young man he had drawn his subjects from the Polish workers, and in Wales he immediately identified with the miners after watching them walk home at sunset, their black figures silhouetted 131 against the sun: 'This image of the miners on the bridge against that

128 Frank Auerbach, *Portrait of Catherine Lampert*, 1981–82

glowing sky mystified me for years with its mixture of sadness and grandeur.' Before moving to Wales, he had spent a period in Glasgow where he befriended a young art student called Joan Eardley (1921–63). She, too, was drawn towards the working class, and moved into a Glasgow tenement slum where she painted and drew children. Her expressionist style is less static than Herman's, more dependent on

132

129 Leon Kossoff, *View of Hackney with Dalston Lane, Evening*, 1975

speed of execution. This served her well when in 1956 she acquired a house and studio at Catterline, a fishing hamlet on the north-east coast of Scotland, and there, outdoors, painted angry seas under leaden skies.

Much 1950s figurative painting makes a virtue of work, the very brushmarks displaying effort and commitment. The effort, however, was primarily visual and muscular, not philosophical or intellectual. To some extent interest in workaday subjects was a fashionable concern, and a continuation of the 1930s interest in working-class

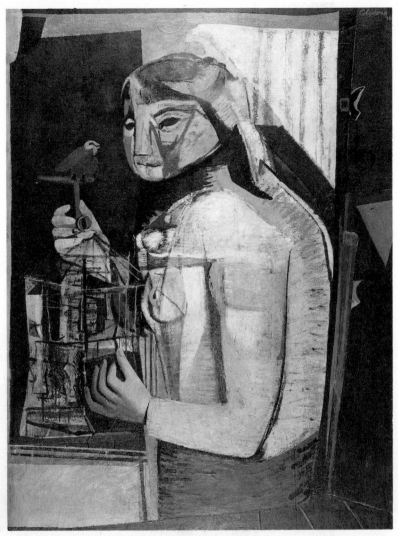

130 Robert Colquhoun, *Woman with a Bird Cage*, 1946

conditions, recorded by Mass-Observation, by documentary photographers such as Humphrey Spender, Edith Tudor-Hart and Bill Brandt, and in George Orwell's *The Road to Wigan Pier*, published in 1937. The Artists International Association still had a body of members committed to portraying proletarian subjects, and in 1942 one of its leading spokesmen, F. D. Klingender, had published *Art and the Industrial Revolution*.

131 Josef Herman,
Evenfall, Ystradgynlais,
1948

132 Joan Eardley,
A Glasgow Close

133 Edward Middleditch, *Cow Parsley*, 1956

Perhaps the most significant realist paintings to be produced in the early 1950s were those by the Kitchen Sink School, a term coined by the art critic David Sylvester in 1954. The artists usually associated with this label are John Bratby (b. 1928), Jack Smith (b. 1928), Derrick Greaves (b. 1927) and Edward Middleditch (b. 1923). Like their counterparts, the novelists and playwrights labelled 'Angry Young Men', the movement was provincial in origin: Smith and Greaves grew up in the same street in Sheffield, and Middleditch, who visited this town at Greaves's invitation, based a series of paintings on it. The choice of dour subjects, gutsily handled, caused affront, as did the anger and frustration expressed by Jimmy in John Osborne's play *Look Back in Anger*, first performed in 1956. Instead of tasteful still-lifes, Bratby painted dustbins, milk bottles, beer bottles, cornflake packets, the clutter and debris of ordinary domestic life.

133
134

126

Just how left-wing this art was is a question still open to debate. Few painted with the political pugnacity that the French-born Peter de

135 Francia (b. 1921) put into his *Bombing of Sakiet*, based on a terrorist raid by the French air force on a small Tunisian village during the Algerian war. But even at their most mute, as in Jack Smith's *Mother Bathing Child* (Tate Gallery) there is a sense of strain and melancholy. When John Bratby temporarily turned to novel-writing after the arrival of American Abstract Expressionism eclipsed his reputation, he argued in *Breakdown* (1960) that his generation of painters had expressed the tensions and unrest of an age conscious of the atom–bomb threat.

Kitchen Sink painting, though locally inspired and provincial in origin, was related to a larger, European move towards realism. The British artists were aware of the Italian social realists associated with

134 Derrick Greaves, *Sheffield*, 1953
135 Peter de Francia, *The Bombing of Sakiet*, 1955–58

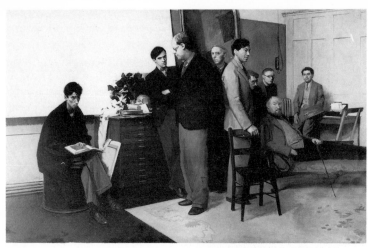

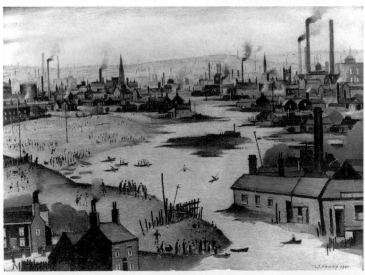

136 Rodrigo Moynihan, *Portrait Group*, 1951

137 L.S. Lowry, *River Scene*, 1942

138 Carel Weight, *The Moment*, 1955

139 Ruskin Spear,
River in Winter, 1951

the gallery La Colonna in Milan, chief of whom was Renato Guttuso
whose work was first shown in London at the Hanover Gallery in
1950. They were also aware of the French realists, among them
Bernard Buffet, André Minaux, Ginette Rapp and Paul Rebeyrolle,
some of whom were included in the exhibition 'Four French Realists'
organized for the Arts Council by Quentin Bell and shown at the Tate
in 1955. Moreover in Britain the search for a realist style was
widespread and not confined to the Kitchen Sink artists, though it was
they, together with Ivon Hitchens and the sculptor Lynn Chadwick
(b. 1914), who represented Britain at the Venice Biennale in 1956.

The critic who did much to promote this art was John Berger (b. 1928), himself a painter. In the *New Statesman* Berger praised figurative realists at every opportunity. As a Marxist, he was alert to the ideological implications of style but in the 'Looking Forward' exhibitions, held at the Whitechapel Art Gallery in 1952, 1953 and 1956, no strict party line curtailed his selection of artists. Academic naturalists such as Rodrigo Moynihan (b. 1910) and Claude Rogers jostled with Kitchen Sink realists; industrial landscapes by L. S. Lowry (1887–1976) and Sickertian cityscapes by Ruskin Spear (b. 1911) hung alongside South London scenes by Carel Weight (b. 1908), whose streets and parks are sometimes haunted by the supernatural. However, after 1956 Berger's appreciation became more critical as his political attitudes hardened. The basis of his criticism was the question: 'Does this work of art help or encourage men to know and claim their social rights?' In answer to this question, Berger was obliged to argue that the work of certain artists whom he had previously praised was 'useless'. Gradually his interest moved away from art criticism to independent texts often written in relation to photography. Yet in 1984, looking back on the 1950s attempt to establish a realist theory and practice, he retained the conviction that 'we were not dupes. By intention, with imagination, and with clumsy anger and dreams of those who see what the privileged ignore, we were close to those without power.'

Figurative art was vigorously promoted during the 1950s by the dealer Henry Roland and by Helen Lessore at her Beaux-Arts Gallery. As recalled by John Bratby, the Beaux-Arts 'was a dry and unhappy place, concerned not with the joy of life and its presentation in oils, but with the misery of the soul, Angst, the Human Predicament, Man's Condition, ugliness and truth.' Helen Lessore mounted exhibitions by Bratby, Smith, Middleditch and Greaves, as well as ones by Freud, Bacon, Michael Fussell (1927–74), Auerbach and Leon Kossoff (b. 1926). The two last were pupils of David Bomberg, whose expressionist method had developed during the 1920s and 1930s. Between 1945 and 1953 Bomberg taught part-time at the Borough Polytechnic in London, having previously been rejected by the Slade and numerous other institutions of various kinds. His teaching was regarded with suspicion because it opposed normal academic methods: he taught his students to aim, not at accuracy, correct measurement or finish, but at an organic structure expressive of what he called 'the incomprehensible density of cosmic forces compressed into a small space,' or, put more simply, 'the spirit in the mass'. Once the student had achieved an 'idea' about the thing drawn, he or she proceeded to make 'throws' at the parts that composed the whole. The movement of the line was to equate with the movement of the eye as it

ranged over the subject, and thus expressed the artist's involvement with it. As a result the drawings and paintings produced under Bomberg's influence represented less a window onto the world than an existentialist expression of being in the world.

Those that responded to Bomberg's teaching formed an embattled unit against the techniques and attitudes that prevailed elsewhere. Between 1947 and 1950 they exhibited under the title Borough Group, and between 1953 and 1956 under the title Borough Bottega. The classes themselves throve on a spirit of radicalism. Frank Auerbach has recalled the atmosphere of research that predominated, how Bomberg rejected anything that was artificial or concocted. Auerbach welded Bomberg's teaching to contemporary subject matter, basing a series of paintings on building sites. Others, on specific north London scenes, are subjected to a welter of brushmarks, some zig-zagging violently into space as if to cancel out the emerging image. The balance between coherence and chaos is kept on a knife edge. In certain of Auerbach's portraits, however, this fierce expressiveness can give way to gentle allusion and subtle colouring.

140 Frank Auerbach, *Primrose Hill*, 1967–68

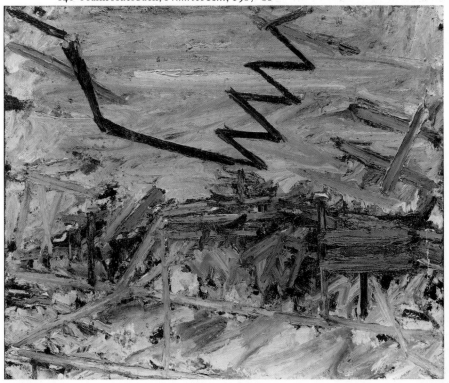

The danger of this kind of art is that its insistent subjectivity can appear solipsistic: its emotive handling guarantees a fullness of means but not always of content. Nevertheless no other post-war artists come remotely near Auerbach and Leon Kossoff in their portrayal of the shuddering sprawl of London, with its changing atmosphere and sudden illuminations. Kossoff has produced one series of works based on the grey environment of Kilburn underground station and another on views of Hackney, treated with restless attack, the paint dripped, 129 dragged, flicked or coagulated, leaving the impression that the surface of the canvas is still moving, heaving and re-forming like boiling tar.

British sculpture of the late 1940s and 1950s was also undergoing change and coming to terms with the more complex post-war attitude to the human figure. The monumentality and assurance that clung to Henry Moore's reclining figures was not sympathetic to a younger generation of sculptors who came to the fore in the early 1950s. To Moore's supporter Herbert Read, the work of Reg Butler (1913–81), Kenneth Armitage (b. 1916) and Lynn Chadwick seemed convulsive and fragmented, full of Kafkaesque imagery, suggestions of snares, teeth and claws.

Chadwick's *Inner Eye*, with its piece of rough crystal precariously 141 held in balance within a cage-like iron structure, is certainly spiky and disquieting. But its use of symmetry and the tapering elegance of line alerts us to the purely formal considerations that helped shaped the whole. Chadwick went on to make a series of sculptures based on animals, and again playfulness mingles with the grotesque. He constructed these sculptures out of steel rods and then filled in the surfaces with stolit, an industrial medium made of gypsum paste and powdered iron that sets rock hard. When he moved on again and introduced the human figure into his work it was semi-transmogrified into a bird. With arms expanded into wings and legs like tapered spikes, these creatures appear to have alighted on the plinth or ground and are at any minute ready to take off.

This sense of the momentary and of fragility owed much to the work of Giacometti, whose influence during the immediate post-war period almost equalled that of Picasso. Photographs of his work had appeared in *Cahiers d'art* during the late 1940s: he contributed three articles to *Labyrinthe* in 1945 and 1946; and in 1948 he had an exhibition in New York which provoked enormous discussion. In London, he was honoured with a retrospective in 1955 and was tirelessly promoted by the critic David Sylvester.

In the aftermath of Belsen, Buchenwald and Auschwitz, Giacometti's rejection of Surrealism for a view of man, vulnerable, anguished, the object of doubt, gained immediate acceptance and coloured the

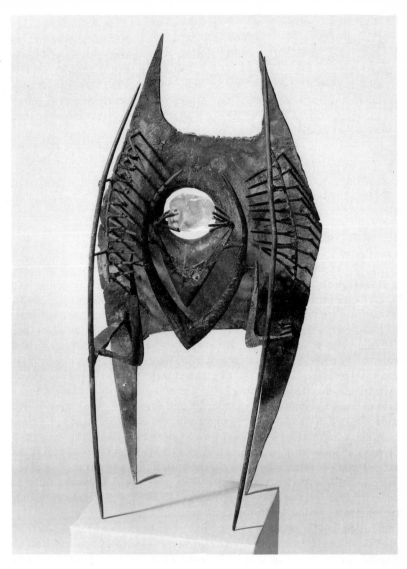

141 Lynn Chadwick, *Inner Eye (Maquette III)*, 1952

142 critics' interpretation of other work of this period. Kenneth Armitage
began merging one figure with another, eventually making an organic
unit out of the group, and indicating only as many heads or limbs
as he felt necessary. These groups, thematically titled 'People in
the Wind', are composed on the slant, suggesting movement and
urgency. Again, critics were quick to find in these unpretentious

165

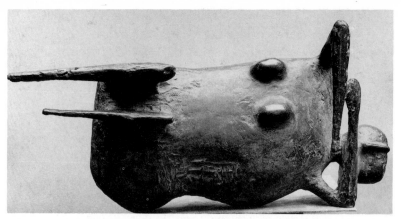

142 Kenneth Armitage, *Figure Lying on its Side (No. 5)*, 1957

works an expression of the human predicament, of struggle and the need for communal endeavour.

Like Giacometti, the leading British sculptors of this period chose to work through modelling or welding rather than carving. In a series of iron sculptures Reg Butler reduced the human figure to a taut arrangement of linear abstract forms. In 1952 he submitted an open construction to the competition for a monument to the Unknown Political Prisoner and won a prize. His original maquette (now destroyed) was enlarged into a working model, though the actual monument, intended to be over three hundred feet high, was never made: the Cold War was at its height and Butler's monument, praising the fight for freedom against political tyranny, would have seemed a deliberate taunt to the Soviet Union with its network of labour camps. Though John Berger thought the winning entries disappointingly abstract, Butler had intended his construction to contain allusions to the cage, scaffold, cross, guillotine and watch tower.

Bernard Meadows (b. 1915) at this time was producing sculptures abstracted from the image of the crab which convey menacing aggression. His pupil, Elizabeth Frink (b. 1930), was specializing in dead or wingless birds. A similar sense of the macabre can be found in Michael Ayrton's 'Minotaur' series. Ayrton, a polymath, began to work in sculpture in the early 1950s and received encouragement from his friend Henry Moore. His interest in classical culture (he advised on a film on Greece, co-directed another on Greek sculpture) fed his interest in myths. He brought an essentially modern interpretation to the Minotaur's search for release from the maze. This theme obsessed him during the greater part of the 1960s and reached a climax in the

143

144

143 Reg Butler, working model for a monument
to the Unknown Political Prisoner, 1955–56

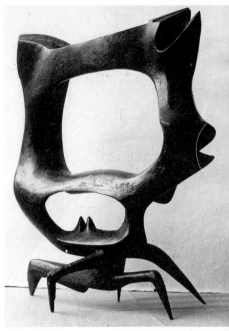

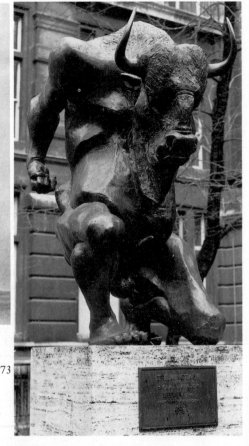

144 Bernard Meadows, *Black Crab*, 1953

145 Michael Ayrton, *Minotaur*, 1973

Arkville Minotaur; the original cast was made for the Arkville Maze
on the Erps estate, in the Catskill Mountains in New York state,
which is said to be the largest labyrinth built since antiquity, and was
commissioned by the late Armand G. Erps of New York. A second
version can be found in Postman's Park near the Guildhall in London. 145

The only sculptor who during the 1950s directly confronted the
issue of war was George Fullard (1923–73). He had been severely
wounded when trapped in a tank during the battle for Cassino. Much
of his work springs out of the joint inspiration of childhood memories 146
and war-time experience. He worked by modelling and through
assemblage: a wooden golf club becomes metamorphosed into a
child's foot, a row of clothes pegs into a horse's mane. The battle he
portrays in his art may be a child's game, but the motif of the tank gun
recurs, making the whole an amalgam of wit and terror.

146 George Fullard, *The Infant St George*, 1962–63

147 Peter Lanyon, *Bojewyan Farms*, 1951–52 (detail of 154)

CHAPTER EIGHT
A RETURN TO ABSTRACTION

Alongside the various figurative styles practised during the 1950s ran a sustained interest in abstraction. It was fostered by the historic moment and by particular exhibitions and publications. In America abstract art, which had been condemned by Hitler and Stalin, was associated with a 'free' society, and realism with the regimentation of a totalitarian state. In England, while the Cold War lasted, this ideology may also have had a surreptitious influence. If so, equally important was the desire to escape provincialism and insularity, to place British art once more on a par with international developments.

The centre for abstract art in the 1930s had been Hampstead, but with the onset of war its coterie of talent dispersed. Ben Nicholson and Barbara Hepworth hurriedly accepted an invitation from Adrian Stokes and his wife the artist Margaret Mellis to take refuge in their house at Carbis Bay, near St Ives in Cornwall. Soon afterwards Naum Gabo also moved from London to St Ives. His presence, together with that of Hepworth and Nicholson, transformed the small town into a vital centre for modern art. It was here that modernist and native traditions merged, abstraction combining with a sense of place.

St Ives, with the nearby Newlyn, had been an artists' haunt since the 1880s. One of the attractions was a light which, reflected off the sea on three sides of the St Ives peninsula, gives to the town an unusual clarity. In addition, the sail-lofts, left empty by the declining fishing industry, made excellent studios and this encouraged the artists to congregate in the old narrow streets of the Downalong area. By the 1920s enough paintings were being sent from St Ives to the Royal Academy each year to fill an entire railway carriage.

Before the arrival of Gabo, Hepworth and Nicholson, St Ives painting was direct and traditional, loosely impressionistic. After 1939 dependence on observation gave way to an emphasis on construction; the artists, no longer concerned with recording appearances, tried to convey the sensations experienced while tobogganing, gliding or moving through landscape. The artist no longer stood outside nature but strove to become one with it.

This fusion of subject and object owes much to the example of Naum Gabo, ironically the artist outwardly least affected by the Cornish landscape. His influence can be felt in the work of John Wells

(b.1907), Wilhelmina Barns-Graham (b.1912) and Peter Lanyon (1918–64), all artists associated with St Ives before 1946, the year that Gabo left for America. Using clear perspex and transparent thread, Gabo made visible the normally invisible, the intersection of two planes: movement could now be studied from within. Inspired by his example, Barns-Graham, in a series of paintings based on glaciers, aimed at bringing 'all angles at once, through, and all round, as a bird flies, a total experience.' Hepworth, for whom St Ives and its surroundings were to be a lasting inspiration, was at this time tunnelling into her carvings, bringing interior and exterior into active dialogue. And Lanyon, Cornish born and deeply familiar with its landscape, began in his paintings of landscape to excavate its surface in order to reveal mine shafts or womb-like cavities.

After the war, artists began to migrate to St Ives during the summer in large numbers, some making it their permanent home. Among those who during the 1950s were in some way associated with this area were Terry Frost (b.1915), Roger Hilton (1911–75), Patrick Heron (b.1920), William Scott (b.1913), Bryan Wynter (1915–75) and Alan Davie (b.1920). What united these artists was a commitment to the town and its surrounding landscape and an astringent pursuit of abstraction. They formed an avant-garde, locally inspired but becoming internationally renowned, producing an art which placed more emphasis on the artist's feeling and encounter with his or her materials than on external referents, and which therefore offers a parallel with American Absract Expressionism.

The 'St Ives School', as this group is sometimes called, had no shared manifesto or set of principles; but all pursued a dialogue between abstraction and landscape or nature. Though they employed different styles and had different interests, an impression of visual coherency emerges from their work: full, rugged shapes recur, hulk-like or, as in some of Hepworth's carvings, echoing the sweep of a bay; and lines have a familial terseness. There was a tendency to depend on gut reaction, the abstract artist being compared by Roger Hilton to 'a man swinging out into the void; his only props his colours, his shapes and their space-creating powers'. In addition, most of these artists developed a rapid, instinctive method, used by Peter Lanyon to convey 'this urgency of the cliff-face . . . where solids and fluids meet'.

Lanyon in fact never ceased to call himself a landscape painter. For a period he concentrated on specific sites: Portreath, St Just and Porthleven. But he brought to his paintings a combination of viewpoints, an imaginative grasp of the history of the place and an interest in concepts of fertility and regeneration. Like others of the St Ives group, Lanyon taught for several years at Corsham Court in 154

148 Terry Frost, *Movement: Green, Black and White*, 1951–52

Wiltshire which, at the invitation of its owner Lord Methuen, housed the Bath School of Art after the war. Lanyon encouraged his students to respond physically to the landscape, to walk through it, to explore the denseness of grass and undergrowth and to view it from unexpected angles. His own paintings developed a free, gestural style as he grew increasingly interested in effects of atmosphere and weather. From this vantage point he was well able to withstand the impact made by Abstract Expressionism when first shown in England in 1956. His work in fact fitted in with the American scene. He was given a one-artist show in New York in 1957, and established friendships with several of the leading American artists. The experience of America and American art brightened his colours which hitherto had been confined to harsh Cornish greens and greys. In 1959 he took up gliding, an experience that fed his attempts to paint invisible forces, thermal winds and the sensation of flight. In 1964 he was killed in a gliding accident at the age of forty-six.

With each artist the emphasis on abstraction or place was differently weighted. William Scott made several short visits to St Ives soon after the war and from 1952 spent every summer there. In paintings of sea, sky and harbour wall he adopted a simplified, flattened style in which representation is honed into near abstraction. This tough, reductive

style was taken further in a series of still-lifes based on pots and pans. At first these are rather too obviously indebted to Picasso, but gradually the hulk-like shapes of the pans spread across the entire canvas with a subtle feeling for rhythm and weight. For a brief period, around 1952, Scott turned to pure abstraction. But after a visit to America in 1953, he reacted in favour of a European tradition that preferred asymmetry and allusions to reality. Equally important to Scott was his experience of the Lascaux caves in 1954, which encouraged him to rely more on instinct.

Terry Frost's abstracts are also deduced from visual experience. He responded to the sight of boats bobbing in the harbour or the experience of walking along the quay, capturing these sensations in abstracts that employ generalized shapes arranged in taut relationships. Others, like Francis Davison (1919–84), Margaret Mellis's second husband, pursued a wholly abstract style (in his case, with torn paper collage) only to evoke an atmosphere reminiscent of the English landscape. Roger Hilton, on the other hand, was first interested in abstraction and only gradually came to be affected by place. He had trained in Paris in the 1930s under Roger Bissière and, like Bryan Wynter, became interested in French 'tachisme' – abstract art in which the paint is applied with small blot-like touches. Whereas Wynter used this style to convey the idea of movement through water, Hilton's early abstracts are solely concerned with pictorial reality. His most severe work was produced in 1953–54, following a visit to see Mondrian's paintings in Amsterdam and the Hague. Hilton's response was to paint white grounds intersected by black lines which, unlike Mondrian's, have a wavering tenacity as they stretch from one side of the canvas to the other. Occasionally a flash of brilliant colour intrudes.

From 1956 onwards Hilton was a regular visitor to Cornwall and in 1965 he settled there. As his association with the place deepened, his paintings began to admit references to atmosphere and seasonal change, and even to the figure. But illusionism never returned, and even when portraying a recognizable image, his line has a raw vitality. He had an abrasive personality which makes itself felt in his improvised canvases and gouaches, which are often humorous and erotic. He and Lanyon, in their emphasis on the artist's encounter with materials and the emotive and moral situation this entailed, came closest to the American Abstract Expressionists. Hilton, in a statement that upholds the Abstract Expressionist position, once declared: 'the picture is to be not primarily an image, but a space-creating mechanism. . . . In the last resort a painter is a seeker after truth. Abstract art is the result of an attempt to make pictures more real, an attempt to come nearer to the essence of painting.'

149 Roger Hilton, *Oi yoi yoi*, 1963

Alan Davie was another artist whose work during the early 1950s invited comparison with recent American art. Scottish born, he had trained at Edinburgh College of Art where strong colour was encouraged and enjoyed. The interruption of war left him for a period undirected; he played in a jazz band, taught for a short period, made and sold silver jewellery. Then between April 1948 and March 1949 he toured Europe, making a grand tour of contemporary art, studying the work of leading twentieth-century artists and seeing the Jackson Pollock paintings in Peggy Guggenheim's gallery in Venice. Davie's omnivorous eye had already enabled him to absorb African carvings, Klee and Picasso, and at first when he began painting in a style

150 William Gear,
Gay Landscape, 1952

recognizably his own, he filled his canvases with inchoate symbols, signs and suggestions of ritual. The marks and shapes have a primitive 157 urgency, as if the product of anger and confusion. However, under the influence of Zen Buddhism, his art became clearer, more joyous, less claustrophobic.

For a period Davie took a cottage near Land's End. He also exhibited with the Penwith Society which was formed in 1949 and which provided the main platform for the St Ives School. His friend William Gear (b. 1915), who was also Scottish and ex-Edinburgh College of Art, had no connection with Cornwall though he was one of the first in the post-war period to use an abstract style. Like Hilton's earliest non-figurative works, it had similarities with French 'tachisme', Gear having spent the years 1947 to 1950 in Paris. His abstracts depend on a linear armature within which are softly brushed 150 patches of brilliant colour. At the Festival of Britain '60 Paintings for '51' exhibition, which had a strong representation from St Ives, Gear's *Autumn* won a £500 prize. Incomprehensible to many in its lack of a recognizable image (it was reproduced upside down in the catalogue), it aroused sufficient furore for questions to be asked in Parliament.

Despite the appearance of Michel Seuphor's book *Abstract Art: Its Origins and First Masters* in 1949, there was still very little intelligent

176

151 Adrian Heath,
Composition: Red/Black,
1954–55

discussion of abstract art in England in the early 1950s. Therefore when Lawrency Alloway's *Nine Abstract Artists* appeared in 1954, it was greeted as a welcome introduction to a new development. The nine artists were Terry Frost, William Scott, Roger Hilton, Adrian Heath (b. 1920), Anthony Hill (b. 1930), Kenneth Martin (1905–84), Mary Martin (1907–69), Victor Pasmore and the sculptor Robert Adams (1917–84). Of these it was chiefly Adrian Heath who acted as the link figure between St Ives and the London-based 'Constructionists', as Pasmore, the Martins and Hill called themselves. Heath had visited Cornwall immediately before and soon after the war, and was a friend of Frost, whom he had met in a Bavarian prisoner-of-war camp. He had been the first to encourage Frost to paint, and stayed six months with him in St Ives soon after he himself had begun painting in an abstract style. In 1951, 1952 and 1953 three weekend exhibitions were held in Heath's London studio at 22 Fitzroy Street. The first two of these focussed on the Constructionists, but Scott, Hilton and Frost were invited to join in the third. This gave Alloway the grouping for his book.

Alloway began his introduction by referring back to the abstract art of the 1930s. He saw the Constructionists as the logical heir of this movement, and was ambivalent towards the 'native romanticism' of

the St Ives artists. 'In St Ives', he remarked, 'they combine non-figurative theory with the practice of abstraction because the landscape is so nice nobody can quite bring themselves to leave it out of their art.' He clearly preferred the firmer geometry, more 'concrete' non-figurative art of the Constructionists. Of this group, Alloway observed that 'a pattern of conversions has been established – with Victor Pasmore as culture-hero.'

Pasmore's move into abstraction in 1948 surprised many; Herbert Read thought it the most revolutionary event in post-1945 British art. During the war Pasmore had produced a series of paintings of the Thames at Chiswick, which, with their lyrical romanticism, had earned him much praise. The rendering of atmosphere invited comparison with the work of Turner, while the control of tone and select use of detail was reminiscent of Whistler. Yet at the same time Pasmore had begun relentlessly pursuing theoretical ideas. He read the writings of the Post-Impressionists, later including many passages in the anthology of artists' statements which he published in 1949 – *Abstract Art: Comments by Some Artists and Critics*. He also sought to discover mathematical and geometrical principles in art, sharing in the vogue for Matila Ghyka's *The Geometry of Art and Life* (1946), Jay Hambidge's *Dynamic Symmetry in Composition* (reprinted in 1948) and J. W. Power's *Les Eléments de la construction pictorale* (1933).

In 1945 the Picasso-Matisse exhibition at the Victoria and Albert Museum had confirmed Pasmore in his search for a constructive, not just an imitative reality. He looked at Hammersmith Gardens and reduced the scene to clusters of pointillist dots offset by a few, sinuous lines. In these semi-abstracted paintings the lyrical and romantic are held in balance by the theoretical and intellectual. In *The Park* (1947) 158 the composition is based on the golden section, but the dappled light, in the foliage and echoed on the path, is intuitive and poetic.

The following year, 1948, he produced his first abstracts. These were mostly small, and to encourage himself to work on a larger scale he turned, the next year, to collage. *Rectangular Motif in Black and White* (Sheffield City Art Galleries), built solely out of rectangles and squares, had a forthright simplicity and a bold, affective rhythm. In its sudden paring away of all inessentials, it looked radical, shorn, severe. Soon after this Pasmore introduced the spiral, a motif rich in art-historical precedents. It gives drama to Leonardo's deluge drawings, Turner's storm pieces, and is often used in Far Eastern, primitive and tribal art. But if compared, for instance, with the emotive charge conveyed by Van Gogh's haloed skies, Pasmore's spiral remains merely a space-creating and largely decorative device.

Early in 1951 Pasmore was lent a copy of Charles Biederman's *Art as the Evolution of Visual Knowledge*, first published in 1948. Its thesis

152 Victor Pasmore, *Relief Construction in White, Black, Maroon and Ochre*, 1956–57

rests on the belief that all significant art depends on the artist's grasp of external reality. In the portrayal of this reality, painting had reached a point of unsurpassable illumination in the work of Cézanne and could go no further; the next logical step was from illusionism to actuality, from the flat surface to the use of real materials in real space; to the making of reliefs.

152 Pasmore, taking his direction from Biederman, made his first reliefs in 1951. They were exhibited in 1952 at the Redfern Gallery and reviewed in the *Manchester Guardian* by the artist Stephen Bone: 'These strangely old-fashioned constructions in plywood and plastic merely look like some of the less important works of the nineteen twenties.' It is a telling observation, for as Pasmore moved towards the mainstream of European modernism his art became, paradoxically, more provincial. His much lauded reliefs nowadays do not compare in importance with the later revelatory impact made by American

Abstract Expressionism. The irony is that this artist, so loudly praised for his aspiration to an international style, drew upon far greater reserves of feeling and expression when at his most English.

What cannot be denied is Pasmore's influence. He gave direction to the 'constructionist' movement of which Anthony Hill and Kenneth and Mary Martin were the leading exponents. Much correspondence was exchanged with Charles Biederman, for his writings directly motivated all those in this group. In *Art as the Evolution of Visual Knowledge* he had traced a 'constructive' line of development from Cézanne through Cubism, De Stijl, Russian Constructivism, the Bauhaus to his own reliefs, several of which were illustrated . He not only provided historical justification for 'constructionism', but directed attention to Mondrian's 'pier and ocean' drawings, in which the horizontal and vertical are used as fundamentals representing the underlying structure in nature. From this Biederman went on to argue that the artist should seek to imitate, not the appearance of nature, but its structural processes. In this parallel with nature lay art's regenerative function.

The British Constructionists diverged from Biederman on two important points. Whereas he coloured his reliefs, the British for the most part eschewed colour, except for that inherent in the material used, fearing its tendency to arouse non-formal associations. They also rejected his search for formal principles in natural laws. Biederman, living in the rural outbacks of Minnesota, might feel this necessary, but in London the desire was for a constructed, architectonic art, something not abstracted from the world but brought in, something concrete, cerebral, composed.

Within this group Mary Martin was the first wholly to abandon painting for the making of reliefs. Between 1951 and 1969, the year that she died, she explored a narrow but seemingly inexhaustible vein with no loss of intensity. For her the essence of relief lay in the 'parting from and clinging to a surface'. Having admired in Analytical Cubism that sense of shift within a compressed space, she employed the tilted plane to measure shallow depth. Her earliest reliefs depended in their composition on proportional systems, her mature and late examples on mathematical permutations which control the changing position of an unchanging unit.

In Mary Martin's art the tilted plane soon became the hypotenuse created by slicing a cube diagonally in two. The position of this unit is then turned, according to numerical progression, but its hypotenuse, covered in satin-finished stainless steel, always faces outwards. The underlying mathematical logic is countered by the secondary and tertiary rhythms set up by the reflections in the polished steel. What should be easy to comprehend remains elusive; reflected light de-

160

153

153 Mary Martin, *Cross*, 1968

materializes form; rhythms collide and refuse assimilation. The image does not release the mind until intellectual battle has been done.

The work of the British Constructionists is always rigorously conceived and understated in effect. The reliefs are usually orthogonal, the units assembled in horizontal and vertical formations. Much use is made of asymmetry, held in taut balance. Most of these artists worked on a domestic scale, but all were interested in developing an exchange between artist and architect and in accepting public commissions. Mary Martin believed that it was through a knowledgeable handling of proportions that the artist was able to contribute to society. It was hoped that 'constructionist' work would infiltrate the environment and bring a sense of measure and order to our lives.

The optimism and integrity of this art still continues to attract a following: among those working in the 'constructionist' style today, other than those already mentioned, are Terry Pope (b. 1941), Michael Kidner (b. 1917), Malcolm Hughes (b. 1920), Gillian Wise Ciobotaru

154 Peter Lanyon, *Bojewyan Farms*, 1951–52

155 William Scott, *Ochre Still Life*, 1957

156 Francis Davison,
Collage, c. 1970

157 Alan Davie,
*Entrance for a Red
Temple, No. 1,* 1960

(b. 1936) and Jean Spencer (b. 1942). At one level this tradition seems to satisfy a native love of orderliness and restraint. Spare, disciplined and systematic, it inclines to tightness and bland self-sufficiency, but, at its best, carries unmistakable authority, concentrates looking and can excite.

In 1956 attitudes towards abstract painting changed radically when the exhibition 'Modern Art in the United States' opened at the Tate. This was a survey covering a wide range of names, but the final gallery was devoted to Abstract Expressionism and included work by Gorky, Kline, de Kooning, Motherwell, Pollock and Rothko. The sheer scale of this work, the passionate involvement and committed professionalism it displayed, made a powerful impact in England. But those artists who responded to its challenge did so with varying degrees of enthusiasm, sometimes with an ambivalence that was most clearly voiced by Patrick Heron.

Heron had spent part of his childhood in St Ives and was a friend of Peter Lanyon. Between 1937 and 1939 he was a part-time student at the Slade and, like others of the St Ives group, had his career interrupted by war. He resumed painting in 1945, and in 1946 visited and wrote on the Tate exhibition of Braque's recent work. For the next ten years his painting drew upon Braque's method of weaving together space and form, foreground and background, in an uninterrupted linear framework. The lines both create visual flow and demarcate areas of colour which are often brilliant in hue, unlike the sombre harmonies preferred by Braque. Many of these paintings take for their subject the view through the window in Heron's St Ives studio which overlooked the sea wall and harbour. In 1947 he began making regular visits to Cornwall and in 1956 settled permanently at Eagles Nest, a house above Zennor overlooking a large stretch of coast.

Heron's foremost interests – the role of colour and the use of restricted pictorial space – frequently determined his writing on art. He published a series of articles in the *New English Weekly* in 1945 and between 1947 and 1950 wrote regularly on art for the *New Statesman*. His articulateness and sensitivity to the artist's intentions made him one of the best critics of the day, and in 1955 his articles were brought together in his book *The Changing Forms of Art*. He wrote very much from the painter's point of view and in 1950 was sacked from the *New Statesman* for placing too much emphasis on 'pictorial space'. In 1955 he became London correspondent to the American magazine *Arts Digest* (later simply entitled *Arts*) and in several of these articles extolled the innovations of the St Ives School and continued to uphold the British contribution.

> At the same time he was weighing up his attitude to Abstract Expressionism. His immediate response had been one of unqualified enthusiasm:

I was instantly elated by the size, energy, originality, economy, and inventive daring of many of the paintings. Their creative emptiness represented a radical discovery, I felt, as did their flatness, or rather their spacial shallowness . . . we shall now watch New York as eagerly as Paris for new developments (not forgetting our own, let me add).

Heron was to expand on his parenthesis at a later date. But in 1956, as a result of American influence, he immediately abandoned his former style and began painting abstracts. He had earlier tried pure abstraction, in 1952 under the influence of Nicholas de Staël, but the experiment had been short lived. In 1956 his experiments with non-figuration quickly settled into the use of stripes, horizontal bands of colour which filled the entire canvas, in a format not unlike Rothko's. He showed a group of these stripe paintings in 'Metavisual, Tachiste and Abstract Painting in England' at the Redfern Gallery in April 1957, the first exhibition to register the effect of the American impact. Shortly after this Heron began to interrupt his horizontals with occasional verticals, a style he described as 'fractured tartan'. By the late 1950s his interests had further coalesced: the colours are now often reduced to two or three, and the shapes, often disk-like, hover like islands amid a sea of colour. Particular to Heron is his use of irregular outlines, reminiscent of the detour made by scissors in paper cut-outs, or of the jagged indentation of the Cornish coast. Again, these
159 abstracts are best described in Heron's own term, 'wobbly hard-edge'.

> In the aftermath of the 1956 exhibition, praise of the American achievement filled the art press. Partly in reaction against this, Heron's initial enthusiasm became modified. In 1957 he wrote against the excessive emphasis that the Americans placed on spontaneity. Then in 1959 the Abstract Expressionist exhibition organized by the New York Museum of Modern Art, 'New American Painting', arrived at the Tate on its tour of eight European countries. The following year Heron visited America and addressed the Artists' Club in Greenwich Village. He attacked the Abstract Expressionists for sacrificing too many painterly qualities in their search for extreme solutions. Now critical of the Americans' tendency to use simple, monolithic imagery, he exhibited in his own work a preference for asymmetry and constant variation. Nor was he continuously committed, like his American counterparts, to a large format, but worked as confidently in gouache on a small scale. In 1966 he published an article entitled 'The Ascendency of London in the '60s' in the December issue of *Studio International*, in which he challenged the idea of American superiority

158 Victor Pasmore,
The Park, 1947

159 Patrick Heron,
*Cadmium with Violet,
Scarlet, Emerald, Lemon
and Venetian: 1969*

160 Kenneth Martin,
*Chance, Order,
Change 24 (4 colours)
History Painting A,*
1982

161 John Hoyland,
Billy's Blues, 6.7.79

162 Robyn Denny, *First Light*, 1965–66

in abstract art. Abstract Expressionism, he argued, had led to an aridity and sterility; it had depended primarily on the intellectual faculty, whereas art, to be good, required a balance between intellect and intuition. British painting, on the other hand, revealed greater reserves of intuitive power and taste. Instead of extremes of flatness,

emptiness and bigness, painting should now move towards a 'recomplication of the picture surface'.

Robyn Denny (b.1930), although a more wholehearted adherent to the American example than Heron, also wanted his abstracts to avoid instantaneity, to remain 'strange' and 'unaccountable'. His own paintings, though symmetrical in lay-out, demand careful, sustained looking. Figure and ground are held in ambiguous relationship, colour is slow-working, subtle in choice of both tone and hue. In addition, the scale of his work is related to human proportions. Denny, like others in the early 1960s, was keen to emphasize the object-like nature of his canvases and carried the painted surface around the edges. At one point he insisted that, instead of hanging on the wall, they should rest with their bases on the floor, occupying the spectator's space.

162

Denny collaborated with Richard Smith (b.1931) and Ralph Rumney on an exhibition entitled 'Place' at the ICA (Institute of Contemporary Arts) in London in 1959. Large, human-size canvases of standardized dimensions and colours (red, green, white and black) were arranged to form corridors and vistas. The intention was to create a total environment, to give the visitor the sensation of being inside a space generated by the colours.

The existence of large-scale abstract painting in London, deriving from American theory and practice, was further confirmed by the two 'Situation' exhibitions, held in 1960 and 1961. Denny acted as organizing secretary and co-ordinated a loose association of twenty artists, including Henry Mundy (b.1919), John Hoyland (b.1934), Bernard Cohen (b.1933), Richard Smith (b.1931), Gwyther Irwin (b.1931) and Gillian Ayres (b.1930). The aim of the exhibition was to by-pass the dealer system and to make better known the existence of new, large-scale abstraction. St Ives artists were deliberately excluded, for the allegiance was primarily to a non-referential art inspired by the American example. The sheer size and physical presence of these canvases created a new conception of space and altered the spectator's relationship to them. Despite a wide range of styles, hard-edge abstracts (the equivalent to New York's 'Post-Painterly Abstraction', a development that led on from Abstract Expressionism) prevailed. The emotive, solipsistic aspect of Abstract Expressionism had given way to something cooler and more laconic. Richard Smith, for example, combined references to communication systems, games theories and the mass media with the sensuous professionalism associated with modern American art, employing, above all, a detachment and irony that made him equally at home in the arena of Pop Art.

163 Richard Hamilton, *Just what is it that makes today's homes so different, so appealing?* 1956

CHAPTER NINE
POP, OP AND
NEW GENERATION SCULPTURE

Pop Art began in England during the 1950s. Today it is hard to imagine the excitement aroused by the advent of the ball-point pen, the long-playing record and colour magazines. To a nation not long released from the restrictions of rationing, the glamour of Hollywood had obvious appeal, but so too did the niceties and naïveties purveyed by much television entertainment. Things were sweeter, fresher, unashamedly concerned with the giving of pleasure. Pop Art drew upon this fast-expanding mass-media culture, making its subject matter the pin-up, the pop star or the advertising slogan. Recently Pop artists have been criticized for failing to transcend the illusions of the period, for failing to objectify the material dealt with. But this is to misunderstand its stance which was essentially playful and ambiguous. Pop Art dealt knowingly with illusions, openly embracing the unreality of the image generated by advertisements and the media. As the cultural historian Dick Hebdige has observed: 'A vicarious and attenuated relation to "authentic" experience is taken for granted, even welcomed for the possibilities it opens up for play, disguise, conceit. . . . Pop . . . refuses to abandon the ground of irony, to desert surface and style.'

Surface and style were much discussed during the 1960s and this is perhaps why Pop Art, though it originated earlier, is often associated with this decade. It certainly contributed to the joyful confidence and optimism of the 1960s and to the art boom. This was fostered partly by an economic resurgence, heralded by Harold Macmillan's famous phrase, 'you've never had it so good'. Much Pop Art is similarly euphoric, even when its tone is wry or mocking. *Just what is it that makes today's homes so different, so appealing?* asked Richard Hamilton (b. 1922), making this the title of a now famous collage.

It was made for reproduction, as catalogue illustration and poster, for the exhibition 'This is Tomorrow' held in 1956. The exhibition was co-operatively organized by members of the Independent Group which met intermittently at the ICA between 1952 and 1955. Hamilton's collage is a humorous reconciliation of the Independent Group's two main interests: modern technology and mass-media culture. The ceiling of the room depicted is filled with a photograph of the earth taken by a high-altitude research rocket; an aerial photograph of a

163

crowded beach is used to suggest a rug. Hamilton was assisted in the 164 making of this collage by his wife and a friend who spent days cutting out possible images from magazines. The fascination with this kind of source material had been stimulated by other Independent Group members: John McHale had brought back from America a trunk-load of comics and magazines in 1954; Eduardo Paolozzi (b. 1924) had been collecting such material in scrap-books since 1947; and Nigel Henderson had, with his photographs, drawn attention to the glut of imagery and information crammed into certain shop windows in the East End of London. Nevertheless, if both the strategy and content were by then familiar, Hamilton's summary is brilliantly concise.

Many of the lectures and discussions held by the Independent Group concerned methods of communication. Hamilton, in his own work, delighted in examining the efficacy of signs and the slippages in meaning caused by playful use of modern reproduction methods. The intellectual acuity that he brought to bear on advertisements must have been sharpened by the Independent Group whose members included the architects Peter and Alison Smithson, John Voelcker, Theo Crosby (editor of *Architectural Design*) and the art critic Lawrence Alloway. The architectural historian Reyner Banham was also a member, interested in detailing the early and high renaissance, not of Italian art, but of automobile styling. This new broadening of interest led Lawrence Alloway to declare that they should abolish any hierarchy of values and talk not of 'high' and 'low' art, but of a 'fine/pop art continuum'. The following year, 1957, Hamilton sent the Smithsons a letter listing all that Pop Art should be: 'Popular (designed for a mass audience), Transient (short-term solution), Expendable (easily forgotten), Low cost, Mass produced, Young (aimed at youth), Witty, Sexy, Gimmicky, Glamorous, Big Business.'

This definition is more applicable to advertising than to Pop Art, which never surrendered its fine art status. Hamilton himself, even when using photographic silkscreen, delighted in the hand-made mark and other evidence of authorial intrusion. In his own work he dealt artfully with pared details: in *Hommage à Chrysler Corp.* there are 165 references to the tail fins and hub caps drawn from various cadillacs, a diagram of the Exquisita Form Bra and the lips of Volupta, the heroine of an American late-night television show. Hamilton also added lips (this time Sophia Loren's) in *Hers is a Lush Situation*, again alluding to the use of female sexuality in advertisements for cars.

Few Pop artists were as obsessed with mass-media imagery as Hamilton. What unites members of the Independent Group with the second and third wave of Pop Art, both of which emerged from the Royal College, was a certain attitude of mind. Pop Art, seeking, like

164 Eduardo Paolozzi,
I Was a Rich Man's Plaything,
1947

165 Richard Hamilton,
Hommage à Chrysler Corp,
1957

Dada had done before, to expand the parameters of art, was a deliberate affront to accepted taste. It preferred the lightweight and, in its choice of encoded imagery, helped broaden the audience for art and made the fine arts less exclusive. It protested, but in a humorous, jokey manner. Like the Vorticists who had drawn up lists of things to 'blast' and others to 'bless', the catalogue to *This is Tomorrow* contained 'hates' and 'loves' compiled from magazine phrases. Among the 'hates' were 'the English Way of Life, personal freshness, those who insist on individuality, beauty of refinement, 'phone bills and church.' 'We love', the contrasting section declared, 'built-in-helps, luck, Eartha Kitt, organized chaos and deep penetration', among other things.

166 Peter Blake, *Children Reading Comics*, 1954

The three artists associated with the second wave of Pop Art were all students at the Royal College of Art (RCA) during the mid 1950s. Peter Blake (b. 1932) seems to have arrived independently at a Pop Art language, for he claims never to have visited any of the Independent Group's exhibitions. Unlike Hamilton, who teased and deconstructed advertisement imagery, Blake accepts his source material wholesale, often incorporating into his art kitsch postcards, photographs of pin-ups or pop stars without alteration of the image. His attitude is less

167 Joe Tilson, *A-Z Box, of Friends and Family*, 1963

intellectual and more nostalgic, at times almost reverential in the collecting and docketing of ephemera. Some of his best paintings have been those based on childhood memories. These are hauntingly evocative of the intensity and sharpness of vision with which a child focuses on a cigarette packet or a comic.

The two other RCA students of Blake's generation who are also associated with the Pop movement are Joe Tilson (b.1928) and Richard Smith. Tilson is best known nowadays for his wood reliefs

166

which play upon a tautology of word and image. A fascination with slot machines lies behind his *A-Z Box, of Friends and Family* made up of box-like units, each resting on a letter of the alphabet. Tilson invited his artist friends to donate pictures to fill the boxes over the initial of their name: Auerbach, Blake, Hockney, Paolozzi, Harold Cohen (b.1928), Kitaj, Hamilton, John Latham (b.1921), Peter Phillips (b.1939), and Anthony Caro (b.1924) are among those who contributed, making an indexical illustration of the Pop movement and related period trends. These boxes could also have included the American Pop artists – Robert Rauschenberg, Jasper Johns, Jim Dine, Andy Warhol and others – whose work lies behind so much of the British achievement.

Richard Smith signalled his allegiance to popular culture while at the RCA by writing articles for its magazine, *Ark*, on American films, jazz and rock 'n' roll. He was the first British Pop artist to visit

168 Richard Smith, *Staggerly*, 1963

169 Mark Lancaster, *James Gibbs*, 1970

America and also the most abstract, making sophisticated play with
the brash patterns imposed on consumer goods to make them sell. He
168 worked on a scale reminiscent of the inflated imagery found on
advertisement hoardings, but his work soon lost all reference to Pop
imagery, becoming quite naturally and easily completely abstract.
Mark Lancaster (b. 1938) also arrived at an abstraction apparently cool
169 and formal but subtly allusive and lyrical.

One strategy that Smith shared with some of the third-wave Pop
artists, those who emerged from the RCA in the early 1960s, was the
use of the shaped canvas. It was a simple device, giving additional
impact to the painting as object, independent of the illusion it
172 portrayed. Peter Phillips, however, used it tautologically, to enhance
170 the motif, and Allen Jones (b. 1937), to convey the movement of a bus.
Jones, in this and other paintings of this period, arrived at a fine
balance between abstraction and figuration, between suggestion and
fact. Much third-wave Pop plays upon ambiguity, setting up and then

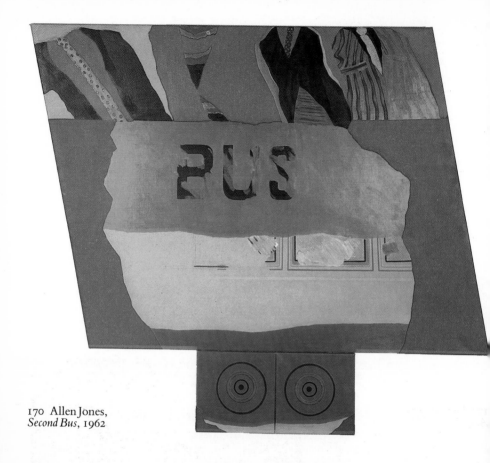

170 Allen Jones,
Second Bus, 1962

refuting expectations. Derek Boshier (b.1937), for example, makes
the familiar cornflake packet, matchboxes, toothpaste and space 171
heroes, through semi-erasure, the subject of uncertainty. He, like
Phillips, Jones and also David Hockney, entered the RCA in 1959, the
same year as the American, R. B. Kitaj (b.1932).

Kitaj's work least justifies the Pop label, yet he was of central
importance to this group. He came to the RCA via the Ruskin School
at Oxford where the teaching, particularly that of Percy Horton,
instilled distrust of fashionable avant-garde styles. At the RCA, Kitaj
turned his back on the rage for abstraction which the 1959 exhibition
of Abstract Expressionism had left in its wake. His figurative
paintings intrigued and dazzled his contemporaries because they broke 173
with conventional visual syntax, with traditional perspective, stylistic
unity and the more usual pictorial logic. With magpie-like wizardry,
he combined a clash of styles with eclectic imagery, drawing ideas

171 Derek Boshier, *First Toothpaste Painting*, 1962

172 Peter Phillips,
AutoKUSTOMotive, 1964

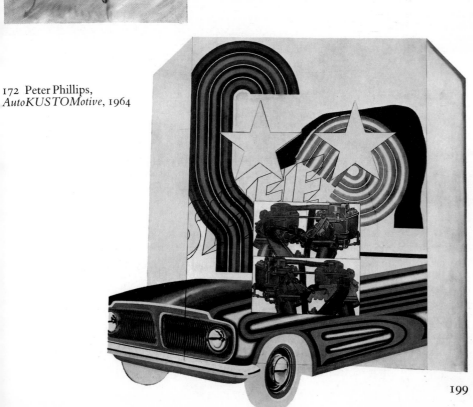

173 R.B. Kitaj, *The Ohio Gang*, 1964

from his wide reading. Deeply interested in left-wing history, he aspired to an art that would engage with the human condition, with the sufferings, humiliations and ironies inherent in the history of revolutionary struggle. In the same way that one of his mentors, Walter Benjamin, collected quotations in small black notebooks, so Kitaj, working through cuts and abrupt elisions, stores up fragments of civilization against the loss of totality of vision.

Kitaj's inventiveness stimulated his contemporaries, but his political interests seem to have left them untouched. Patrick Caulfield (b. 1936) developed a style that is deliberately bland, impersonal and detached.

He arrived at the RCA a year after the rest, in 1960, and at first kept a low profile, with the result that he has occasionally been omitted from Pop Art surveys. In his art, objects are reduced to ideograms and encased with an unvarying black line. Any suggestion of sensibility or individuality is deliberately suppressed. The imagery is either dependent on cliché (a tourist's souvenir view, a diamond ring) or anonymous and uninflected (empty interiors in familiar architectural styles). But the extreme economy of his means cancels out romanticism or conventionality and gives a refreshing pungency to tired visual facts: in *Still-life, Mother's Day* the choice of colour releases a wrapping-paper sweetness which the drawing style denies.

174

It was during the early 1960s at the 'Young Contemporaries' exhibitions held at the Whitechapel Art Gallery, where Bryan Robertson ran a programme of major American and British exhibitions, that this third wave of Pop artists first began to reach a wide public. The movement was quickly acclaimed by the media and its artists turned into cult heroes. None more so than David Hockney (b.1937) who developed a personal image that catered to audience interest. Rumour began to circulate that something was happening at the RCA, and people began visiting the studios to see what was going on. Hockney chose this moment to reveal his homosexuality. He began scribbling furtive messages to his boyfriend onto his canvases, giving to his marks and lettering the agonized urgency of graffiti. The work of Francis Bacon and Jean Dubuffet helped form Hockney's style, as did the art of Alan Davie, Jackson Pollock and Roger Hilton, for on first arriving at the RCA Hockney had tried his hand at abstraction. After Kitaj had suggested that he should paint what interested him, his work remained unashamedly autobiographical. Excited by the Tate Gallery Picasso exhibition of 1960, he learnt that style was a thing to be chosen at will, according to the needs of the subject. When exhibiting four works at the 1962 'Young Contemporaries' show, he gave them the generic title 'Demonstrations of Versatility'.

175

As his career has developed, Hockney's work has continued to surprise. After the success of his etchings, *The Rake's Progress*, he moved to California where his style changed to suit the new subjects that surrounded him. He wanted to make his paintings clearer and more specific, and achieved a deadpan coolness enlivened by a subtle irony and an understated wit. His former throwaway manner, his juggling with styles and rejection of skill is replaced with a concern for precision, an acuity of statement. Formal problems, such as how to portray light on glass or water, began to obsess him. From 1965 until the late 1970s his work grew progressively more naturalistic as he relied more and more on the camera for information. His paintings of this period often disappoint in actuality but reproduce well: colour

174 Patrick Caulfield, *Still Life, Mother's Day*, 1975

reproduction returns them to a similar medium to that from which they were composed, with detail reduced and crisper presentation.

Like Ingres, Hockney may come to be admired chiefly for his portraits and draughtsmanship. Given the success of the former, he could have become the John Singer Sargent of the 1970s had he not, except in one instance, refused to paint commissioned portraits. Instead his sitters are mostly confined to figures within the art world and his friends. His clever placing and use of detail has been developed through constant drawing. He excels, in particular, with pen-and-ink. His line is brittle yet tender, economical yet sensitive to the smallest nuance. Its delicacy and fragility in the portrait of W. H. Auden 176 beautifully catch and offset the poet's bulldog-like appearance.

In general, the ethos of the 1960s, with its emphasis on the consumer, on fashion and innovation, was very much directed towards urban life. The city had become a major cultural force and much of 1960s art reflects its influence. Very little landscape painting of any conviction was produced during this decade, which was less concerned with nature than artifice.

Much 1960s abstract art explored the limitations of the picture surface: Op Art explored the destruction of that surface by illusion.

175 David Hockney,
*We 2 Boys Together
Clinging*, 1961

176 David Hockney,
W.H. Auden, 1968

Patterns and colours were composed in such a way as to create movement, not actually on the canvas but in the retina of the viewer's eye. Bridget Riley (b. 1931) is the foremost exponent of this style. She began working solely in black and white, charting her images with exact, mathematical precision. She then moved gradually and logically through greys into colour, making her chosen unit the stripe. She exploited the way that the after-image of one coloured stripe can affect and modify its neighbour: looked at from a distance, her paintings appear to contain more colours than are in fact on the canvas. The stripes set up vibrations and cross-rhythms which accumulate with exhilarating yet subtle effect. 178

Once the image became unstable it was not long before the work of art itself began to move, became 'kinetic'. Alexander Calder's mobiles responded to warm air currents; Pol Bury's reliefs twitched and shifted by degrees as a result of motorization. Neither of these artists was British, for 'kinetic art' was an international phenomenon. It was also one that received a strong injection of fashionable interest. One of the more elegant works in this vein was *Liquid Reflections* by the 177 expatriate American Liliane Lijn (b. 1939). It sets in motion a clear perspex turntable beneath which are trapped drops of clear liquid. On top of the table rest two perspex balls which react in movement to the turning base, at the same time attracting and dispelling the liquid drops beneath, and setting up a multiplicity of changing reflections.

The search for new ideas was often little more than a desire to take advantage of the consumer boom, to place art in the living-room and

177 Liliane Lijn, *Liquid Reflections*, 1968

on the executive's desk. An interest in printmaking revived, some of the Pop artists producing their best work in this medium. Many ingenious small works of art in the 1960s appeared as 'multiples', in unlimited editions, appealing to a market that virtually disappeared in the less affluent and less spontaneous 1970s. At the same time the boundary lines between painting and sculpture became less distinct, with canvases often shaped like objects, and sculpture taking on the optical appeal of painting by adopting the use of colour. Often the nature of the materials used now lay hidden beneath a layer of paint.

The man who pioneered this revolutionary development in sculpture was Anthony Caro. As is often the case with radical artists, the first part of Caro's career was markedly traditional: as a youth, he had received encouragement from a future President of the Royal Academy, Charles Wheeler; and after reading engineering at Cambridge, which he did to satisfy his father, he trained at Regent Street Polytechnic in London, then at the serenely old-fashioned Royal Academy Schools. A dutiful student, Caro, while training to become a sculptor, worked his way through art history, 'swallowing history', as he put it, 'and getting it inside yourself making a pool or a pond inside yourself on which you are going to be able to sail'.

For two years, between 1951 and 1953, Caro worked as a part-time assistant to Henry Moore. The insistent horizontality of Moore's reclining nudes was later to reappear in Caro's post-1959 sculpture – as was the older master's highly attuned sense of rhythm and balance. Caro has admitted his debt to Moore but says that he owes as much to the books on contemporary art that Moore lent him. By the end of the 1950s, Caro's sculpture bore certain similarities with the work of Kenneth Armitage and Bernard Meadows, and revealed a tendency to exaggerate one dimension in order to bring out his feeling for mass, weight and gravity.

In 1959 Caro met the American critic Clement Greenberg at the house of the painter and sculptor William Turnbull (b.1922). Subsequently Greenberg visited Caro's studio and gave advice on his art, causing Caro radically to rethink his work. Shortly after this Caro was awarded a scholarship which enabled him to spend two months in America. He visited New York, afterwards travelling to various cities, meeting many artists, including the painter Kenneth Noland and the sculptor David Smith, and renewing his friendship with Greenberg. Greenberg's advice – 'If you want to change your art, change your habits' – led Caro to reject the modelling of clay for the more direct and impersonal method of bolting and welding together steel units.

Caro's first constructed steel sculpture was made on his return to England in 1960. His aim was to relocate sculpture, to remove it from

178 Bridget Riley,
Winter Palace, 1981

179 Antony Caro,
Prairie, 1967

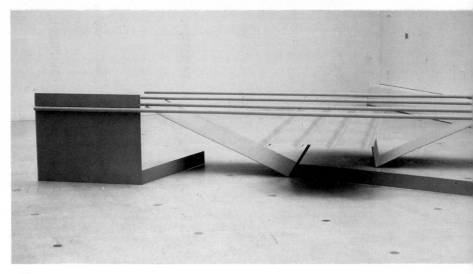

the realm of rarefied aesthetic discourse and place it in the everyday world. In order to do this he abolished the pedestal and placed the work directly on the ground, in the spectator's own space. The materials he used – steel, sheet metal and girders, found in scrapyards – also registered a protest against the preciousness that clung to some of Henry Moore's more rhetorical bronzes. Moreover, though the images he made were abstract, they related to bodily experience, to sensations of weight, compression, release, to the act of balancing, leaning or supporting. As his control of this new language developed, Caro, in his relating of the parts to the whole, brought to his work a fine control of phrase, interval and melodic line, often creating effects of surprising lyricism and casual grace. Mood is heightened by colour, which Caro, in consultation with his wife, also an artist, chose for each piece after it was completed. This further unified the work and acted as a psychological pedestal, drawing attention to the conglomeration of parts.

In 1954 Caro accepted a two-day-a-week teaching post at St Martin's School of Art in London and remained in that post until 1974. He helped turn the sculpture department into a centre for innovation and was himself infected by its spirit of research. Largely owing to his example and influence, a group of sculptors emerged from this department who were given the label 'New Generation', after an exhibition of that name held at the Whitechapel Art Gallery in 1965. William Turnbull was the only artist associated with this group

180 William Turnbull, 5 × 1, 1966

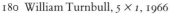

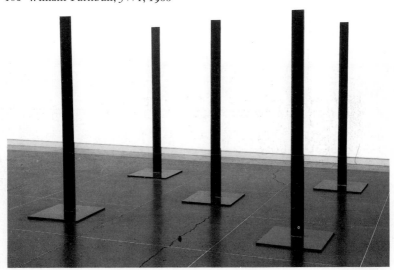

who had no affiliation with St Martin's. David Annesley (b.1936), Michael Bolus (b.1934), Phillip King (b.1934), Tim Scott (b.1937), William Tucker (b.1935) and Isaac Witkin (b.1936) all made constructed, coloured sculpture and were all either students or staff at St Martin's.

Because St Martin's, in the Charing Cross Road, is situated right in the centre of London, it is not surprising that 'New Generation' sculpture looks better situated in a gallery or on a concrete plaza than in a park or landscape setting. It strove after modernity, emulated modern building techniques and was strongly related to the architectural environment. The right angle is insistently present; even when the lines or planes lean, bend or curve, they do so in implied relation to the horizontal of the ground and the vertical of a wall. New Generation sculpture was in addition influenced by the current interest in 'gestalt' psychology, which revolted against the atomistic approach in its concern with wholeness. In keeping with ideas about 'a good gestalt', much of this sculpture is immediately explicit: the forms can be perceived at a glance, understood from any angle. If the work was based on repetitive units, the suggestion was always present that it was capable of infinite extension. Close at times to American Minimalism, an extreme form of reductive abstraction, it, too, cultivated impersonality; paint was sprayed on, to deny material expressiveness and to give the work a factory-like finish.

Because of its use of strong colour and simple shapes, New Generation sculpture has often been related to hard-edge abstraction;

181 David Annesley, *Untitled*, 1968–69 182 Phillip King, *Rosebud*, 1962

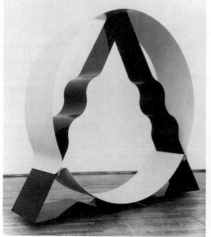
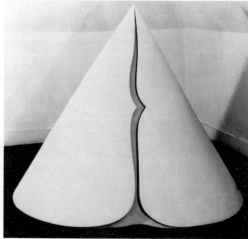

183 William Tucker, *Tunnel*, 1960

182 but it is also akin to Pop Art. Phillip King's *Rosebud*, in 1962, must have presented a saucy alternative to the abstract humanism of Henry Moore, in the same way that Peter Blake's *Love Wall* diverged from the aesthetic perfectionism of Ben Nicholson's reliefs. During the early 1960s King's imagery was as zany and allusive as much Pop, his choice of colours, as in *Rosebud*, heightening the playful idea. William

183 Tucker, on the other hand, represents the more conceptual aspect of New Generation. He became an influential teacher and writer, and in his art favoured explicitness, arguing that the form of a work should be determined by the idea, not by the choice of material. He eschewed Caro's elegant lyricism and produced some of the most teasingly simple works in the New Generation idiom.

Much New Generation sculpture falls very neatly within the parameters of the decade. Caro and King continued working without any apparent loss of impulse, but among the rest a temporary or permanent loss of motivation set in around the late 1960s. A minimalist style, having aroused much discussion in the art magazines during the mid 1960s, inevitably invited a reaction. Constructed sculpture remained a viable method for articulating forms in space and was in the late 1970s revived. But the use of colour was dropped, and with it the openness and optimism that had characterized New Generation work at its best.

184 Gilbert and George, *Are You Angry or Are You Boring?*, 1977

CHAPTER TEN
CONCEPTUALISM AND POST-MODERNISM

During the 1960s a more aggressive art market was matched by an increase in sophistication in the art press. Magazines now boasted glossy black-and-white and colour reproductions. The growth of art history as an academic discipline meant that much art criticism was now better informed and more analytic. As the titles of two of these magazines suggest – *Art International* and *Studio International* – the focus was not on national or local interests but on cultural ideas often entirely abstracted from the socio-political domain. This internationally orientated art press did much to sustain American influence in Britain during the 1960s and early 1970s, helping to make familiar Abstract Expressionism, Post-Painterly Abstraction and Minimalism, all movements that maintained the dominance of abstraction.

Much abstract art of this period was frankly formalist, concerned with 'immanence' – an intensive examination of its intrinsic qualities. The critic who did more than any other to promote this concern was the American Clement Greenberg. He argued that the essence of modernism lay in the 'use of the characteristic methods of a discipline to criticize the discipline itself – not in order to subvert it, but to entrench it more firmly in its area of competence'. According to Greenberg's view, painting should insist exclusively on its material attributes, on pigment, the shape of the canvas and its ineluctable flatness. Though this argument enabled Greenberg to expound the move into Post-Painterly (hard-edge) Abstraction, he had arrived at his belief much earlier – in 1939, in his article 'Avant-Garde and Kitsch'. 'Content', he wrote, 'is to be dissolved so completely into form that the work of art or literature cannot be reduced in whole or in part to anything not itself . . . subject matter or content becomes something to be avoided like the plague.'

Minimalism, a movement that emerged in America in the 1960s, also aspired to muteness and can be regarded as a further reductionist development in abstract art. Its chief practitioners – Don Judd, Dan Flavin, Carl Andre, Robert Morris and Frank Stella – made use of repeated identical units and industrial materials that were deliberately inexpressive and devoid of traditional aesthetic content. Though this movement was acknowledged and discussed in Britain, it never gave rise to any binding group. However, by the 1970s, a number of artists

185 Keith Milow, *1 2 3 4 5* 6 *... B*, 1970

186 Peter Joseph, *Ochre Colour with Dark Border, October 1976*

were making use of the aesthetics of exclusion and producing severely 'minimal' work. Among these were Bob Law (b. 1934), Peter Joseph
185 (b. 1929), Keith Milow (b. 1945), Edwina Leapman (b. 1934) and Alan Charlton (b. 1948). As in American Minimalism, there is an emphasis on serial progression or the repetition of simple geometric shapes. But whereas the Americans achieved an almost aggressive coolness and neutrality, much British Minimalism is subtly nuanced: Edwina Leapman's hand-painted stripes create an intermittent pulse; Charlton's grey monochromatic canvases are coloured by surface
186 variations; and Peter Joseph's abstracts, with their door- or window-like format painted with just two hues, are gently involving.

The effect of Minimalism on painting was further to purify and limit its frame of reference. The art schools upheld this development. In 1958 Sir William Coldstream, then professor at the Slade, had taken charge of a policy committee asked to make recommendations for the restructuring of British art education. This committee had delivered its conclusions in 1960, and the task of implementing them was passed on to another committee chaired by Sir John Summerson. Traditional training methods, such as a grounding in life drawing and painting techniques, were replaced with a set of modernist attitudes, largely American in origin, which placed more emphasis on the student as a creative individual. By the late 1960s, however, a growing body of art students were becoming dissatisfied with the formal stylistics that the new pedagogy sought to promote.

This dissatisfaction helped give rise to the 'conceptual' movement which was to run parallel with the 1970s interest in 'minimal' painting and sculpture. The American Minimalists were shown at the Tate in 1969, in 'The Art of the Real' exhibition, and their example helped confirm in Britain a dominant critical attitude that saw art as autonomous, independent of ideology, tradition or history and therefore, by implication, socially irresponsible. In 1964 Susan Sontag had observed that a characteristic of modern painting was its flight from interpretation, that both abstract art, with its apparent absence of content, and Pop Art, by using a content so blatant, ends by being uninterpretable.

Sontag saw this as a strength and argued that the habit of interpretation can become reductive. But to a late-1960s generation of students, living through a period of political crisis and idealism, this resistance to interpretation seemed unsatisfactory. They were also aware, as they turned the pages of the latest issue of *Studio International* or the American periodical *Art Forum*, that rapid expansion of an increasingly investment-conscious art market had turned even the most avant-garde artists into mere pawns within the capitalist system. The sheer glut of art was also disturbing. Victor Burgin (b. 1941), who

was to become a leading figure within the 'conceptual' movement, has said: 'I remember coming across this enormous compendium of international abstract art that some German publisher had done – it was really appalling to just see *so much*, and you knew that for every guy in the book there were fifty or a hundred others just as competent.'

'Conceptual' art was international and not confined to any one country. Originally it attempted to oppose the existing system by producing an art that would not become the property of certain classes and cultural reserves. Inspired by the anti-authoritarian example of Dada, it sought to expand the parameters of art to include the whole of life. Sometimes manifesting itself as Land Art, Body Art, or Process Art, the title 'conceptual' art remains the broadest and most useful label. The shift of emphasis that it entailed was first described by the American critic Lucy Lippard in her article 'The Dematerialization of Art', published in *Art International* in February 1968. In this she argued that the anti-intellectual, emotional and intuitive processes of art-making, characteristic of the 1950s and 1960s, had given way to an almost exclusive emphasis on the thinking process: 'matter is denied, as sensation has been converted into concept.'

Don Judd's remark, that the discovery of a form which was neither geometric nor organic would be an achievement, led Victor Burgin, who was studying at Yale University in 1965-67, to conceive of work that involved psychological form. On his return to England he began to replace the art object with written descriptions that provided the reader with instructions for the making of minimal art objects. These did not need to be made, being constructed in the reader's mind with his or her assimilation of the instructions. Likewise Burgin's *Photopath* (1969), a path made across the gallery floor with photographs of, and precisely aligned to, the floorboards that lay beneath, invited conceptual play. The idea for this piece arose from Burgin's reading of a passage in Ludwig Wittengenstein where the philosopher talks about looking at an object and simultaneously *thinking* of what you see.

By the end of 1969 Burgin was making written pieces in which numbered statements build up a dense network of associations and cross-references, again held in the reader's mind. Burgin soon grew dissatisfied with the non-committal character of these pieces and moved on to deal with contemporary society through the use of text and photographic imagery. His familiarity with semiology left him aware that one possible job for the artist was the dismantling of existing communication codes (particularly those used in advertising) and the re-combining of their elements in such a way as to generate new pictures of the world. At first he made use of images drawn from 187 advertisements (later making his own photographs in an advertise-

A PROMISE OF TRADITION
You mustn't be too hard on them.
So many things to cope with. So much to do.
They keep rabbits. They keep house.
They keep up appearances.
If they fail to keep their word
you must excuse them. They're good people.
Almost all of them. They may not see you.
They may not hear you. They may not want to.
It's not their fault. They mean well.
They have promised to try again.

187 Victor Burgin, *A Promise of Tradition*, 1976

ment style) and adding a text composed of advertisement clichés, sociological or newspaper reports. Text and image display an obvious variance, their codes clash, one often subverting the initial meaning of the other.

'Conceptual' art could take any conceivable form. Its practitioners, reacting against the excessive emphasis previously given to material presence in art, were primarily concerned with ideas and information and only secondarily with their visual presentation. The first exhibition of 'conceptual' art in London, 'When Attitudes Become Form' (subtitled 'Live in your head'), shown at the ICA in August–September 1969, was an expanded version of that seen earlier at the Kunsthalle, Berne. To the critics Edward Lucie-Smith and Patricia White it seemed 'an exhibition of quite outstanding dreariness'. Much 'conceptual' art was visually dull or workaday. It turned deliberately to the more depersonalized media – photography, video, maps, diagrams, typewritten texts – in order to escape the contaminated convention of the unique, hand-crafted art object. But even its ideas could border on the self-consciously neat or banal. It offered the mind a teasing game, not the shock of revelation. In the case of *4 Identical* 188 *Boxes with Lids Reversed* by Michael Craig-Martin (b. 1941) it made the mind active in order to clarify actual and imagined looking.

188 Michael Craig-Martin, *4 Identical Boxes with Lids Reversed*, 1969

One of its most extreme strategies was that adopted by Art & Language, a collective of artists and art historians who decided to make an art form out of the discourse about art. This they announced, with characteristic circumlocution, in the first issue of their magazine, *Art & Language* (May 1969): 'It is not beyond the bounds of sense to maintain that an art form can evolve by taking as a point of initial enquiry the language use of the art society.' Two of its founders, Terry Atkinson (b.1939) and Michael Baldwin (b.1945), met at Lanchester Polytechnic in 1966. Other members included David Bainbridge, Mel Ramsden, Ian Burn, Harold Hurrell and Charles Harrison. By the time the second issue of *Art & Language* appeared, it had annexed Joseph Kosuth as its American editor. The group met, like Bloomsbury, simply to talk, to avoid the use of closed concepts and to strive for scientific objectivity. Its discussions drew heavily on empiricist philosophy, information theory and cybernetics. The use of theoretical terminology and abstruse references made their work difficult and impenetrable, even though one of their aims was to evolve a socialist theory of art.

If Art & Language represents an arcane extreme within the 'conceptual' movement, Gilbert and George have protected their seriousness behind a polite gentility and outward simplicity. Their single, most

important 'conceptual' act was the decision to put on 'the responsibi-
lity suits of our art' and to become 'living sculptures'. As this decision
was first made while both were still students at St Martin's School of
Art, one original intention must have been to needle Anthony Caro
and the New Generation sculptors whose very masculine sculpture
dominated the sculpture department. After that, everything Gilbert
and George did became sculpture, their everyday lives forming a
continuous performance. Born Gilbert Proesch (1943) and George
Passmore (1942), they have so successfully submerged their two
personalities into a dual-headed persona that it is impossible to
conceive of them independently. Moreover the success of their art
depends on ambiguity, on the fact that their committed stance remains
challengingly unbelievable.

At the time when they first adopted a quaint formality of dress and
behaviour, student clothes and relationships were avowedly casual;
and to their peers, Gilbert and George, with their old-fashioned
romanticism, seemed a humorous satire on certain English traditions.
As their work progressed, however, and was recorded in 'photo-
pieces', a darker, more sinister note was occasionally struck. Their
'drinking sculptures', though humorous, hinted at self-destructive
instincts. These became palpable in the subsequent series *Human
Bondage*, while the empty rooms in their house, in a dilapidated street
in London's East End, became the setting for some 'photo-pieces'
exploring psychological disquiet. By the mid 1970s 'photo-pieces' had
become the artists' chief form of expression. In a series dealing with
inner-city life Gilbert and George, no longer central, are pushed to the
side or into the corners, as if observing the hustling crowds and traffic,
184 the salacious graffiti or the dejection and boredom of East End youth.
By adopting a spectatorial role, they have succeeded in charging their
surroundings with positive unease: offset by their passivity, every-
189 thing becomes art.

With the gradual breakdown of traditional forms, the boundaries of
art expanded to include anything that involved a matter of choice. 'Art
is what we do,' declared the American Carl Andre. 'Culture is what is
done to us.' Keith Arnatt (b.1930) pursued as a theme the possible
disappearance of art and the artist. In 1967 the American sculptor
Claes Oldenburg, in connection with a 'Sculpture in Environment'
exhibition, had arranged for a pit to be dug in Central Park, New
York, and then filled in again; it was, he said, 'an underground
sculpture', a 'conceptual thing'. This, for Keith Arnatt, questioned
'the relation between what one sees, or does not see, and what one
knows, or does not know'. His response was to make *Earth Plug*. A
section of turf and soil was cut out of a field and placed in an
identically shaped box which became invisible when it was returned to

189 Gilbert and George, *Fallers*, 1984

the hole like a plug. The following year, 1968, he made *Invisible Hole,* 190
as Revealed by the Shadow of the Artist, by lining the four sides of a cube
cut into a field with mirror and its base with a layer of turf. Except
when the artist placed his shadow over it, the hole was almost
impossible to see. Subsequent developments on the theme of disap-
pearance included *Self-burial* (1969) in which Arnatt himself, provid-
ing a metaphor for the increasingly reductive nature of modernism,
gradually disappeared into the soil. The following year he sent to
Charles Harrison's exhibition 'Idea Structures' at Camden Art Centre
an essay entitled 'Is it possible for me to do nothing as my contribu-
tion to the exhibition?'

Much 'conceptual' art investigated itself, deconstructing the processes that had gone into its making. It annexed the functions of the critic, blurring the division between production and evaluation. By questioning the nature of the creative process, it shifted attention away from the finality of the art object towards a more open-minded aggregate of information and ideas. Traditional aesthetic assumptions proved useless in the face of this art which nimbly escaped categorization. It successfully broke the hegemony of Greenberg's influence. For this reason, one significant act was that performed in 1966 by John

190 Keith Arnatt, *Invisible Hole, as Revealed by the Shadow of the Artist*, 1968

Latham, a part-time teacher at St Martin's School of Art. Having taken Greenberg's *Art and Culture* out of the library, he and the sculptor Barry Flanagan (b. 1941) invited artists, students and critics to Latham's house in order to take a page from this book, chew it and, if necessary, spit out the remains into a flask. The chewed pages were then immersed in acid until the solution was converted into a kind of sugar. This was neutralized by the addition of sodium bicarbonate, yeast was added and the solution allowed to bubble. Almost a year later Latham, in response to an urgent request for the book's return, sent back the solution together with a distilling apparatus. A few days later his teaching at St Martin's was abruptly terminated.

The sculpture department at St Martin's also encouraged the incorporation of time into sculpture. Roelof Louw (b.1935), one of the school's influential teachers, in 1967 made a pyramid of 5,800 oranges which were gradually reduced over two weeks to nil. John Hilliard (b.1945) grew tired of taking photographs of his constructed steel sculpture and decided to make photography itself his subject, displaying the effect of differently timed exposures in the series *Sixty Seconds of Light* (1970). He also delighted in impermanence, filling a room with 765 paper balls suspended in space on invisible thread. 191

The St Martin's-trained artist who most successfully introduced time into the concept of sculpture was Richard Long (b.1945). He and

191 John Hilliard, *765 Paper Balls*, 1969

Hamish Fulton (b.1946) began making long treks through the landscape, both at home and abroad, bringing back photographs, one of which would then be exhibited together with a terse descriptive statement, and, in Long's case, sometimes a map of the area with the journey marked on it. Compared with their American equivalents, the land artists Robert Smithson, Dennis Oppenheim or Walter de Maria, Long and Fulton promoted a gentler, more nostalgic attitude to landscape. Long does occasionally impose on his surroundings, but he has always used materials at hand in the landscape and the results are usually impermanent (as when he made a cross in a daisy-filled field simply by picking the flowers). Both artists have tapped a

192 Richard Long, *A Hundred Mile Walk*, 1971–72

narrow, poetic vein, reviving the traditional concern with landscape in a new way. Ironically, the further they moved away from the gallery, the more eagerly did a metropolitan art audience seize upon their work, perhaps because a recollection of wide open spaces helped salve the blight of inner-city over-crowding and decay.

Under the influence of the 'conceptual' movement, sculpture lost its traditional attributes and dissolved into a variety of activities including performance. This had been an important artistic strategy since the early decades of this century, helping to advertise the aims of the Futurists, Dada, the Bauhaus and the Russian revolutionaries. Performance art had taken root in America in the late 1930s, and during the 1950s and early 1960s was converted into 'environments' and 'happenings' that were often closely related to Pop art. In the late 1960s performance became a fertile medium, largely because, like much 'conceptual' art, it was inspired by the desire to escape the art market.

193 Mary Potter,
The Sink, 1975

194 Michael
Andrews, *Melanie
and Me Swimming*,
1978–79

195 Anne Redpath,
Altar at Chartres, 1964

196 Gillian Ayres,
Papagena, 1983

But if performances could not be bought and collected they neverthe-less had to be funded, and many of these artists escaped the dealers only to fall into the arms of state bureaucracy.

Performance art varies enormously in its choice of methods and range of expression. Some of its practitioners follow in the tradition of street theatre, which for a period involved John Fox's group, Welfare State, in a nomadic way of life. Welfare State aimed its work not at an art audience but at the general public, by working with universal archetypes presented in an accessible idiom. Much performance art, however, depended upon its collusion with a tolerant audience. In the seclusion of a studio or a gallery it would pursue strange, ritualistic acts, using a symbolism often too arcane or personal to decode. Moreover, the pursuit of boredom, through repetitious or minimal actions, was often little more than a thinly disguised, disturbing exercise of power.

Feminists, with their slogan 'the personal is political', quickly recognized in performance a medium through which they could raise consciousness, reject dominant modes of thinking and deal with issues normally excluded from 'high' art. Bobby Baker (b. 1950), with the aid of slides and improvised monologue, humorously drew attention, as she served a packed lunch to a large audience at the Hayward Gallery, to the labour and preparation that had gone into its making. More notorious was the exhibition 'Prostitution' orchestrated by the performance artists Cosey Fanni Tutti and Genesis P. Orridge at the ICA in 1976, in which blood-stained items sparked off such fury in the press (for the exhibition was partly funded by the state-financed Arts Council) that questions were asked in Parliament.

Much performance art has a political edge and reflects the influence of the German artist Joseph Beuys. He at one point devoted himself to political debates, 'social sculptures', in which he tried to revolutionize people's thought, mobilize their creativity and thus help towards the transformation of society. In England one of the most unsettling performance artists is Stuart Brisley (b. 1946), who in various ways pushes himself beyond the limits of normal physical endurance, his 197 discomfort obliging an anaesthetized, depoliticized society forcibly to consider the isolation and alienation of the individual.

Though 'conceptual' activity still continues, it is no longer a dominant artistic mode. Its cerebral appeal was bound to produce a reaction which, in the late 1970s, began to lead in two directions: to the revival of traditional media and to an enhanced awareness of the need for a more social art. In 1978 two exhibitions were mounted to promote the work of artists who deliberately sought to engage with a wide public: 'Art for Whom', selected by the art critic Richard Cork and shown at

197 Stuart Brisley, *Moments of Decision/Indecision*, 1975

198 R.B. Kitaj, *If Not, Not,* 1975–76

the Serpentine Gallery, and the more broadly based 'Art and Society' at the Whitechapel Art Gallery. Cork declared that 'a strong social concern ought to lie at the core of *all* art', and that 'art for whom' was the most pertinent question an artist could ask him- or herself. Those whose work he approved included the political artist Conrad Atkinson (b. 1940), the muralists David Binnington (b. 1949) and Desmond Rochfort (b. 1949) and those specializing in community arts, Stephen Willats (b. 1943) among others.

Cork's stance ignored the fact that much twentieth-century art has resisted coercion and has remained adamantly anti-social. Nor does a commitment to contemporary social and political concerns necessarily

199 Howard Hodgkin,
French Restaurant,
1977–79

200 Stephen Buckley,
Java, 1980

201 Alexis Hunter, *Approach to Fear XIII: Pain – Destruction of Cause*, 1977

guarantee that the art produced will communicate with a wide audience. As James Faure Walker astutely observed in the magazine *Artscribe* (no.12, 1978), much of the art exhibited in the above two exhibitions was 'directed at a minute portion of the total population – smaller even than the constantly reviled "small circle of initiates" who cultivate modernism'. But the call for a 'social art' did underline a need for greater involvement with contemporary life. Obviously worthy, it offered direction and purpose.

By the late 1970s the feminist art movement in Britain had gained in strength. Working in a variety of media, and often at this time with mass production techniques, feminist artists sought to criticize, oppose or deconstruct traditional methods and meanings. Alexis Hunter (b.1948) made photo-narratives which drew upon the fetishistic glamour of advertising but used it to explore suggestions of self-mutilation, anxiety and fear. Mary Kelly (b.1941) preferred more distancing devices – text, actual objects, diagrams and charts – in her *Post-Partum Document*, the generic title she gave to several related series, all of which explore the construction of femininity within the mother–child relationship. Much .feminist art examined dominant ideologies, and gained strength from a close working relationship between artists and critics.

At the same time, one voice publicly haranguing the aridity of much 'conceptualism' was that of the American expatriate painter R. B. Kitaj. Invited to select an exhibition by the Arts Council for the Hayward Gallery in 1976, he promoted figure drawing and painting under the title 'The Human Clay'. His public statements were given additional weight by the subsequent success of his one-artist show held at the Marlborough Gallery in April 1977 – a gap of some eight years having passed since his previous London exhibition. David Hockney, after his 1970 show, and the six small pictures shown at Kasmin's in 1972, had likewise not exhibited in London during the greater part of this decade. Together these two artists now set out to promote a return to figuration. In support of their cause, both appeared naked on the cover of the January/February 1977 issue of *The New Review* and inside circled round their desire for, and the difficulty in making, representations of the human figure.

In his catalogue to the Arts Council exhibition, Kitaj spoke of the need, 'keeping ordinary people in mind', for an art 'to which many modest lives can respond'. In his own paintings and drawings he now strove for greater accessibility. His larger canvases remained complex, filled with multifarious references, oblique signals to historic memory and the imagination. But whereas before he had employed abrupt contrasts of style, he now began to ease the transitions, sometimes embedding detail in a sea of gently fluctuating, seductive colour.

Kitaj's and Hockney's promotion of figurative art helped to re-focus interest on drawing and, often at student request, encouraged the revival of life classes in art schools. Hockney's refusal to stand still as an artist, his experimental 'Paper Pools', his imaginative theatre designs, brilliance as a draughtsman and his original use of photography have all distracted from the often disappointing nature of his painting and the rootlessness that its content displays. Yet his most recent surprise has been a revival of that liberating eclecticism which first surfaced at the RCA. As a result, his 1980s paintings promise to be some of his most inventive.

If painting had been a medium of reduced possibilities, during the late 1970s it began to broaden and deepen as an art form. As it revived, the alternatives practised by 'conceptual' artists became increasingly marginal. A number of artists who had for some time been underrated or ignored now came to the fore. Michael Andrews became highly regarded as a figurative painter capable of expressing social disequilibrium and alienation. The art of Mary Potter (1900–83) was reappraised. Her late work, like that of Anne Redpath (1895–1969), achieved a breakthrough with its elliptical description and gentle visionary mood. Frank Auerbach and Leon Kossoff achieved recognition as artists profoundly occupied with their mediums and with the difficulty of making an image which, in Auerbach's terms, 'remains in the mind like a new species of a living thing'. 194 193 195

Their fascination with the physical nature of paint came as a relief after the modernist emphasis on flatness. Even former hard-edge abstract painters like Gillian Ayres and John Hoyland now employed heavy impasto, adding layer after layer to their canvases. Each mark added to Hoyland's late 1970s paintings related, not to anything outside the canvas, but to earlier marks which they attempted to rectify or resolve. As the colour harmonies grew rich and sonorous, the success or failure of his paintings increasingly rested on a knife edge. 196, 161

The change in climate helped to focus attention on certain artists who had for some time been employing various strategies to enrich and recomplicate the picture surface. John Walker (b.1939) gave to his abstracts a battered and time-worn air by adding chalk dust and collaged pieces of canvas. Stephen Buckley (b.1944) first wove strips of canvas across the stretcher frame in 1969, later taking this technique further in canvases that are cantilevered, bent or fragmented, the physical properties of each work being made insistently felt. Instead of refining the essential characteristics of a medium, certain artists began to create through repeated alteration and excess. Howard Hodgkin (b.1932) admitted in an interview with Timothy Hyman that much of his work depended on 'a kind of desperate improvisation'. The 202 200

202 John Walker, *Ostraca VI*, 1976–78

starting point for his pictures is often the experience of social exchange with friends in a domestic setting. More concerned with the emotional than the visual reality of the scene, Hodgkin deliberately avoids the illustrational and works with shapes that are impersonal and almost banal – the disk, stripe or loop – forging with these an immediately recognizable personal language. Working mostly on wood (old table tops or bread boards), he constantly alters his images by radical additions that nevertheless allow traces of the earlier states to show through. In this way dense, rich effects are achieved, combining clarity of form and colour with spatial complexity. The lusciousness of paint is allowed, yet everything extraneous to his purpose is ruthlessly excised.

199

No single style or set of ideas now dominated. The avant-garde, instead of forming a spearhead, became dispersed as individual concerns increasingly took precedence over collective effort. Because contemporary practice was no longer shaped by a linear evolutionary progression, of the kind that underlay Greenberg's theory of modern-

ism, the term 'post-modernism' came into use. Much that modernism had suppressed now vigorously asserted itself: an interest in narrative, myths, symbols, expressionism, primitivism, and even the classical landscape tradition. These interests were displayed in gargantuan form in the late work of the renegade American Abstract Expressionist, Philip Guston, shown at the Whitechapel Art Gallery in 1982, and in the Neo-Expressionism that began to emerge from Germany, America and Italy. A sample of these artists' work hit London in 1981 when the Royal Academy mounted 'The New Spirit in Painting'. But it was the success of the 'Zeitgeist' show in Berlin at the end of 1982 that turned Neo-Expressionism into an international style. 206

In England this became 'New Image' painting, characterized by abrasive handling and strident colour. The image is seized greedily and fast, for emphasis was now given to an anti-intellectual spontaneity. This new cult, in the work of two young Scottish artists, Steven Campbell (b.1954) and Adrian Wiszniewski (b.1958), has released a

203 John Bellany, *Bethel*, 1967

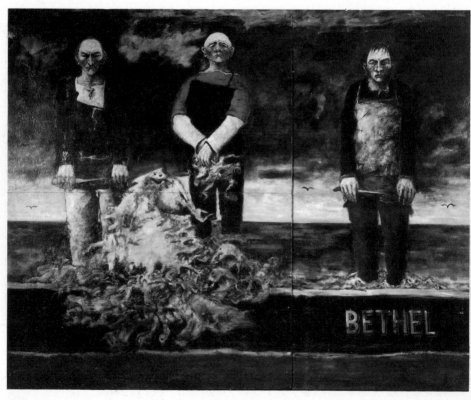

204 fertile imagination. Campbell's clumsily earnest heroes are found in
205 macabre, dream-like, situations in which, as in Wieszniewski's more
colourful and romantic world, signs and portents abound. The rage
for expressionism has also helped bring to the fore an older generation
of artists, among them Paula Rego (b.1935), Ken Kiff (b.1935) and
203 John Bellany (b.1942) whose work deals with urgent psychological
perceptions, often autobiographical. Paula Rego invents strange,
cartoon-like characters with which to explore aspects of human
behaviour. In these, humour makes a welcome return after the
seriousness of the 1970s, as it did also in Roger Hilton's late gouaches
through which he rebelled against his physical decline.

The censoriousness of the 1970s was replaced by a liking for the
swift and succinct. Art could once again be about something as off-
hand and evanescent as a joke. One artist who had always known this
was Barry Flanagan. At St Martin's School of Art, in the mid 1960s
when New Generation sculpture was the vogue, he had adopted the

204 Steven Campbell, *God's in His Heaven, all's well with the World*, 1984

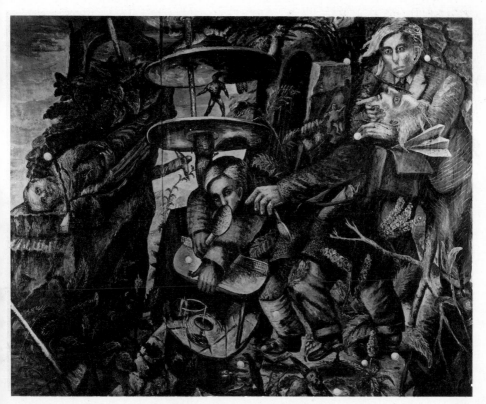

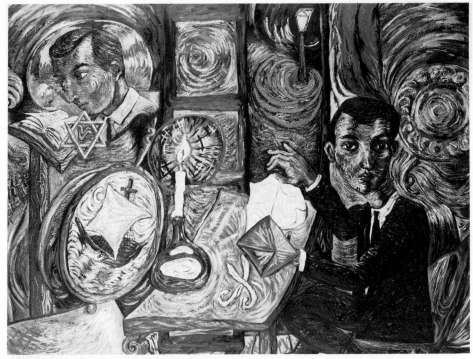

205 Adrian Wiszniewski, *My Jewish Brother*, 1983–84

role of heretic and, as if to mock the rigidity of steel, had made *aaing j gni aa*, in which five biomorphic shapes, made out of hessian 207 and stuffed, stood inside a white circle added at the suggestion of Phillip King. Flanagan has remained the joker in the pack, flirting with issues directing contemporary sculpture, cocking a snook at art yet still obeying its rules.

In 1973 Flanagan began carving stone, a technique he had originally learnt at Birmingham in the late 1950s. With this technique he made mostly small, informal works, often rough-cut and incised with descriptive or allusive detail. The Tate Gallery's *a nose in repose* (1977–79) gently castigates the grandiloquent tendency in British sculpture. In 1980 he modelled a hare leaping and the following year portrayed this animal in a variety of poses, balancing on a bell, helmet or cricket stumps, boxing or performing acrobatics. These works had a joyous élan and instant appeal, the hares perhaps symbolizing the imaginative agility of the artist's mind.

Flanagan was not the only sculptor to revive traditional materials and methods. Much work shown in the sculpture parks in Yorkshire, Wales and at Grizedale during the late 1970s was made out of wood

206 Christopher Le Brun, *Painting on a Dark Ground*, 1980

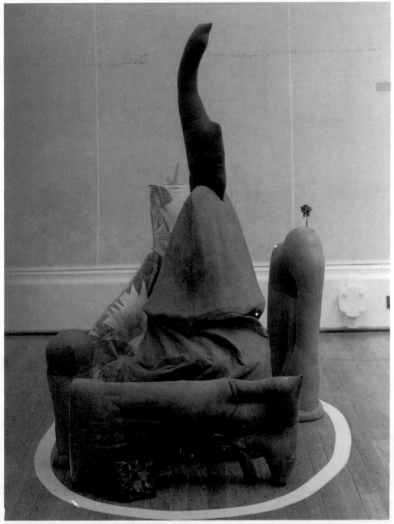

207 Barry Flanagan, *aaing j gni aa*, 1965

and displayed pleasure in the activity of splicing, joining or carving. David Nash (b.1945), in pieces like *Running Table*, deftly fashioned work that required only the minimum alteration to the natural shape of his material. At Stockwell Depot, an old warehouse in South London which had been taken over co-operatively by artists in need of studio space, there was a revival of interest in welded-steel sculpture, now mostly left uncoloured and indebted to a Cubist language.

During the early 1980s sculpture, responding to the rapid successive

changes affecting art generally, began to display rampant individual-
ism and wily eclecticism. It now often by-passed previous traditions
in British sculpture in order to ransack more distant cultures,
imitating primitive examples or plundering the Italian Renaissance for
ideas. What made much of this work distinctly British was a delight in
the eccentric or off-beat; for instance, the slightly mad jokes that
young sculptors like Julian Opie (b.1958), in his recreation of an office

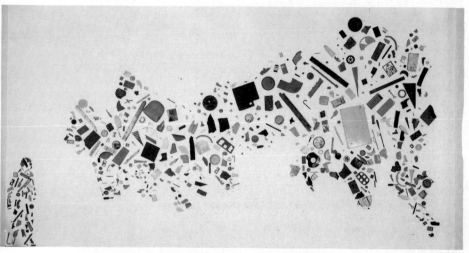

208 Tony Cragg, *Britain Seen from the North*, 1981

hold-up, or Andy Frost (b.1957) in his *Batmobile*, began to employ. At
the Hayward and Serpentine Galleries' 'Sculpture Show' mounted by
the Arts Council in 1983, that which reflected most on contemporary
society was the nostalgia for outdated technology. This concern is
shared by Tony Cragg (b.1949) who makes a gesture of reclamation
by scouring rubbish dumps, selecting, for example, plastic items and
fragments which are then arranged in coloured bands or in the shape
208 of an image on the gallery floor or wall. Bill Woodrow (b.1948) also
extemporizes with cast-offs, fashioning a guitar or projector out of an
209 old washing machine, a miniature tank out of the seat of a child's
tricycle. David Kemp (b.1945) performing the role of a future
archaeologist, reconstructs our demons, gods and goddesses out of
rusting machine parts or the insides of electronic gadgets, the
210 mutilated fragments of a blasted civilization. Anish Kapoor (b.1954)
looks back to his Indian heritage, from which he has become exiled,
using symbolic shapes coated with powdered pigment.
211 Melancholy humour turns to satire in the work of Bruce McLean
(b.1944). No artist has been more tongue-in-cheek than he, satirizing

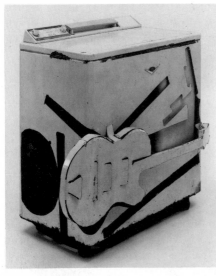

209 Bill Woodrow,
Twin-tub with Guitar, 1981

211 (Opposite) Bruce McLean,
Pose Work for Plinths I, 1971

210 Anish Kapoor, *Three*, 1982

the limitations of New Generation sculpture while still a student at St Martin's and mocking the whole art system, with its various cultural channels and dependence on clichés, in his 'King for a Day' retrospective held at the Tate in 1972 when he was still only twenty-seven. The previous year McLean, with Paul Richards, and Ron Carra, had formed Nice Style, the World's First Pose Band, which over the next four years through its hilarious emphasis on pose drew attention to social hypocrisy. After the group disbanded, McLean continued to perform, with the help of others, satirizing conventions and attitudes associated with society, bureaucracy, artists and architects. His choice of detail, phrase, object or allusion is often bitingly apposite, in the Hogarth-Rowlandson tradition. Invigoratingly anti-authoritarian, he has always been suspicious of styles and though he has worked as a land artist, making 'floataway' sculptures on the Thames at Barnes, as

a 'conceptual' and performance artist and now paints in an expressionist manner, his sense of irony and wit has kept him at a safe distance from any stylistic formula.

The realism of satire remains a key strength but it is not the reason why British art currently enjoys a high reputation. Viewed from abroad, the strength of British art is seen to rest not with any school, movement or style but with the achievement of a handful of individuals, among them Henry Moore, Francis Bacon, Lucian Freud, Frank Auerbach and Howard Hodgkin, all of whom, variously handling metaphor, description, psychological ambiguity, the raw or freshly perceived, bring to their art an intensity that can startle, delight, discomfort or appease, but which carries their discoveries and experience into the minds and hearts of others, creating that dialogue without which the act of communication remains incomplete.

BIBLIOGRAPHY AND SOURCES

General

John Rothenstein, *Modern English Painters*, Vols I, II and III (London, 1952–74, revised 1984); Mary Chamot, Dennis Farr and Martin Butlin, *Modern British Paintings, Drawings and Sculpture*, vols I and II (cat., Tate Gallery, London, 1964); Dennis Farr, *English Art 1870–1940* (Oxford, 1978); William Hardie, *Scottish Painting, 1837–1939*, (London, 1976); Anne Crookshank and The Knight of Glin, *The Painters of Ireland c.1660–1920* (London, 1978); Richard Shone, *A Century of Change: British Painting since 1900* (Oxford, 1977); Charles Harrison, *English Art and Modernism, 1900–1939* (Indiana and London, 1981); *English Art Today, 1960–76*, vols I and II (exh. cat., British Council, London, 1976); Sandy Nairne and Nicholas Serota (eds), *British Sculpture in the Twentieth Century* (Whitechapel Art Gallery, London, 1981); Edward Lucie-Smith, *Movements in Art since 1945* (London, 1969, revised 1984).

1 Edwardian Reflections (pp. 10–35)

WILLIAM NICHOLSON: Lillian Browse, *William Nicholson* (London, 1956). *William Nicholson: Paintings, Drawings and Prints* (exh. cat., Arts Council, London, 1980). Duncan Robinson's introduction is the source of the quotation on p. 11.
DIEGO RODRIQUEZ VELÁSQUEZ: R. A. M. Stevenson, *Velasquez* (London, 1895, repr. 1962).
J. A. M. WHISTLER: the chapter 'Friends and Followers' in Hilary Taylor, *James McNeill Whistler* (London, 1978) provides a summary of the artist's immediate influence.
GWEN JOHN: Susan Chitty's *Gwen John 1876–1939* (London, 1981) quotes extensively from the artist's letters and notebooks, but it is Mary Taubman's introduction to *Gwen John* (London, 1985) that discusses her desire for 'strangeness'.
WALTER SICKERT: the quotation on p. 15 comes from *London Impressionists* (exh. cat., Goupil Gallery, London, 1889). For all subsequent quotations by Sickert, see Osbert Sitwell (ed.), *A Free House or The Artist as Craftsman. Being the Writings of Walter Richard Sickert* (London, 1947).
Jewish émigré artists: see *The Immigrant Generations: Jewish Artists in Britain 1900–1945* (exh. cat., Jewish Museum, New York, 1983). Fry's comment on *Jews Mourning in a Synagogue* is from *Nation* (London, 11 Jun 1910).
ROGER FRY: Frances Spalding, *Roger Fry: Art and Life* (London, 1980, California, 1981). D. S. MacColl's description of the artist is from 'The New English Art Club', *Studio* (London, Mar. 1945, vol. 129), p. 72.
CHARLES RICKETTS: Joseph Darracott's *Charles Ricketts* (London, 1980) substantiates the importance of this late Victorian. The C. J. Holmes quotation is from *Self and Partners (Mostly Self)* (London, 1936), p. 212, and Rothenstein's remark from his *Men and Memories*, Vol. 1 (London, 1931), p. 176.
Impressionism: Camille Mauclair, *The French Impressionists* (London, 1903). Wynford Dewhurst, *Impressionist Painting* (London, 1904).
'French Impressionist Fund': Frank Rutter, *Since I Was Twenty-Five* (London, 1927), pp. 154–58.
JOHN SINGER SARGENT: Carter Ratcliff's *John Singer Sargent* (London, 1983) summarizes this artist's career, and is also the source (pp. 224–25) of Osbert Sitwell's remark. A biography is forthcoming, by Stanley Olson.
AUGUSTUS JOHN and WILLIAM ORPEN are the subject of two authoritative biographies, by Michael Holroyd (London, 1975) and Bruce Arnold (London, 1981) respectively. The Frank Rutter quotation is from his *Art in My Time* (London, 1933), p. 89.
Slade teaching: the description of the Slade style is from Quentin Bell's introduction to *Mark Gertler: Selected Letters*, ed. Noel Carrington (London, 1965), p. 9. More information on Slade teaching can be found in Joseph Hone, *The Life of Henry Tonks* (London, 1939), from which Tonks's comment is taken (p. 127), and in Lynda Morris (ed.), *Henry Tonks and the 'Art*

of Pure Drawing', (exh. cat., Norwich School of Art, 1985).

Late Victorian and Edwardian sculpture: the authority is Susan Beattie; see her *The New Sculpture* (New Haven and London, 1983). Ezra Pound's remark is from his *Gaudier-Brzeska: A Memoir* (London, 1916), p. 96.

WILLIAM STRANG: *William Strang RA, 1859–1921* (exh. cat., Sheffield City Art Galleries, 1981) brings together the information available on this little-known artist.

WALTER SICKERT *and the Fitzroy Street and Camden Town Groups*: two books by Wendy Baron, *Sickert* (London, 1973) and *The Camden Town Painters* (London, 1979), are written with impeccable scholarship, but also useful are the essays by Andrew Causey and Richard Thompson in *Harold Gilman 1876–1919* (exh. cat., Arts Council, London, 1981). Sickert's remark about nudes is quoted in Wendy Baron's introduction to *Camden Town Recalled* (exh. cat., Fine Art Society, London, 1976). Subsequent quotations by him can be found in *A Free House* (see above).

2 Post-Impressionism: Its Impact and Legacy (pp. 36–59)

Key source books on the 1910–1914 period: Ian Dunlop, *The Shock of the New* (New York and London, 1972), William Wees, *Vorticism and the English Avant-Garde* (Manchester and Toronto, 1974) and Richard Cork, *Vorticism and Abstract Art in the First Machine Age, vol. I: Origins and Development, vol. II: Synthesis and Decline* (London, 1976, and California, 1977). The critic Robert Ross's reaction to 'Manet and the Post-Impressionists' appeared in the *Morning Post* (London, 7 Nov. 1910). Clive Bell's remark is from *The Cornhill Magazine* (no. 962, London, May 1944), p. 23; Sickert's comment is from *New Age* (London, 2 Jun. 1910), and Fergusson's from his *Modern Scottish Painting* (London, 1943), p. 170.

Second Post-Impressionist Exhibition: Fry's catalogue introduction was reprinted in his book *Vision and Design* (London, 1920, repr. in paperback, Oxford, 1981).

Vanessa Bell's comment on the 1910 Post-Impressionist Exhibition is quoted in Frances Spalding's *Vanessa Bell* (New York and London, 1983), p. 92.

Spencer Gore's advice to J. D. Turner is quoted in Malcolm Easton's *Art in Britain 1890–1940. From the Collection of the University of Hull*, (Hull, 1967), p. 63.

C. R. W. NEVINSON: see his autobiography, *Paint and Prejudice* (London, 1937). The comparison of his work to a Channel steamer, and the three following quotations, are from Richard Cork's *Vorticism and Abstract Art in the First Machine Age*, vol. I (see above). Nevinson's belief in war as an incentive to Futurism is taken from an interview with the *Daily Express* on 25 Feb. 1915, and the following quotation from his autobiography.

Artists' autobiographies: Jacob Epstein, *Let There Be Sculpture* (London, 1940), Wyndham Lewis, *Rude Assignment: A Narrative of My Career Up-to-Date* (London, 1950) and Paul Nash, *Outline: An Autobiography and Other Writings* (London, 1949).

3 Painting and Printmaking in the 1920s (pp. 60–89)

The autonomy of form: Roger Fry's comment on Post-Impressionism is from his introduction to the catalogue of the Second Post-Impressionist exhibition (see Chapter 2). Clive Bell's remarks are from *Art* (London, 1914), pp. 25 and 8 respectively.

Henry Moore's comment on Roger Fry is from Philip James (ed.), *Henry Moore on Sculpture* (London, 1966), p. 33.

Seven and Five Society: the first exhibition was at Walker's Galleries in London in April 1920. The complete manifesto is reprinted in Charles Harrison's *English Art and Modernism, 1900–39*, pp. 164–65.

Wyndham Lewis's remark on Vorticism is from his autobiography, *Rude Assignment*, p. 129, and the following quotation from Paul Nash's autobiography, *Outline* (see Chapter 2).

MATTHEW SMITH: F. Halliday and J. Russell, *Matthew Smith* (London, 1962). *Matthew Smith* (exh. cat., Barbican Art Gallery, London, 1983).

DAVID BOMBERG: William Lipke, *David Bomberg: A Critical Study of His Life and Work* (London, 1967), in which Muirhead Bone's comment is quoted (p. 52).

PAUL NASH: Andrew Causey, *Paul Nash* (Oxford, 1980). Causey's remark is from his introduction to *Paul Nash. Paintings and Watercolours* (exh. cat., Tate Gallery, London, 1975).

BEN NICHOLSON: Herbert Read, *Ben Nicholson* (London, 1948). Nicholson's remark was made in a letter to John Summerson on 3 Jan. 1944, and quoted in Jeremy Lewison's introduction to *Ben Nicholson: The Years of Experiment 1919–1939* (exh. cat., Kettle's Yard, Cambridge, 1983).

CHRISTOPHER WOOD: Eric Newton, *Christopher Wood: His Life and Work* (London, 1959). Wood's remark about Bankshead life is quoted in William Mason's introduction to *Christopher Wood* (exh. cat., Arts Council, London, 1979). Winifred Nicholson's comment is quoted from an unpublished memoir on 'Kit [Christopher] Wood in the Tate Gallery archives, with kind permission of Andrew, Kate and Jake Nicholson.

IVON HITCHENS: Alan Bowness, *Ivon Hitchens* (London, 1975).

S. J. Peploe's description of Iona is quoted in Stanley Cursiter's *Peploe: An Intimate Memoir of an Artist and of His Work* (London, 1947), pp. 71–72.

ERIC RAVILIOUS: two recent publications, complementary in their approach, are Freda Constable, *The England of Eric Ravilious* (London, 1982) and Helen Binyon, *Eric Ravilious: Memoir of an Artist* (Guildford and London, 1983).

ERIC GILL: Malcolm Yorke's *Eric Gill: Man of Flesh and Spirit* (London, 1981) provides an excellent account of his work and thought. Fry's remark is quoted in Robert Speaight's *The Life of Eric Gill* (London, 1966), p. 53.

DAVID JONES: much has been written, but the best introduction to his art is Paul Hills's essay in *David Jones* (exh. cat., Tate Gallery, London, 1981).

WYNDHAM LEWIS: for his work of the 1920s, see Richard Cork's essay in *Wyndham Lewis 1882–1957: The Twenties* (exh. cat., Anthony d'Offay Gallery, London, 1984). Lewis's remark on post-war Vorticism is from his autobiography, *Rude Assignment* (see Chapter 2), p. 129, and the following quotation from his *Time and Western Man* (London, 1927), p. 129.

WILLIAM ROBERTS: despite his popularity, very little has been published. The most useful item remains *William Roberts ARA* (exh. cat., Arts Council, London, 1965).

STANLEY SPENCER: *Stanley Spencer* (exh. cat., Royal Academy, London, 1980) summarizes the scholarship on this artist, but highly recommended is Richard Carline's *Stanley Spencer at War* (London, 1978) with its lengthy quotations from Spencer's unpublished writings.

EDWARD BURRA: the monograph on this artist is by Andrew Causey (Oxford, 1985), but the flavour of his wit and personality is vividly caught in *Edward Burra. A Painter Remembered by His Friends*, ed. William Chappell (London, 1982).

Clive Bell's criticism of the R.M.S. *Queen Mary* decoration was published in *The Listener* (London, 8 Apr. 1936).

Roger Fry's comment on the 'London Group Retrospective' appeared in the catalogue introduction (Burlington Galleries, London, 1928).

MEREDITH FRAMPTON was the subject of a retrospective at the Tate Gallery in 1982 (catalogue by Richard Morphet).

WALTER SICKERT's late work was reviewed in an Arts Council exhibition at the Hayward Gallery in 1981 (catalogue contributions by Wendy Baron, Richard Morphet, Helen Lessore and others).

4 Sculpture between the Wars (pp. 90–105)

Roger Fry's criticism of memorial sculpture is from 'London Statues', *Nation & Athenaeum* (London, 19 Sept. 1925).

Charles Jagger expressed his views in 'The Sculptor's Point of View', *Studio* (London, Nov. 1933).

FRANK DOBSON: a useful summary of his career will be found in *True and Pure Sculpture. Frank Dobson 1886–1963* (exh. cat., Arts Council London, 1981). William Rothenstein's comment is from his *Men and Memories, 1900–1922* (London, 1932), p. 196.

Virginia Woolf's comment on the 1920 exhibition is quoted in *The Question of Things Happening: The Letters of Virginia Woolf, vol. 2*, ed. Nigel Nicolson (New York and London, 1976), p. 429.

LEON UNDERWOOD: Christopher Neve, *Leon Underwood* (London, 1974). Ezra Pound influenced the development of sculpture in the 1920s through his book *Gaudier-Brzeska: A Memoir* (London, 1916) and through his article 'Brancusi' in *The Little Review* (New York, Autumn 1921).

BARBARA HEPWORTH and HENRY MOORE: of the many books published, the following are recommended: A. M. Hammacher, *Barbara Hepworth* (London, 1968); Herbert Read (ed.), *Barbara Hepworth: Carvings and Drawings* (London, 1961); Margaret Gardiner, *Barbara Hepworth: A Memoir* (Edinburgh, 1982); Barbara Hepworth, *A Pictorial Autobiography* (Bath, 1970). Herbert Read, *Henry Moore: A Study of his Life and Work* (London, 1965); John Russell, *Henry Moore* (London, 1968); Philip James (ed.), *Henry Moore on Sculpture* (London, 1966), from which all quotations by Moore are taken; *The Drawings of Henry Moore* (exh. cat., Tate Gallery, London, 1977).

5 Art and Politics in the 1930s (pp. 106–25)

The 'classical' aesthetic of the inter-war years: R. H. Wilenski, *The Modern Movement in Art* (London, 1927).
Paul Nash's comment on the Surrealists is from *The Listener* (London, 29 April 1931).
Unit One's achievement was reviewed in an exhibition (of the same title) at Portsmouth City Museum and Art Gallery in 1978 (catalogue introduction by Charles Harrison). See also *Unit One*, ed. Herbert Read (London, 1934), from which the quotations on p. 109 are taken.
BEN NICHOLSON: *Ben Nicholson: The Years of Experiment 1919–39* (exh. cat., Kettle's Yard, Cambridge, 1983). His description of the Picasso abstract, and the two following quotations, are quoted in John Summerson, *Ben Nicholson* (London, 1948). The remark about art being an active force in our lives is from Nicholson's 'Notes on "Abstract" Art', *Horizon* (London, Oct. 1941).
Hampstead and its artists: of seminal importance is *Hampstead in the Thirties: A Committed Decade* (exh. cat., Camden Arts Centre, London, 1974).
Constructivism in Britain: see *Circle*, ed. J. L. Martin, N. Gabo and B. Nicholson (London, 1937), from which the quotations by Gabo, Moore and Hepworth are taken.
Surrealism in Britain: the only book on the subject is Paul Ray, *The Surrealist Movement in England* (Ithaca and London, 1971), which should be read alongside Roland Penrose, *Scrapbook 1900–1981* (London, 1981), with its plentiful period photographs. There is a summary of the debate on Realism versus Surrealism in Lynda Morris and Robert Radford, *AIA. The Story of the Artists International Association, 1933–1953* (see below), p. 43. See also *A Salute to British Surrealism* (exh. cat., Blond Gallery, London, 1985).
Euston Road School: nothing has so far been written, though a book by Bruce Laughton is forthcoming. The quotation from Coldstream is taken from Morris and Radford, *AIA* (see below).
Artists International Association: Lynda Morris and Robert Radford, *AIA. The Story of the Artists International Association, 1933–1953* (Oxford, 1983) is densely informative and indispensable.
PERCY HORTON: *Percy Horton 1897–1970: Artist and Absolutist* (exh. cat., introduction by Janet Barnes, Sheffield City Art Galleries, 1982), from which the quotation is taken (p. 21).

6 Neo-Romanticism and Second-World-War Art (pp. 126–41)

Myfanwy Evans's quotations are from *The Painter's Object* (London, 1937).
The quotation from Robert Medley is from his *Drawn from the Life: A Memoir* (London, 1983), p. 199.
JOHN PIPER: recent publications include Anthony West, *John Piper* (London, 1979); Richard Ingrams and John Piper, *Piper's Places: John Piper in England and Wales* (London, 1983); *John Piper* (exh. cat., Tate Gallery, London, 1983). The quotation on p. 129 is from John Piper, *Buildings and Prospects* (London, 1948), p. 87.
GRAHAM SUTHERLAND has been the subject of a recent Tate Gallery retrospective (1982), a monograph by John Hayes (Oxford, 1980) and a biography by Roger Berthoud (London, 1982). However, Douglas Cooper's *The Work of Graham Sutherland* (London, 1961) remains the starting point for this artist, and has a very useful bibliography. The quotation from his letter to Paul Nash (in the Tate Gallery archives) is quoted in Roger Berthoud's biography (see above), p. 90. The 'Welsh Sketch Book' letter is reprinted in *Sutherland in Wales. A Catalogue of the Collection at the Graham Sutherland Gallery, Picton Castle, Haverfordwest, Dyfed* (London, 1976).
Neo-romanticism figures largely in Robin Ironside's *Painting Since 1939* (London, 1947), but otherwise there is little available on this subject apart from catalogues on individual artists. The quotation from John Craxton is from 'Dialogue with the Artist', *John Craxton: Paintings and Drawings 1941–66* (exh. cat., Whitechapel Art Gallery, London, 1967). Kenneth Clark's 'The New Romanticism in British Painting' appeared in *Art News* (New York, February 1947). William Scott's remark is quoted in Alan Ross, *Colours of War* (see below), p. 125.
War Artists' Advisory Committee: Alan Ross, *Colours of War* (London, 1983), from which Edward Bawden's description of Anthony Gross's art is taken (p. 139); Roberto Tassi, *Sutherland: The War-time Drawings* (Milan and London, 1979). John Russell's comment on Moore's 'shelter drawings' is from his *Henry Moore* (London, 1968), p. 81.

7 Realism and Angst in the Post-War Years
(pp. 142–69)

FRANCIS BACON: the chief source remains David Sylvester, *Interviews with Francis Bacon* (London and New York, 1975; rev. edn London, 1980, New York, 1981), from which all quotations by Bacon are taken. Other publications of especial interest are John Russell, *Francis Bacon* (London and Greenwich [Conn.], 1971), Michel Leiris, *Francis Bacon: Full Face and in Profile* (New York and Oxford, 1983) and Dawn Ades's essay 'Web of Images' in the catalogue to the retrospective exhibition *Francis Bacon*, Tate Gallery, London, 1985.
K. C. Clark's *Positioning in Radiography* was published in London in 1939.
LUCIAN FREUD: the quotation on p. 149 is taken from Lawrence Gowing, *Lucian Freud* (London and New York, 1982, p. 56), which is the only monograph on this artist.
PRUNELLA CLOUGH: an interview with Bryan Robertson can be found in *Prunella Clough. New Paintings 1979–82* (exh. cat., Warwick Arts Trust, London, 1982).
JOSEF HERMAN: the quotation is taken from Josef Herman, *Related Twilights: Notes from an Artist's Diary – Places and Artists* (London, 1975), p. 91.
Kitchen Sink and other realists: see *The Forgotten Fifties* (exh. cat., Sheffield City Art Galleries, 1984), from which the Berger and Bratby quotations are taken.
JOHN BERGER: the quotation on p. 162 is taken from his introduction to his book *Permanent Red* (London, 1960), p. 15. For a critique of his stance, see Richard Wollheim's article in *Encounter* (London, Jun. 1961).
DAVID BOMBERG: his late work was the subject of an exhibition at the Whitechapel Art Gallery in 1979, and his teaching methods and writings are discussed by Roy Oxslade in *David Bomberg 1890–1957* (Royal College of Art Papers, no. 3, London, 1977).
FRANK AUERBACH discusses Bomberg's teaching in conversation with Catherine Lampert in *Frank Auerbach* (exh. cat., Arts Council, London, 1978).

8 A Return to Abstraction (pp. 170–89)

St Ives: Peter Davies, *The St Ives Years. Essays on the Growth of an Artistic Phenomenon* (Wimborne, 1984); Tom Cross, *Painting the Warmth of the Sun*. *St Ives Artists 1939–75* (Guildford, 1984); *St Ives 1939–64. Twenty-five Years of Painting, Sculpture and Pottery* [exh. cat., Tate Gallery, London, 1985). Roger Hilton's views on abstract art are quoted in Lawrence Alloway, *Nine Abstract Artists* (London, 1954), pp. 29 and 30, and Peter Lanyon's quotation about the 'urgency of the cliff face' is from his article 'A Sense of Place', in *The Painter and Sculptor* (London, vol. 5, no. 2, Autumn 1962). Further documentation on the abstract art of this period is found in Adrian Lewis, 'The Fifties. British Avant-Garde Painting 1945–56', *Artscribe* (London, no. 34, Mar. 1982: no. 35, Jun. 1982; no. 36, Aug. 1982). The quotations from Lawrence Alloway's *Nine Abstract Artists* are on pp. 12 and 3.
VICTOR PASMORE: a usefully concise account of the artist's career is found in Alistair Grieve's introduction to *Victor Pasmore* (exh. cat., Arts Council, London, 1980), from which Bone's review of Pasmore's first reliefs is quoted (p. 38).
Constructionism: Charles Biederman's *Art as the Evolution of Visual Knowledge* was published in Minnesota in 1948; for an analysis of Biederman's influence, see Alistair Grieve, 'Charles Biederman and the English Constructionists', *Burlington Magazine*, London, Sept. 1982, pp. 540–51, and Feb. 1984, pp. 67–76. The Constructionists have been the subject of many individual and group exhibitions, the most recent of which was Mary Martin's retrospective at the Tate Gallery in 1984.
Patrick Heron's response to Abstract Expressionism comes from 'Americans at the Tate', *Arts* (New York, Mar. 1956).
ROBYN DENNY is the subject of a monograph by David Thompson, published in the Penguin New Art series (London, 1971).

9 Pop, Op and New Generation Sculpture
(pp. 190–209)

Pop Art: a mass of literature has been published, but two recent articles which have displayed a new slant are Lynda Morris, 'What made the Sixties' Art so Successful, so Shallow', *Art Monthly* (London, Oct. and Nov. 1976) and Dick Hebdige, 'In Poor Taste: Notes on Pop', *Block*, 3 (London, 1983) from which the first quotation in this chapter is taken (p. 67). Marco Livingstone has published books on *David Hockney* (London, 1981) and *R. B. Kitaj* (Oxford, 1985), and provides detailed documentation in the following: *Allen Jones* (exh. cat., Walker Art Gallery, Liverpool, 1979); *Patrick Caulfield* (exh. cat., Tate Gallery, London, 1981); *retroVISION. Peter Phillips* (exh.

cat., Walker Art Gallery, Liverpool, 1982).
Richard Hamilton's *Collected Words 1953–1982*
(London and New York, 1983) is a key book
(and the source of his letter to the Smithsons,
p. 28), as is *David Hockney by David Hockney*
(London and New York, 1976).
Op Art: Cyril Barrett, *An Introduction to Op Art*
(New York and London, 1971); *Working with
Colour. Recent Paintings and Studies by Bridget
Riley* (exh. cat., Arts Council, London, 1984).
Kinetic art: Guy Brett, *Kinetic Art* (New York and
London, 1968) deals with a subject more inter-
national than British.
ANTHONY CARO: Diane Waldeman, *Anthony
Caro* (Oxford, 1982), from which Caro's
remark about swallowing history is taken
(p. 18) and also Greenberg's advice (p. 30).
Sculpture: The New Generation: 1968 Interim (exh.
cat., Whitechapel Art Gallery, London, 1968).
General issues: Hugh Adams, *The Sixties*
(Oxford, 1978).

10 Conceptualism and Post-Modernism
(pp. 210–39)

CLEMENT GREENBERG: the source of the first
quotation is 'Modernist Painting', *Art and
Literature* (no. 4, spring 1965), reprinted in G.
Battock (ed.), *The New Art* (New York,
1966). The essay 'Avant-Garde and Kitsch' is
found in his *Art and Culture* (New York and
London, 1961).
Susan Sontag's essay 'Against Interpretation' was
reprinted in her book of that title (New York
and London 1967).
'Conceptual' art: one of the earliest British publi-
cations, and still the most useful, is *The New
Art* (exh. cat., Arts Council, London, 1972),
from which the quotation from Victor Burgin
is taken (p. 76). Victor Burgin's own publica-

tions include *Work and Commentary* (London,
1973). The comment on the 1969 ICA show is
from Edward Lucie-Smith and Patricia White,
Art in Britain 1969/70 (London, 1970, p. 61).
GILBERT AND GEORGE: two of the weightiest
publications are *Gilbert and George 1968–1980*
(Eindhoven, 1980) and *Gilbert and George* (Bal-
timore, 1984).
Carl Andre's remark is quoted in Barbara Rose
and Irving Sandler, 'Sensibility of the Sixties',
Art in America, (New York, Jan/Feb. 1967),
and Arnatt's view of Oldenburg's pit is quoted
in *Beyond Painting and Sculpture. Works Bought
for the Arts Council by Richard Cork* (exh. cat.,
Arts Council, London, 1974, p. 35).
Performance art: much has been written in recent
years. RoseLee Goldberg, *Performance: Live
Art 1909 to the Present* (London, 1979) provides
a useful introduction. See also Jeff Nuttall,
*Performance Art, vol. I (Memoirs), vol. II
(Scripts)*, (Dallas and London, 1979).
The extract from Richard Cork's essay 'Art for
Whom' is from the catalogue to the Arts
Council show of that title, p. 11.
Faure Walker's criticism of Cork is found in 'The
Claims of Social Art and Other Perplexities',
Artscribe, no. 12 (London, 1978, p. 12).
Auerbach's remark on p. 230 is from an inter-
view with Catherine Lampert, in *Frank Auer-
bach* (exh. cat., Arts Council, London, 1978).
HOWARD HODGKIN: see David Sylvester's inter-
view in *Howard Hodgkin: Forty Paintings* (exh.
cat., Whitechapel Art Gallery, London, 1985).
Hodgkin's remark to Timothy Hyman is
quoted in *Artscribe*, no. 15 (London, Dec.
1968, p. 28).
BARRY FLANAGAN: *Barry Flanagan: Sculpture* (exh.
cat., British Council, London, 1982) provides
a useful survey of his career.
BRUCE MCLEAN: Nena Dimitrijevic, *Bruce
McLean* (exh. cat., Kunsthalle, Basel, 1981).

LIST OF ILLUSTRATIONS

NICHOLSON, Ben (1894–1982)
Dymchurch, 1923. Oil on canvas, $11\frac{1}{2} \times 15\frac{1}{4}$ (29.2 × 38.7). Private Collection. **56**
St Rémy, Provence, 1933. Oil and pencil on board, $41\frac{1}{2} \times 36\frac{5}{8}$ (105.5 × 93). Private Collection. **93**
White Relief, 1935. Oil on carved board, $20\frac{1}{2} \times 29$ (52.3 × 73.8). Ivor Braka Ltd, London. **94**

NICHOLSON, William (1872–1949)
Queen Victoria, 1897. Woodcut, handcoloured on Japanese paper, $9\frac{1}{2} \times 9$ (24.2 × 22.8). Fitzwilliam Museum, Cambrige. **1**
Girl with Tattered Glove, 1909. Oil on canvas, $35\frac{3}{8} \times 28$ (89.8 × 71.1). Fitzwilliam Museum, Cambridge. **2**

NICHOLSON, Winifred (1893–1981)
Rock Roses in Shell, 1936. Oil on panel, $14\frac{1}{2} \times 21\frac{1}{2}$ (36.8 × 54.6). Private Collection Sally Kalman, London. **62**

ORPEN, William (1878–1931)
Lady on a Couch, 1900. Oil on canvas, $31\frac{1}{2} \times 35$ (80 × 88.6). Leicestershire Museum and Art Gallery. **12**

PAOLOZZI, Edouardo (b. 1924)
I Was a Rich Man's Plaything, 1947. Collage, $14\frac{3}{8} \times 9\frac{3}{8}$ (35.9 × 23.8). Tate Gallery, London. **164**

PASMORE, Victor (b. 1908)
The Park, 1947. Oil on canvas, $43\frac{1}{4} \times 30\frac{5}{8}$ (110 × 78.5). Sheffield City Art Galleries. **158**
Relief Construction in White, Black, Red and Maroon, 1956–57. Plywood, 29×27 (73.7 × 68.6). Private Collection. **152**

PENROSE, Roland (1900–84)
Last Voyage of Captain Cook, 1936. Mixed media, $27\frac{1}{4} \times 26 \times 33\frac{1}{2}$ (69.2 × 66 × 85.1). Tate Gallery, London. **99**

PEPLOE, S.J. (1871–1935)
Still Life with a Melon, c.1919–20. Oil on canvas, 18×16 (46 × 40.5). National Galleries of Scotland, Edinburgh. **23**

PHILLIPS, Peter (b. 1939)
autoKUSTOMotive, 1964. Oil on canvas, $108\frac{1}{4} \times 108\frac{1}{4}$ (275 × 275). Private Collection. **172**

PIPER, John (b. 1903)
Seaton Delaval, 1941. Oil on wood, $28 \times 34\frac{3}{4}$ (71.1 × 88.3). Tate Gallery, London. **111**

POTTER, Mary (b. 1900)
The Sink, 1975. Oil on canvas, $29 \times 39\frac{3}{4}$ (73.7 × 101). Private Collection. Photo New Art Centre, London. **193**

PROCTOR, Dod (1891–1972)
Morning, 1926. Oil on canvas, $30 \times$

60 (76.2 × 152.4). Tate Gallery, London. **73**

RAVILIOUS, Eric (1903–42)
Illustration to *The Writings of Gilbert White of Selbourne*, 1938. Wood engraving. **52**
Norway, 1940. Watercolour, $17\frac{5}{8} \times 22\frac{5}{8}$ (44.7 × 57.4). Laing Art Gallery, Newcastle. **54**

REDPATH, Anne (1895–1965)
Altar at Chartres, 1964. Oil on canvas, 40×60 (101.6 × 152.4). Prudential Assurance, London. **195**

RICHARDS, Albert (1919–45)
The Drop, 1944. Oil on canvas, $21\frac{5}{8} \times 21\frac{5}{8}$ (54.9 × 54.9). The Trustees of the Imperial War Museum, London. **115**

RILEY, Bridget (b. 1931)
Winter Palace, 1981. Oil on linen, $83\frac{1}{2} \times 72\frac{1}{4}$ (212.1 × 83.5). Juda Rowan Gallery, London. **178**

ROBERTS, William (1895–1980)
Rush Hour, 1971. Oil on canvas, 48×38 (121.9 × 96.5). Private Collection. **65**

ROGERS, Claude (1907–79)
The Cottage Bedroom, 1944. Oil on canvas, 25×30 (63.5 × 76). Arts Council of Great Britain. **101**

ROTHENSTEIN, William (1872–1945)
Charles Ricketts and Charles Shannon, 1897. Lithograph. Private Collection. **8**
Jews Mourning in a Synagogue, 1906. Oil on canvas, $50 \times 39\frac{1}{2}$ (127 × 100.3). Tate Gallery, London. **6**

SARGENT, John Singer (1856–1925)
The Misses Hunter, 1902. Oil on canvas, $90\frac{1}{4} \times 90\frac{1}{4}$ (229.2 × 229.2). Tate Gallery, London. **15**

SAUNDERS, Helen (1885–1963)
Atlantic City. From *Blast*, no. 2, 1915. **35**

SCOTT, William (b. 1913)
Ochre Still Life, 1957. Oil on canvas, 34×44 (86.4 × 111.8). Private Collection. **155**

SICKERT, Walter (1860–1942)
Noctes Ambrosianae, 1906. Oil on canvas, 25×30 (63.5 × 76.2). Castle Museum, Nottingham. **21**
Off to the Pub (The Weekend), 1912. Oil on canvas, $19\frac{1}{4} \times 11\frac{1}{2}$ (48.9 × 29.2). Leeds City Art Gallery. **28**
Viscount Castlerosse, 1935. Oil on canvas, $83 \times 27\frac{7}{8}$ (210.8 × 70.1). The Beaverbrook Art Gallery, Fredericton, New Brunswick. **74**

SKEAPING, John (1901–80)
Blood Horse, 1929. Wood, $27\frac{1}{4} \times 29\frac{1}{2} \times 14$ (69.2 × 74.9 × 35.6). Tate Gallery, London. **85**

SMITH, Matthew (1879–1959)
Winter Evening, 1920. Oil on canvas, $20\frac{3}{8} \times 24\frac{5}{8}$ (51.8 × 62.5). Swansea Museum Services, Glynn Vivian Art Gallery. **55**

SMITH, Richard (b. 1931)
Staggerly, 1963. Oil on canvas, 89×89 (226 × 226). National Museum of Wales, Cardiff. **168**

SPEAR, Ruskin (b. 1911)
River in Winter, 1951. Oil on canvas, $77\frac{3}{8} \times 37\frac{1}{8}$ (196.4 × 94.3). Swansea Museum Services, Glynn Vivian Art Gallery. **139**

SPENCER, Stanley (1891–1959)
Zacharias and Elizabeth, 1914. Oil on canvas, 60×60 (152.4 × 152.4). Private Collection. **66**
Christ Carrying the Cross, 1920. Oil on canvas, 60×56 (152 × 142). Tate Gallery, London. **70**
The Dustman (The Lovers), 1934. Oil on canvas, $45\frac{1}{4} \times 48\frac{1}{4}$ (114.9 × 122.5). Laing Art Gallery, Newcastle. **71**

STEER, Philip Wilson (1860–1942)
The End of the Chapter, 1911. Oil on canvas, $44\frac{1}{4} \times 56\frac{1}{4}$ (112.4 × 142.9). Bradford Art Galleries and Museums. **9**

STRANG, William (1859–1921)
Bank Holiday, 1912. Oil on canvas, $60\frac{1}{8} \times 48\frac{1}{4}$ (152.7 × 122.6). Tate Gallery, London. **20**

SUTHERLAND, Graham (1903–80)
Welsh Mountains, c.1938. Oil on panel, $21\frac{5}{8} \times 21\frac{5}{8}$ (55 × 55). Crane Kalman Gallery, London. **112**
Tin-mine: Emerging Miner, 1944. Gouache, $46 \times 28\frac{3}{4}$ (116.8 × 73). Leeds City Art Gallery. **113**
Thorn Cross, 1954. Oil on canvas, $43\frac{3}{4} \times 36\frac{1}{2}$ (111 × 93). National Gallery, Berlin. **127**

THORNYCROFT, Hamo (1850–1925)
Frieze for the Institute of Chartered Accountants, 1889–93. Great Swan Alley, London EC2. Photo Courtauld Institute of Art. **19**

TILSON, Joe (b. 1928)
A–Z Box, of Friends and Family, 1963. Mixed media, 92×60 (233 × 152.4). Collection the artist. **167**

TOMLIN, Stephen (1901–37)
Virginia Woolf, c.1935. Lead, h.16 (40.6). National Portrait Gallery, London. **80**

TONKS, Henry (1862–1937)
Half-length Study of a Seated Girl, nd. Pencil, 14×11 (35.6 × 27.9). Slade School of Art. **13**

TUCKER, William (b. 1935)
Tunnel, 1960. Steel, $16\frac{7}{8} \times 21\frac{1}{4} \times 16\frac{3}{8}$ (43 × 54 × 41.5). Private Collection. **183**

249

TURNBULL, William (b.1922) 5 × 1, 1966. Synthetic media, each 22 × 72½ × 21 (55.9 × 184.2 × 53.3). Tate Gallery, London. **180**

UNDERWOOD, Leon (1890–1975) *The Cathedral*, c.1931. Poplar wood, h.42 (106.7). National Museum of Wales, Cardiff. **51**

VAUGHAN, Keith (1912–77) *Fourth Assembly of Figures*, 1956. Oil on canvas, 45 × 48 (114.3 × 121.9). Castle Museum, Nottingham. **109**

WADSWORTH, Edward (1889–1949) *Dunkerque*, 1924. Tempera on canvas on panel, 25 × 35 (63.7 × 81.2). Manchester City Art Gallery. **46**

WALKER, John (b.1939) *Ostraca VI*, 1976–78. Oil on canvas, 96 × 120 (244 × 305). Collection the artist. **202**

WALLIS, Alfred (1855–1942) *St Ives Harbour, Hayle Bay and Godrevy and the Fishing Boats*, nd. Oil on

card, 25¼ × 18 (64.1 × 45.7). Private Collection. **61**

WATERHOUSE, John William (1849–1917) *Destiny*, 1900. Oil on canvas, 27 × 21¼ (68.5 × 54). Townley Hall Art Gallery and Museums, Burnley Borough Council. **4**

WEIGHT, Carel (b.1908) *The Moment*, 1955. Oil on panel, 24 × 72 (61 × 182.9). Castle Museum, Nottingham. **138**

WISZNIEWSKI, Adrian (b.1958) *My Jewish Brother*, 1983–84. Oil on canvas, 72 × 96 (182.9 × 243.8). Scottish Arts Council Collection. **205**

WOOD, Christopher (1901–30) *China Dogs in a St Ives Window*, 1926. Oil on board, 25 × 30 (63.5 × 76.2). Private Collection. **48**

WOODROW, Bill (b.1948) *Twin-tub with Guitar*, 1981. Mixed media, 26 × 30 × 35 (66 × 76.2 × 88.9). Tate Gallery, London. **209**

YEATS, Jack Butler (1871–1957) *A Lift on the Long Car*, 1914. Oil on canvas, 18 × 34 (45.7 × 86.3). Leeds City Art Gallery. **5**

Miscellaneous Illustrations

Toltec-Mayan *chacmool*, c.900–1224. Limestone, l. 58½ (148.6). Museo Nacional de Antropología, Mexico. **82**

Interior of Kettle's Yard, Cambridge. Photo Kettle's Yard, University of Cambridge. **84**

The 'Abstract and Concrete exhibition, 1936. Photo courtesy Nicolete Gray. **96**

The International Surrealist Exhibition, 1936. Photo courtesy Eileen Agar. **98**

Muriel Belcher. Photo Michael Parkin Fine Art, London. **120**

INDEX